DIANA
AND THE PAPARAZZI

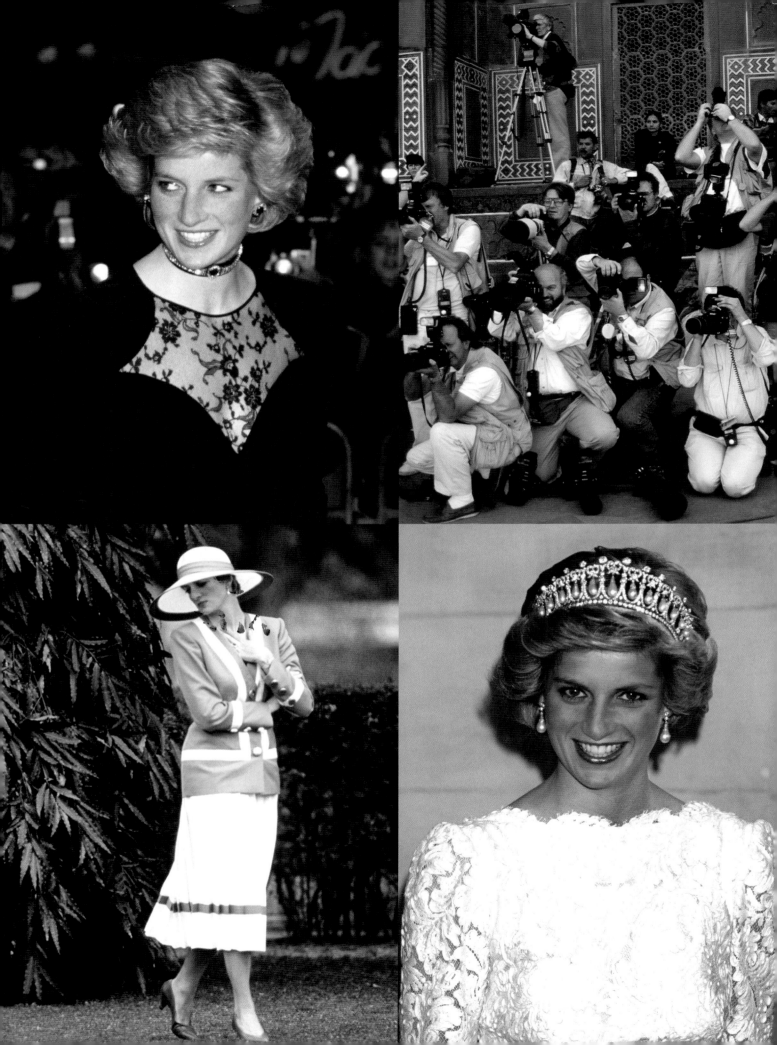

DIANA
AND THE PAPARAZZI

THESE ARE THE TRUE STORIES WE HAVE
NEVER DARED TELL, UNTIL NOW ...

GLENN HARVEY AND MARK SAUNDERS

JOHN BLAKE

Published by Blake Publishing Ltd,
3 Bramber Court, 2 Bramber Road,
London W14 9PB, England

www.blake.co.uk

First published in hardback in 2007

ISBN:978-1-85782-217-5

British Library Cataloguing-in-Publication Data:

A catalogue record for this book is available from the British Library.

Design by www.envydesign.co.uk

Printed in Croatia by Zrinski DD

1 3 5 7 9 10 8 6 4 2

Papers used by Blake Publishing are natural, recyclable products made from
wood grown in sustainable forests. The manufacturing processes conform to the
environmental regulations of the country of origin.

This book is dedicated to our families
for all their love and support

Mark would like to thank Svetlana Mitushena for her invaluable
help and support throughout the writing of this book.

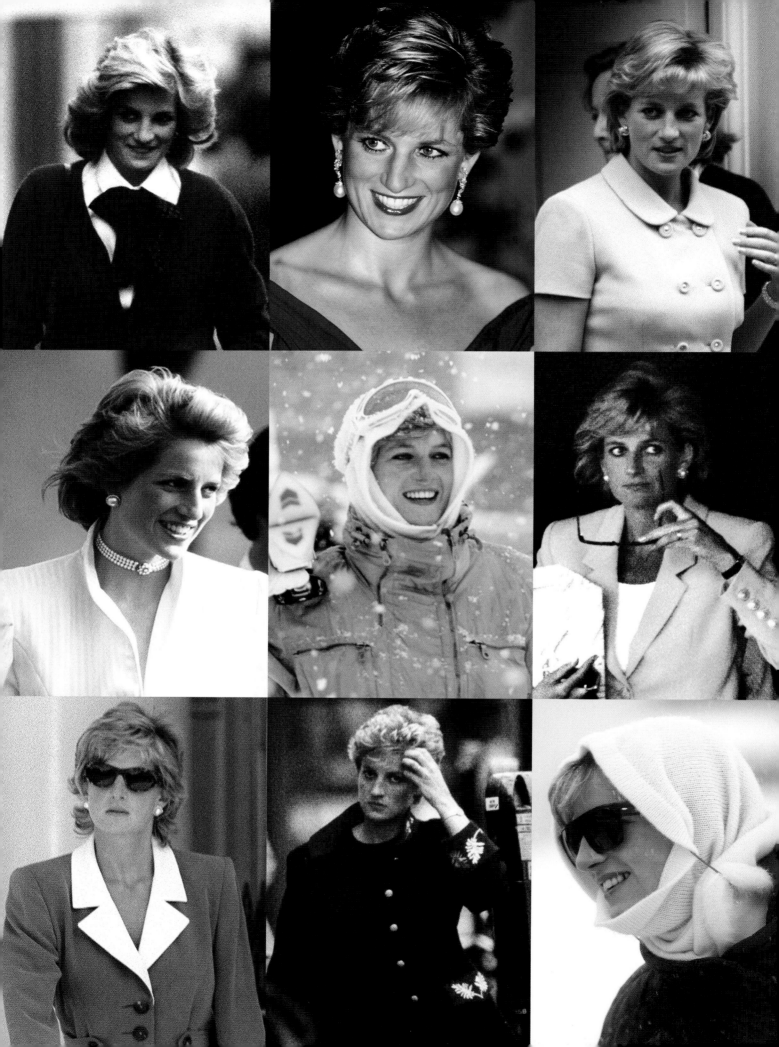

Contents

Foreword

There has never been a single person in history that dominated the front pages of the media as much as Diana. Hers was celebrity on a large scale. When she came on the scene, a new phenomenon had arrived that would capture the hearts and imagination of everyone. She became everybody's favourite topic of conversation: did you see what she was wearing, did you hear what she said? All around the world, whenever Diana's image graced the cover of a magazine that publication would enjoy record-breaking sales. Newspapers jostled with each other for every snippet of gossip – the boyfriends, the glamour, the marriage, the glitz, the holidays, the sad times and, of course, Camilla. They came to rely heavily on fresh and meaty stories about Diana of any kind to boost their circulation figures. It was a time when most members of the public knew more about the princess than they did about their own partners.

The princess was, simply, the most famous person in the world. The only person who didn't seem to think so was Diana herself. In this environment, the scene was well and truly set for all the bizarre and unbelievable events to come...

And we, the paparazzi, were at the cutting edge of the public's insatiable interest in Diana. We were sandwiched between a vulnerable, lonely woman and the power of the world's media.

When Diana went into self-imposed exile in December 1993, we, the authors of this book, appointed ourselves her personal paparazzi. We had many roles to play in our new job – her unofficial PR team, her sounding board and her consultants.

But we were also the flies in Diana's champagne. We were the spies in a Cold War between the future king and the queen-in-waiting. This assignment took us across the globe and into an abyss of surprise and scandal that the royal family, ourselves and the public had never before encountered.

There are two central characters in this book: the Princess of Wales and Diana. They are not the same person. All of the incidents related in this book were witnessed by the authors. For this reason, we have not included testimonies from any second-hand sources, palace insiders or so-called 'close friends'. Nor have any of the incidents been doctored, condensed or elaborated. This is how we witnessed the events following Diana's retirement from public life. It is the plain truth, however harsh that truth sounds.

The job Diana performed for her country was exceptional and unique, and was carried out with genuine warmth and love. However, this is not a book about the Princess of Wales and how she executed her royal duties. It is a book about Diana, the woman we knew.

Prologue

'I never know where a lens is going to be'

HRH The Princess of Wales, *Panorama*, 20 November 1995

On 3 December 1993, Princess Diana retired from public life. In an emotional speech at the London Hilton Hotel, she told a charity audience that she needed time and space in her private life, something that had been lacking in recent years. Diana's decision to retire was prompted by 13 years of unprecedented media attention. No facet of her life had been left uncovered by an insatiable media desperate for every detail of the world's favourite princess.

Diana's new dream was to be able to walk down a public street, unrecognised and unhindered. Just like everybody else. But it was just that – a dream. The world's most photographed and famous woman could not simply wake up one morning and say: 'Hey, I don't want to be famous any more.' Diana naïvely dreamt of the new world she would create for herself. At last, she would enjoy a life like normal people: shopping, eating, drinking, going to dinner parties or on holidays with friends, sharing special moments with her boys. Now, at last, she would have her privacy. She would be free forever from tabloid intrusion into her private life... or so she thought.

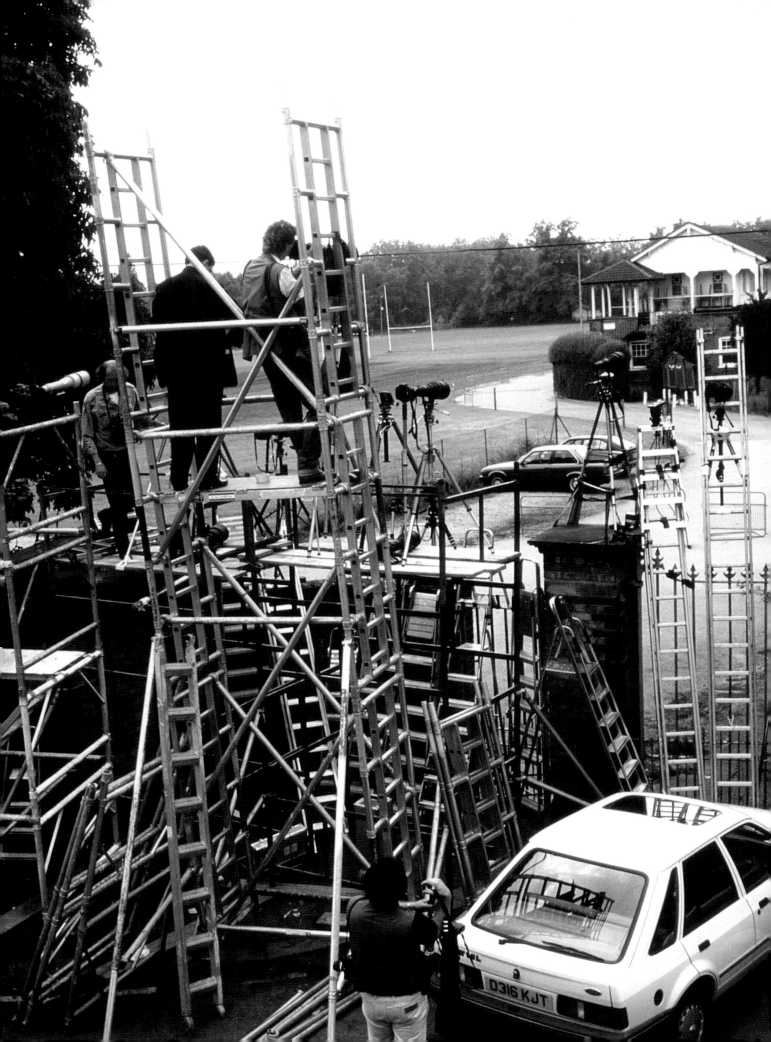

Technical Stuff

This is not a photographic textbook. It is the true story of our experiences with Diana, and we emphasise that the best equipment in the world is worthless if a photographer is not in the right place at the right time. A good photographer with a cheap, plastic auto-focus camera will always snatch better news shots than a poser with £20,000 worth of snazzy gear dangling from his neck.

Listed here is the equipment and settings we would have used in a typical day.

FILM: Fuji colour 800 ASA, at times pushed to the limit.

SHUTTER SPEED AND APERTURE: 250th of a second at whatever aperture the auto lens delivers.

CAMERAS AND LENSES: Canon 35-350mm f3.5-5.6 lens, 80-200mm f2.8 lens, 300mm f2.8 lens, 500mm f4.5 lens, 90 cameras; EOS 1N camera; EOS 1 cameras; Canon power-drives; Quantum Turbo battery; Nikon flashgun B24; Mono-pod.

COMPUTER EQUIPMENT: Apple Macintosh Powerbook 180C; Kodak Film-scanner RFS2035 Plus; Motorola Codex Modem 3265 VFAST.

With the advent of computer technology, the most vital piece of equipment was, and still is, the laptop, which enables a photographer to transmit photos down a telephone line in seconds. As competition is so tough, getting the snaps to the newspapers can mean the difference between a making a sale or not.

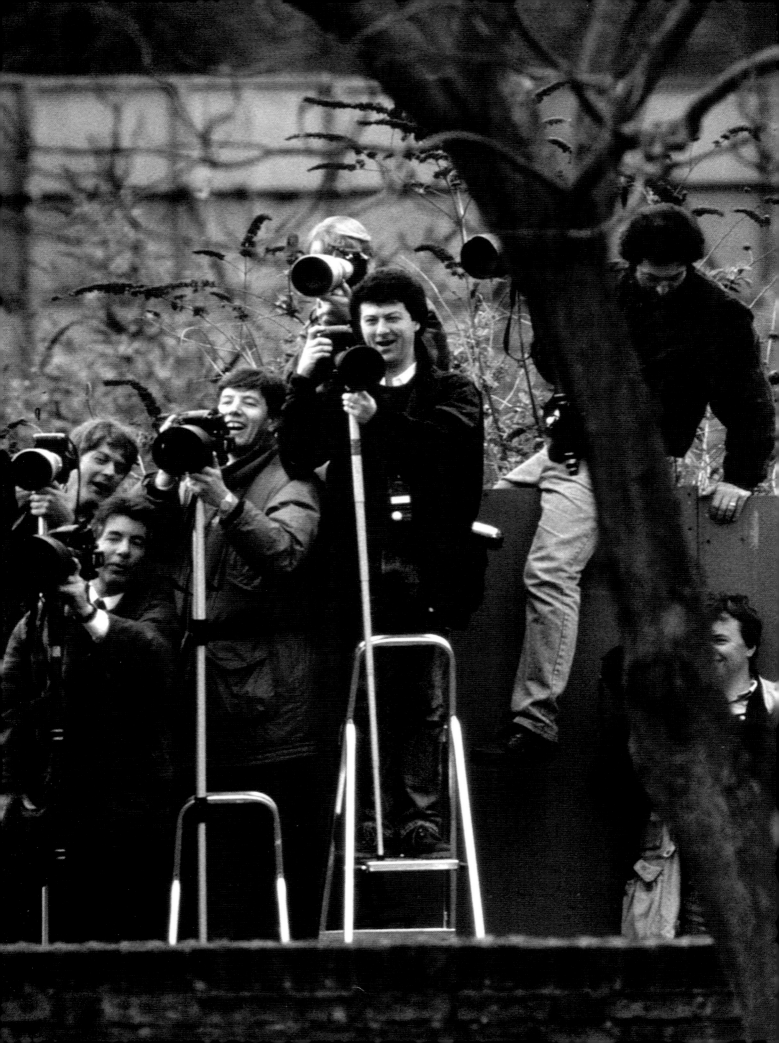

Glossary

AP Associated Press.

Back-up Royal Protection Officers.

Bang, Blitz, Hose, Rip, Smudge, Whack
To compose and take pictures very rapidly.

Di Popular tabloid abbreviation for HRH
The Princess of Wales.

Doorstep Sit, stand or sleep outside someone's
home, place of work, restaurant, shop, etc., in the
hope of taking a photo.

Fleet Street Collection of newspaper
photographers and journalists representing
publications with offices previously based in Fleet
Street, London.

GMTV Good Morning Television.

ITN Independent Television News.

KP Kensington Palace.

LWT London Weekend Television.

Mac'd To delete or add digital information to
photographs using a digital imaging program on an
Apple Macintosh computer.

Paps Paparazzi.

PCC Press Complaints Commission.

Rat-pack Royal reporters, photographers and
television crews representing the national
newspapers, magazines and television networks.

Red-tops British tabloid newspapers.

RPO Royal Protection Officer.

PR Public relations.

Stress sandwich A rushed junk meal usually eaten
on the move.

Trawl A search for known Diana haunts
and locations.

WPC Woman Police Constable.

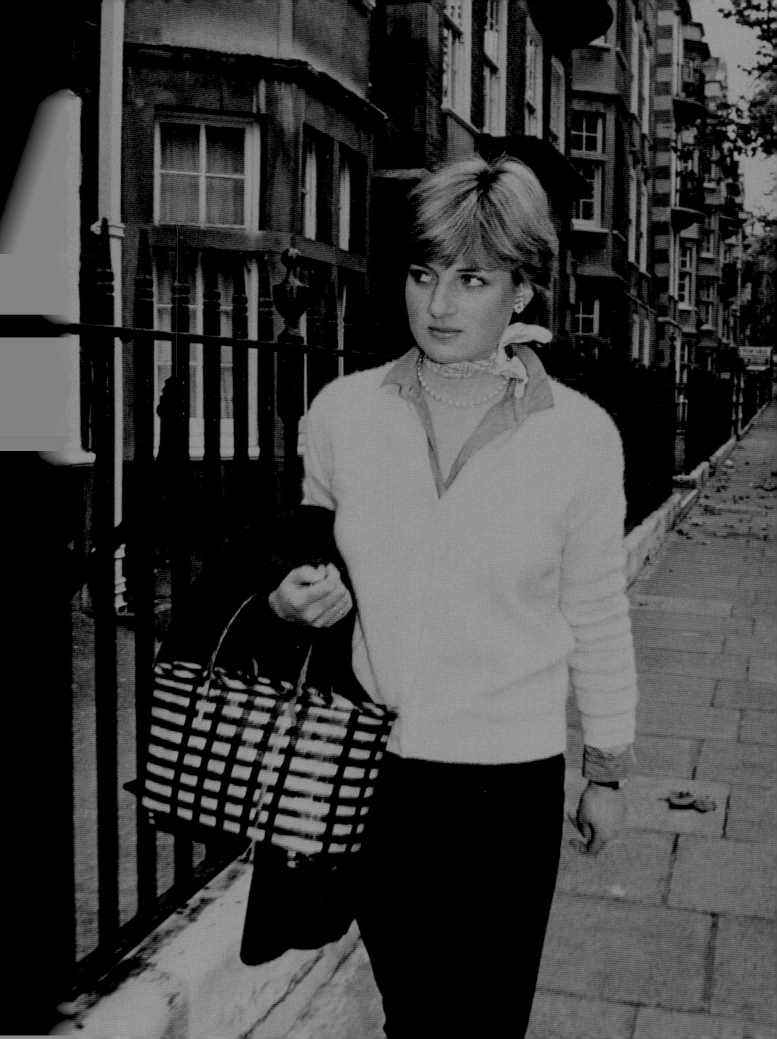

Close Encounters with Diana

Glenn, November 1993

'Why?' Diana said.

I glanced behind me to see who the hell her words were aimed at. There was no one there. Turning back towards Diana, I was surprised to see her striding towards me.

'Why?' she said again.

I realised she was talking to me. The princess stopped about 5m from where I stood. I could see she was upset.

'Why?'

I have to be honest. I was lost for words. So, it appeared, was she.

'Why?' I asked.

'Why?' she repeated once more.

The conversation, such as it was, had dried up before it had begun. She was now standing in front of me, staring. Her huge blue eyes looked into mine, searching for an answer.

'Oh, for God's sake, this is getting ridiculous,' I thought. 'Why what?' I managed to say boldly, just to move the conversation along a bit. It was a genuine question. I honestly did not have a clue what she was talking about.

'Why are you taking my picture?'

Here I was, at 8:00 a.m., a paparazzo photographer, in a busy London shopping street, face-to-face with the world's most famous woman. Diana was dressed in a crazy military showbiz-style jacket, and she was asking me why I wanted to take her photograph.

I had been sitting in my purple Golf GTI at the end of a street near San Lorenzo, once Diana's favourite restaurant. But on this particular morning it was not San Lorenzo I was interested in. For several months there had been strong rumours that Diana was using a clinic for colonic irrigation treatments in Beauchamp Place.

I had seen the clinic door open and watched as Diana stepped out on to the pavement. 'Wow!' I said out loud. She was wearing what can only be described as a Michael Jackson-style vintage army jacket that would not have been out of place on the front of the Beatles' *Sgt. Pepper* album. In addition to this bizarre garment, she wore tight-fitting black trousers that stretched down her endless legs. I knew it was Diana when I saw her hair – as always, she was walking with her head down so that you could not see her face, but the most famous blonde locks in the world gave away her identity.

I grabbed my cameras as I leapt out of the car. Still about 100m away, I dived into a shop doorway for cover. The princess was heading my way and I had a clear view along the pavement. Lifting the camera, I managed to bang a few pictures off. By now, Diana was too close for the 500mm lens I had been using, so I quickly swapped cameras for a shorter lens, hoping to get a clear close-up of her face. This was the moment when she stopped in front of me and asked me, 'Why?'

Our exchange continued. 'Surely you know why. You're a princess!' I told her. The conversation had now become totally ludicrous.

'I just want to be left alone,' she said, Garbo style.

'Brilliant way to be left alone,' I thought, 'walking down the street like an extra from a Wacko-Jacko video.'

'It's just a picture,' I said. 'I don't want to bother you.'

'But you do bother me,' she replied, her voice rising. 'Why don't you just go away?'

Below and overleaf: Alone on the streets of London, Diana finds a new outfit to blend in with the shoppers.

'I wish I could,' I said under my breath.

At that point, she turned as if to go but, on seeing a group of people standing on the pavement opposite who were watching us in amazement, she turned to me and implored: 'Please, just leave me alone.' I had to smile at that comment, which was said entirely for the benefit of the spectators. With that, she stormed off – casting a quick glance over her shoulder to make sure the growing crowd had heard her parting comments. I looked across at the 10 people who had watched our encounter, and they looked back at me with something approaching contempt.

I went back to my car and immediately rang the *Sun* picture desk. Despite the run-in with Diana, I knew the pictures I had were good and extremely sellable.

Ken Lennox, the *Sun*'s new picture editor, seemed remarkably cool when I told him what had just happened. I had half-expected him not to believe that Diana was out walking alone on the street. Instead, after expressing great interest in the pictures, he said: 'So it's true – she's dropped her police protection.' There was a moment's pause before he added: 'It's going to be interesting to see what happens now.'

I don't think I'll ever hear a truer statement!

The paparazzi drums began to beat across town as soon as the *Sun* hit the streets that Thursday. The Princess of Wales, one of the biggest-selling picture subjects in the history of photography, was now walking around London without any police protection. There wouldn't be any more coppers to stand in your way and obscure your lens from now on. From London to Milan, from Madrid to Paris, the paparazzi prepared for action. Lenses were cleaned, flashes recharged and cameras loaded

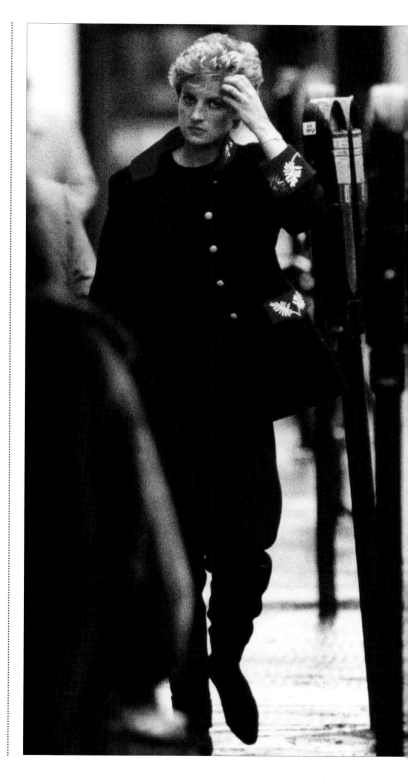

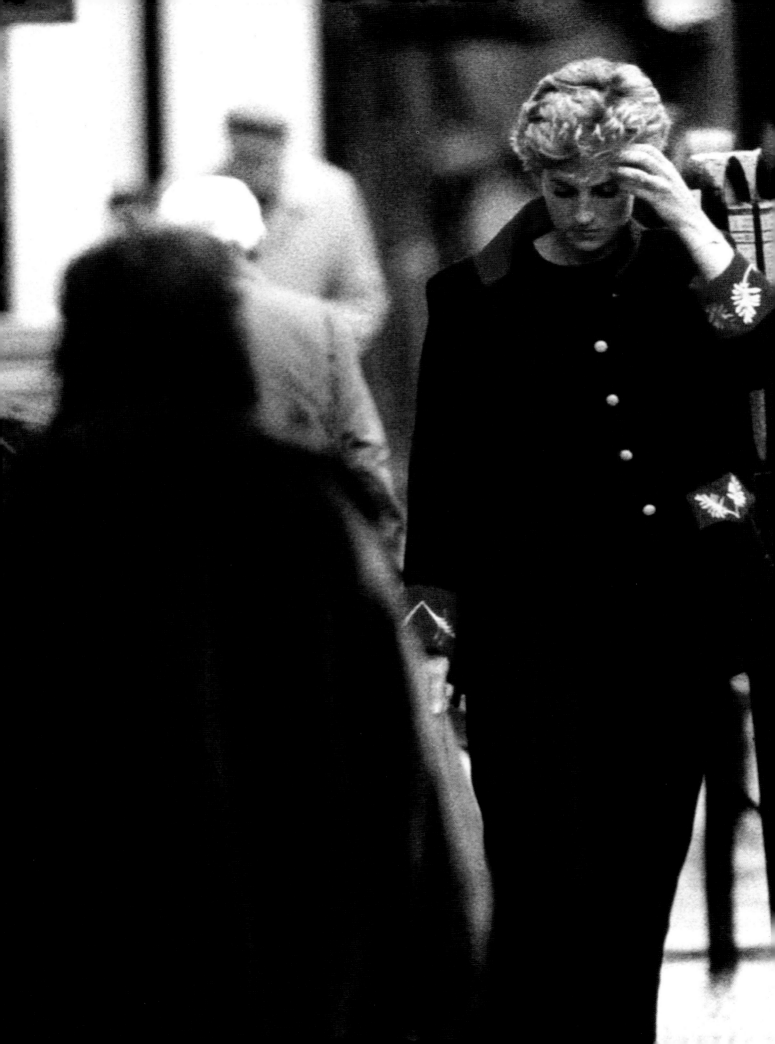

with film. Everyone in the business was suddenly aware of a new smell on the streets of London – the smell of money.

No matter what Diana did, she could never shake off the fact that she was famous. Extremely famous. Any attempt by her to lead a normal life was always bound to be frustrated by the knowledge that everyone was desperate to please her because of who she was. If Diana popped into a coffee shop, she knew she would be given the best table, and that the service would be considerably quicker than most patrons enjoyed. She would invariably find the assistants falling over themselves to serve her – and then tell the press afterwards exactly how long it took her to drink her coffee and in how many sips. Because of this, Diana walked around London in a kind of dream world, her famous Shy Di glance used as a means to both hide her face and to slyly check that no one was staring at her or taking her photo.

And yet, for all her complaints about wanting to be left alone, Diana went out of her way to be the centre of attention. She was either very naïve or she was just kidding herself.

I came to my own conclusion that morning in Beauchamp Place.

About a week after the Beauchamp Place incident, I was back in the land of the mega-rich shoppers. Driving up Sloane Street, I had a stroke of luck. On the opposite side of the road was Diana, at the wheel of a green Ford Escort, heading in the other direction. Once again, she was alone. It was about noon on a Saturday and the lunchtime traffic was solid. I saw Diana turn left off Sloane Street and

into Pont Street, but I couldn't follow. My car was blocked in between two buses and I was trapped. No sooner had I found Diana than I'd lost her again! In a mad panic, I checked my watch and began to think what she could be doing at that time of day. It was too early for her to be meeting friends for lunch and it was way past her favourite time to go to the gym. Shopping was the best bet, I decided. When, in a foul mood, I finally managed to turn off Sloane Street, I could see that the road ahead of me was clear. There was no princess in sight.

Diana loved to shop. Armed with her gold American Express card, it is something she did more frequently and more extensively than most women. But where could she be shopping now, I thought. Mayfair was her usual territory, but she had gone in the wrong direction. The Kings Road in Fulham seemed a possibility, but it would be absolutely packed on a Saturday afternoon. I decided to try the obvious first and headed for Harrods. There was no sign of Diana's car outside. I cruised the store's exterior before checking the side roads, but could see nothing. Heading back to Sloane Street, I decided to check out the Kings Road after all. It was a long shot, but it seemed the only possibility.

The traffic was particularly thick that day and everyone on the roads was getting irate, especially me. I was not happy at losing Diana and was preoccupied with trying to find her again. It didn't help that other drivers were attempting to pull out of side roads in front of me, getting in my way and slowing me down. I stopped to allow a taxi out of one road and, as I drove forwards after it, a Ferrari which had been behind the cab suddenly accelerated out on to the street. I slammed on the

brakes and just managed to avoid crashing into the Ferrari. It had been all his fault but, with the incredible arrogance that seems to come so naturally to Ferrari drivers, the car's owner began to hurl abuse at me.

'Oh, sod off,' I said, and we began to trade obscenities. After a full and frank exchange of views, and satisfied that I'd had the last word, I made to drove off. And then I saw it. As if by magic, the car behind the Ferrari was a green Ford Escort – with the blonde princess at the wheel! She was even laughing to herself over the altercation

I'd been having with the Ferrari driver. Gathering my wits, I waved her out in front of me, taking care to duck my head below my dashboard so that she would not recognise me.

I was right about the shopping. She finally parked in Lowndes Square and I watched as she skipped across the road into Harvey Nichols, the shopping Mecca for all Sloane Rangers. I pulled up outside a nearby hotel, took out a newspaper and began to eat my lunch. It was going to be a long wait.

For some reason we 'paps', the paparazzi, had an unwritten rule when pursuing someone. It was that

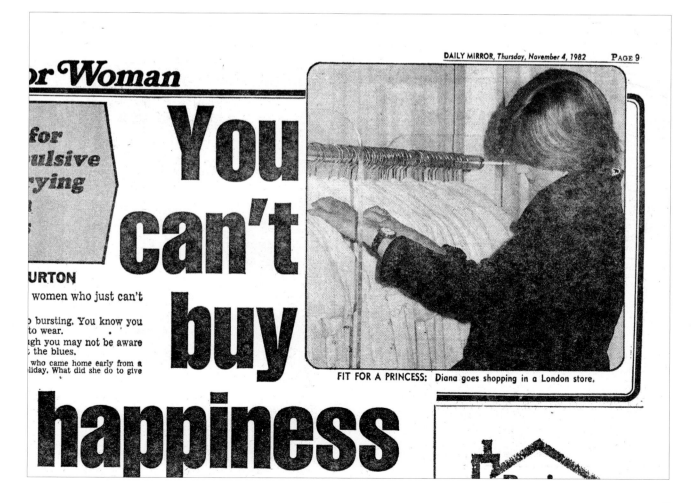

DAILY MIRROR, Thursday, November 4, 1982 PAGE 9

or Woman

for ulsive rying

URTON

women who just can't

bursting. You know you to wear.

igh you may not be aware the blues.

who came home early from a liday. What did she do to give

You can't buy happiness

FIT FOR A PRINCESS: Diana goes shopping in a London store.

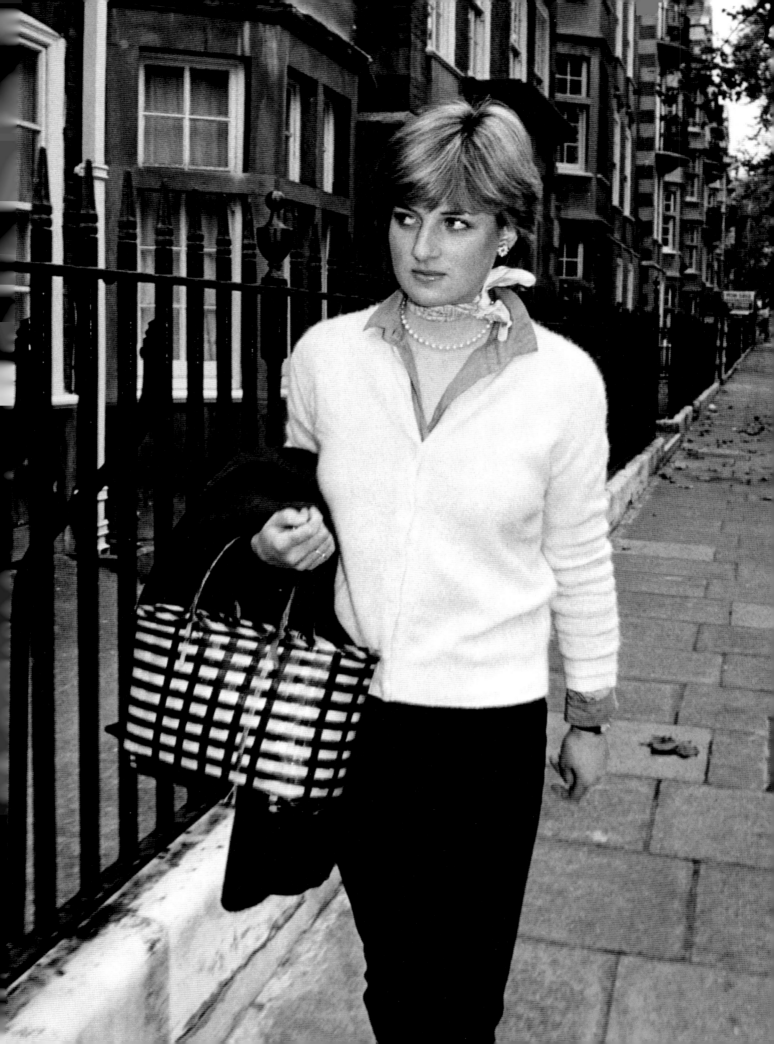

Left: Strikingly beautiful. Lady Diana
Spencer emerges from her
Brompton Road flat as rumours
increased about her 'romantic
linking' with Prince Charles.

we would never follow our subject into shops or
restaurants to get a picture. They were fair game on
a public street, but shops and restaurants were off
limits. It was a lesson I had learned the hard way
back in 1980 when I was a young photographer
pursuing a new lady in the life of Prince Charles –
one Lady Diana Spencer. I was 18 years old at the
time, spotty with greasy hair down to my shoulders
and on one of my first assignments for a
photographic agency. I had just been promoted
from the position of darkroom manager and I had
been given the task of doorstepping an unknown
beauty who was said to be romantically linked to
the future king.

Lady Diana Spencer, as she was then known,
came out of her flat in Brompton Road and took a
taxi to Harrods. As she left her front door for the
waiting cab, I naïvely took my camera away from
my eye and politely asked her to stop and pose for
a photo. She responded to this with the now
famous 'Shy Di' look and a very polite and very
posh 'No, not today, thank you.' The Shy Di look
would soon become her trademark. Her eyes
would be hidden under a very thick, low fringe and
the flat of her face would be parallel to the ground.
The public found this look endearing, but us paps
found it BLOODY annoying!

In the split second that she gave her answer,
lifting her head slightly, a *News of the World*
snapper had stolen in and grabbed a half-
reasonable photo. 'Christ!' I thought. 'If he's got a
photo, I'll have to get one too.' I couldn't tell my
boss: 'Yeah, I saw her but I didn't take a picture. Oh,
by the way, the *News of the World* guy did get a half-
decent one though.' He would have hit the roof. My
job that day was to get a photo at all costs. What

was the point of me being there otherwise? This
was stress as I'd never experienced it before. My
target was disappearing from view up the
Brompton Road in a taxi. I didn't have a car, so I
ran up the road after the taxi, cameras falling from
my shoulders and kit spilling everywhere. As the
taxi sailed out of sight, I realised that I had failed
miserably on my first assignment.

But I didn't give up. I continued my pursuit on
foot as fast as I could, heading towards
Knightsbridge. When I got there, I was amazed to see
Diana disappearing through a revolving door into
Harrods. I caught up with her and, barely able to
breathe, asked her again for a picture. Seeing my
obvious distress, maybe she took pity on me. She said
yes, adding: 'But don't use any of those flashy things.'

The News of the World photographer, who I later
learned was Chris Ball, had followed the taxi on his
motorbike. He'd been shadowing Diana all day and
must have had hundreds of images of her by now.
He came swaggering along the pavement, a sly grin
peeping through his large furry beard, and followed
Diana and I into the store. I explained to him the
deal I had just struck with Diana as we followed her
up to the womenswear department. My heart sank
when we got there. It was one of the darkest areas
of the shop. There was no way I could have taken a
decent image there without my flash.

'Can we go to a room where I can at least see
where you are?' I asked cheekily.

'No! Take it quick! This is all you'll get!' she
replied as she buried her face in a rail of clothes.

The shaggy-bearded Chris, an old Fleet Street
hand, had a lot more experience than me. He
adjusted his camera for indoor use and began
banging away, taking his pictures – without a flash.

Here I was, with my subject right in front of me, and I had no idea how to take a photo without a flash. My camera had been set up for me before I'd left the office by my boss, top veteran war photographer Terry Fincher. It was still in flash mode and I didn't know how to change the settings. My day was getting worse and worse by the minute. I tried again to persuade Diana to move to another room. Each time I asked, her head bowed even lower, the Shy Di look in full swing.

I realised that I only had a few seconds left. 'Sod it!' I thought. Bang went my camera and pop went the flash. As a blinding light lit up the shop floor, everyone there turned to look at me in shock. Diana, Chris and I all immediately scarpered in different directions. It's forbidden to take photographs in Harrods without written permission and the security men appeared within moments. There was no way that I was going to hand over my film without a fight, so I headed for the fire escape and smashed through the doors. As I burst out on to the stairwell I almost fell into Diana, who was standing there trying to compose herself. Her face was like thunder.

'I said no flashy thingys!' she exclaimed. She flicked her head backwards and I got my first really clear view of her face that day. 'Now why couldn't you have done that earlier?' I thought to myself. I was tempted to reel off a couple of shots right there and then but, considering the situation, I decided it might have been a bit rude. Instead, I apologised and tried to explain that I didn't know how to take a picture without using a flash. Unsurprisingly, she wasn't interested and we both made our way down the fire escape stairs in silence… that is, until I blurted out in typical teenage boy fashion:

'So, are you going out with Prince Charles then?'

After a pause, Diana replied smugly: 'I'm not telling you. You'll have to find out for yourself.'

I'd been trying to lighten the mood but I'd only made things worse. When we got to the bottom of the stairs I put my foot in it again by asking her again to pose for a photo. What was I thinking?

'What's your name?' she asked bluntly.

'Glenn,' I answered.

She pointed her finger at my nose, her face just inches from mine. I could clearly smell her perfume. 'Well, Glenn,' she said, 'I've got my eye on you.'

I suppose it's ironic really: from that day on it was I who had my eye on her.

About a week after this first experience with Diana, I shared a taxi with Terry to Diana's flat. When we got there, Terry, a huge grin on his face, wished me better luck this time as he handed me my camera. He was on his way to his Fleet Street press club for a long liquid lunch with his newspaper chums. These were legendary events, where the old lags would swap funny stories, none more so than those told by Terry. Many a time after one of these lunches, Terry would drift off into a merry sleep on the train home, miss his stop at Guildford and wake up when the train came to a stop at Portsmouth Harbour, 60km away.

With Terry gone, I was left to get the goods. It was Friday night and many of the locals were beginning to head out of town for the weekend. The communal door to Diana's block of flats opened and a suitcase appeared in the opening, closely followed by another. 'Hello, how are you?' Diana said brightly as she emerged from the doorway. She seemed to be in a great mood but I could only tell this from her tone of voice. As ever, her face was pointed firmly to the ground.

Below: 'Slow it down on the cobblestones, I've just had my breakfast!' Lady Diana Spencer gets a job at a kindergarten in Pimlico, London.

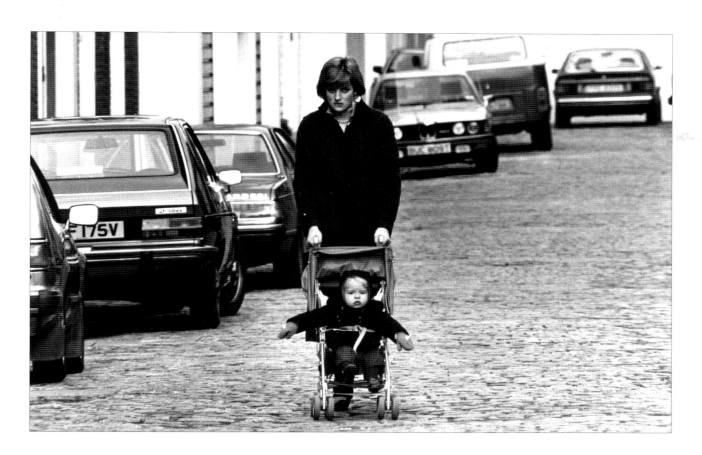

'Hello, Di, sorry about what happened the other day,' I answered, crawling shamelessly. 'Are you off anywhere?' I stupidly asked.

Diana took hold of the enormous, heavy suitcases and began to half-drag, half-carry them along the pavement. She was struggling hard and had to keep stopping for a rest every few metres. She wasn't making her task – or mine – any easier by keeping her head down. I was never going to get a picture of her at this rate. 'Hey, stop, let me take those,' I offered. I can be quite a gentleman at times, despite my profession and scruffy appearance. 'I'll carry them for you if you pose for a picture,' I added. (OK, I can be a gentleman – but only up to a point.)

Diana tried to soldier on, but eventually gave up. 'All right. My car is round the corner. Thank you,' she said.

'No, thank you,' I thought. Brilliant! I was going to get my own exclusive posed photo of Prince Charles's new girlfriend.

I handed Diana my camera to carry, as it would otherwise have slipped off my shoulder. She took it with apprehension and put it over her arm. What a great photo that would have made – Diana walking along behind me, armed with a camera and looking like a paparazzo. I think she was glad to take charge of my camera, as it stopped me trying to stick it in her face for a few minutes while I grappled with her cases.

Right: Princess Diana in Knightsbridge, pondering what to buy her Prince Charming for Christmas in 1984.

We reached her tiny blue Ford Fiesta and she opened up the rear hatch. The huge cases would barely go in the car as I struggled to lift them. It was back-breaking work. '1,2,3... heave!' I yelled, as I shoved the suitcase into the car – and fell into the rear footwell after it. Diana gave me a beaming smile. 'Thank you, you're my knight in shining armour,' she said.

'Can I have a picture now?' I asked, like a good doggy waiting for his biscuit.

'No, not today, thank you,' she replied quietly as she climbed into the driver's seat and started the engine.

'But what about our deal?' I pleaded.

As the car began to move away I felt for my camera, looking to snatch a photo anyway. But where was my camera? I looked at the crafty grin on Diana's face and saw that it was on the passenger's seat beside her in the car. She pulled out into traffic and I called out after her: 'Stop! Stop! My camera. You've still got my camera.' Shy Di had become Sly Di.

I did get my camera back from her a week later, but it was obviously too late. I found out that she'd headed off that day to stay with Prince Charles at Sandringham, no doubt to do some 'romantic linking'.

When I told my boss what had happened the next day in the office he saw the funny side, sharing with the rest of us one of his huge, infectious belly laughs.

※

What those early days had taught me was that it was not worth ever asking for a photo and that nothing was to be gained by following your subject into a shop. From then on, my policy was to just take what I could, when I could and to keep a low profile – even if it didn't seem very polite to the person I was after.

Sitting outside Harvey Nichols in the comfort of my car and eating sandwiches, while Diana shopped inside, was a lot less stressful than following her inside to ask for a photo – or going in and taking one anyway and having to deal with the consequences. From where I sat, I could clearly see the shop's entrance and Diana's parked car. Even so, after an hour's wait I began to get a bit edgy. Both my cameras were primed and ready, but still she had not shown. I was beginning to think that maybe she had slipped out the back entrance and had gone off shopping somewhere else.

Looking for Diana was never easy. London is a big city and there are so many places she could have gone that, no matter how experienced you were, it was almost impossible to anticipate her next move. Indeed, when she finally did show, nothing in the world could have prepared me for what happened next.

BANG! BANG! The sudden noise made me jump out of my seat. I whirled round and came face-to-face with Diana staring through my car window. I had just stuffed a large portion of a stress sandwich into my mouth and was chewing rapidly to get rid of it. I wound down the window, still munching, swallowing hard. 'Why don't you leave me alone?' she hissed.

'Oh shit,' I thought, 'here we go again.'

'You're famous!' I tried to explain, my mouth still full of cheese sandwich. 'You can't expect to walk around the West End and be ignored by everybody. People are still going to recognise you.'

Diana was having none of it. 'What do you want me to do?' she demanded. 'Stay cooped up at

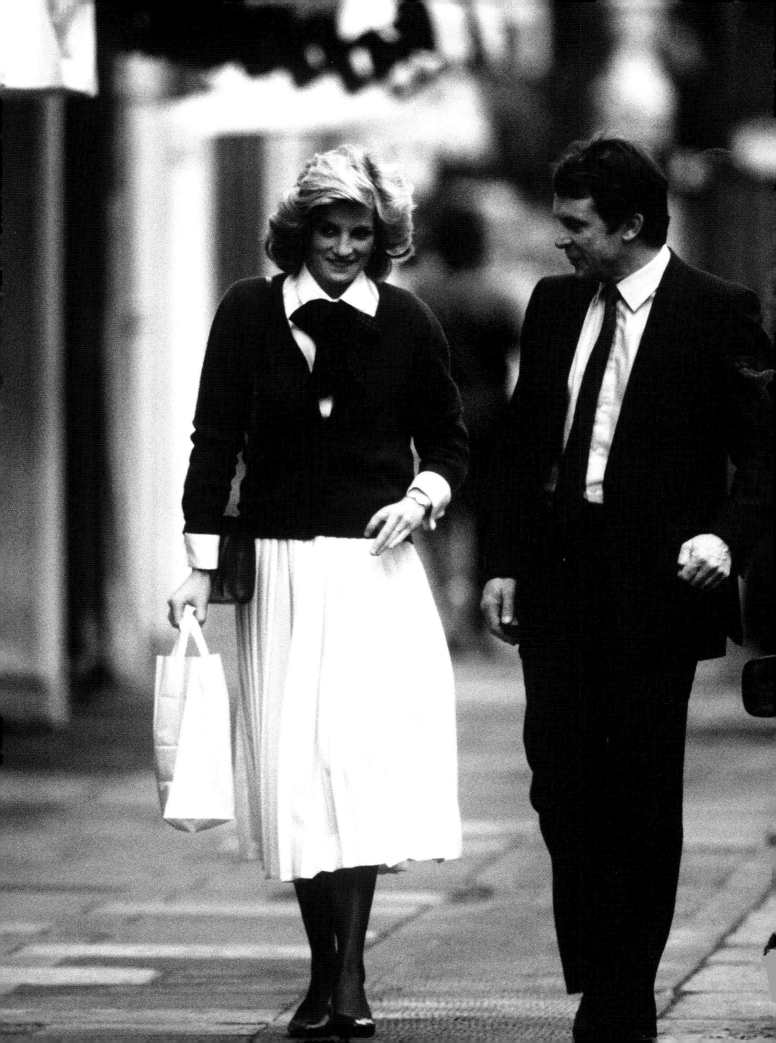

Below: 'You're famous!' I tried to explain, my mouth still full of cheese sandwich. Diana has a lunch date at Harvey Nichols in London in November 1993.

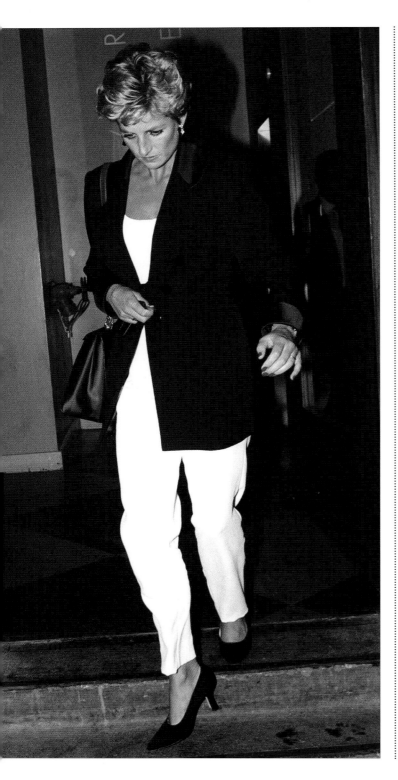

Kensington Palace for the rest of my life? I won't do that.'

I opened the car door and gestured with my hand for her to step back to let me out. Diana just stood there silently. When she did this, it made things uncomfortable and was a very effective weapon that she had in her arsenal. She looked at me, looked at the cameras on the car passenger seat, then looked back at me. I didn't know what to do. Her silence made me feel guilty and I was grateful when she finally spoke.

'I loathe those things,' she said at last, nodding towards the cameras. 'I really loathe them.'

I followed her gaze towards the cameras, but I was even more embarrassed at the sight of a half-eaten pizza still in its box, which lay alongside empty Coke cans and the remains of a week's worth of stress-sandwich wrappers. This disgraceful mess was the result of my previous week spent doorstepping. A paparazzo's car is his home, and I had not been doing the housework.

'You didn't seem to mind them before,' I replied, remembering my time as an official accredited photographer on the Charles and Di road show when they had toured the world extensively. 'You looked as if you were enjoying yourself in front of the cameras,' I continued. In those days, she'd clearly loved having the gaze of the world upon her, and she had proved herself an expert at exploiting the cameras and cameramen to her best advantage.

'That was my job,' she said sternly, taking a quick glance around to make sure that no one had overheard. Stunned, I thought of all the small children, hospital patients and homeless people who had gone out of their way to make her feel welcome when she had visited them on their

special day. It seemed harsh to dismiss all this effort on their behalf as her 'job'.

She stared at me, her head bowed low, and whispered: 'You would never understand.' With that, she stormed off, leaving me thinking how right she was – I would never understand.

I'd had two encounters with Diana in just over week, but talking to fellow photographers I found I had not been the only recipient of Diana's increasingly bizarre street behaviour. Many of them had similar tales to tell of how Diana had launched a tirade of abuse at them in front of stunned members of the public. One Spanish photographer working in London even had Diana try to pull his cameras from his neck during a particularly strained encounter outside the Ritz Hotel. Her erratic behaviour had begun to concern the London paparazzi. Why did she hate us all of sudden? we asked ourselves.

Sometimes, one of these encounters involved Diana sprinting towards a photographer, forcing him to leap out of her way. At other times, she would run at full pelt away from snappers, creating a mad charge as they desperately tried to catch up with her. Worst of all, though, was when Diana would just stand stock-still in front of you, head down, giving you the silent treatment. Invariably, these types of encounters happened after she had visited one of her many therapists.

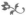

The foretaste of all this had come a few months before, when the first-ever 'crazed Diana' encounter took place in London's Leicester Square. Hordes of tourists, shop-keepers, taxi drivers and two photographers saw a new side to the princess

that day, a side that had never been witnessed before, except perhaps by Prince Charles.

Diana had left Kensington Palace with William and Harry. Both boys were on school holiday and Diana had arranged a special treat for them. I was out that day looking for Robert De Niro with my fellow snapper Keith Butler. We were sitting outside a restaurant in Knightsbridge when I received a call from an informant telling me that Di was just leaving Kensington Palace in a blue Ford Scorpio. I turned to Keith and told him: 'They're out. Let's go!' The hunt was on!

As we sped up Montpelier Street towards Kensington Keith screamed. 'Shit!' he yelled, hot tea pouring over the rim of his plastic cup. 'There they are!'

He was right – we had chanced upon Diana and her police escort almost immediately. They raced in front of my car towards the West End, forcing me to U-turn in front of a black cab. I looked in the rear-view mirror to see the cab driver gesturing wildly out of his window. 'Ha! A taste of his own medicine,' I said to Keith.

Eventually, we managed to get in front of Diana and her escort car without making it obvious who we were and what we were up to. I guessed that they were heading for the video arcade at the Trocadero in Leicester Square, which had recently opened, so I sped on, hoping that we could get inside the complex before Diana and her boys arrived. When we screeched to a halt outside the building, I parked on a double yellow line and Keith and I burst out of the car, our cameras smashing together and we hurtled into the arcade, trampling young children underfoot. Once we were inside we took up our position and waited.

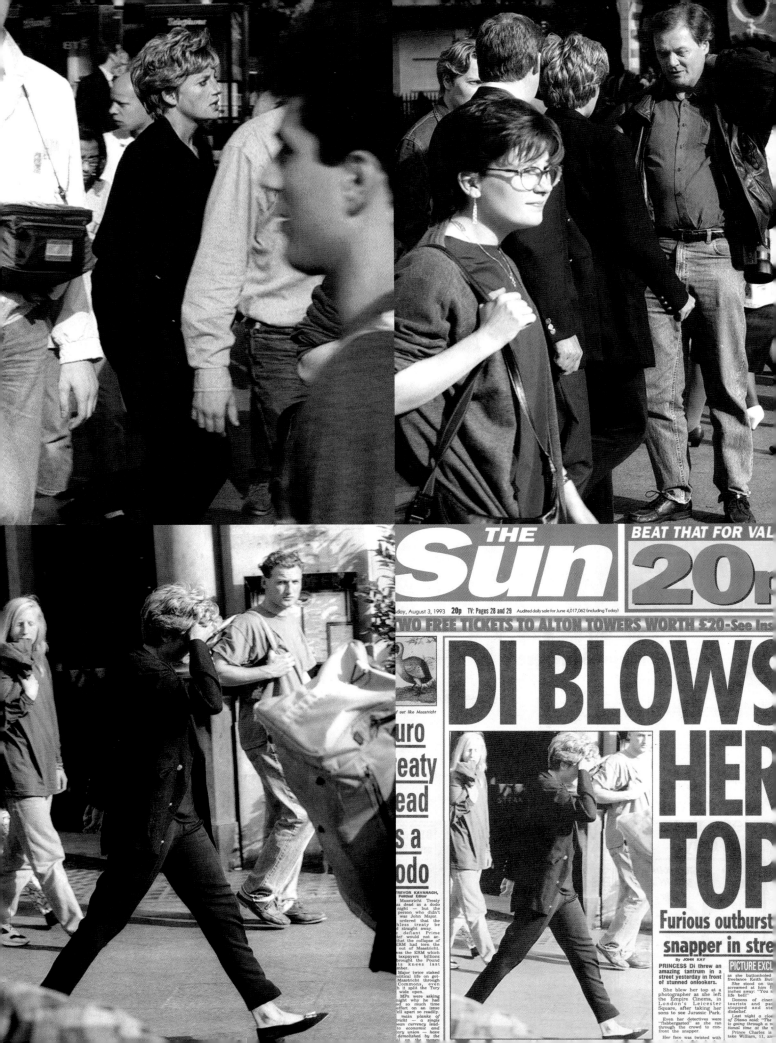

THE **Sun** BEAT THAT FOR VAL

20p

...day, August 3, 1993 20p TV: Pages 28 and 29 Audited daily sale for June 4,017,062 (including Today)

...WO FREE TICKETS TO ALTON TOWERS WORTH £20-See Ins...

DI BLOWS HER TOP

Furious outburst

snapper in stre...

BY JOHN KAY

PRINCESS DI threw an amazing tantrum in a street yesterday in front of stunned onlookers.

She blew her top at a photographer as she left the Empire Cinema, in London's Leicester Square, after taking her sons to see Jurassic Park.

Even her detectives were "flabbergasted" as she ran through the crowd to confront the snapper.

Her face was twisted with

as she buttonholed freelance Keith Bu...

She stood on tip screamed at him th inches away: "You life hell!"

Dozens of cine tourists and pas stopped and sta disbelief.

Last night a clo of Diana said: "Th is going through a tional time at the Prince Charles an take William, 11, an

PICTURE EXCL

TREVOR KAVANAGH, Political Editor

... Maastricht Treaty ... dead as a dodo ... night — but the ...person who didn't ... was John Major. ... ordered that the ...less treaty be ...straight away.

...e defiant Prime ...er would not ac-...that the collapse of ...RM had torn the ...out of Maastricht.

...as the ERM which ...rought the Pound ...s knees last ...mber.

...Major twice staked ...olitical life on get-...Maastricht through ...Commons, even ...h it split the Tory ...wide open.

...MPs were asking ...ght why he had ...d so much time ...ffort on an issue ...ell apart so readily.

...main planks of ...richt — a single ...an currency lead-...to economic and ...ary union — have ...demolished by the ...on the mone...

...uro ...eaty ...ead ...s a ...odo

And waited. After 15 minutes we realised that they weren't coming. They'd gone somewhere else.

After bursting back out of the Trocadero, we jumped back into the car and began to cruise the West End, desperately looking for any sign of them. And 30 seconds later we struck lucky. 'Stop the car!' yelled Keith again. 'There's the back-up!' He was right. We spotted them parked up a side street off Leicester Square, enjoying a quiet smoke as they waited for their charges.

Keith and I dumped the car and went on foot. There were four major cinemas in Leicester Square, so we assumed Diana must have taken the kids to see a movie. Unfortunately for us, the schools were all on holiday, so all the cinemas were showing blockbuster family films. As we stood in the middle of the square, wondering where to start, my eye was drawn to the Odeon, where *Jurassic Park* was showing. This was *the* film of the year and I felt it was a dead cert that Diana would have taken Wills and Harry to see it. Leaving my cameras with Keith, I strolled as nonchalantly as possible into the foyer. Nothing I saw suggested a royal presence, but you never know.

Looking about me, I noticed a plaque commemorating the cinema's opening by Prince Charles 10 years earlier. A ticket collector was standing by a barrier just in front of me and I saw my chance. He was about my age and seemed the approachable type. I wandered over to him and pointed towards the plaque. 'So, this cinema was opened by the Prince of Wales,' I said in my best 'that's really interesting' voice.

'Yes,' he replied, with a smile.

'Does he ever come here?' I asked.

'Only for premières,' he replied. 'Official jobs, like.'

'What about Princess Diana?'

He glanced over his shoulder before looking back at me. 'Well, I shouldn't really say…' he said quietly, pleased at last to be able to tell someone his bit of gossip.

'Oh, please do,' I thought.

'…but she's inside with William and Harry at the moment.'

Bingo! I couldn't get back to Keith quickly enough. 'It's a go,' I said, as I took my cameras from him. 'They'll be coming out of the Odeon in about an hour.' After that, all we could do was watch and wait, taking care to avoid the attentions of the royal protection officers who would come out of the cinema before Diana to make sure that the coast was clear.

We first realised that the film had finished when people began pouring into the square. In fact, all the films seemed to have finished at the same time as suddenly the place was packed. The crowds grew so large that we could no longer see the cinema entrance, so Keith and I left our hidey-hole by the railings and joined the throng. I spotted Diana's detective talking into his radio by the cinema doorway and there, just behind him, was Diana, dressed in figure-hugging black trousers and matching jacket, walking out with Harry and William. I was about 30m away, a safe distance I thought, and I immediately began snapping.

Because of the crowds, I couldn't actually see what I was taking pictures of. I was just snapping blindly, hoping to get something useful. Suddenly, a flash of black shot across my eyeline. It was Diana – a Diana I had never seen before. Her face was red and twisted with anger. She was racing towards us through the crowds, her eyes were fixed on Keith and me. She let out a scream like a wild animal.

Below: 'Wow, Mum! You're better than the movie.' The cartoon by Griffin that appeared in the *Mirror.*

Hundreds of pigeons took to the sky in fear and shocked tourists were stopped in their tracks. William and Harry rushed up behind their mother to see what was going on. No monster's roar they'd just heard in the film could have scared them as much as the one that came from Diana.

'YOU MAKE MY LIFE HELL,' she screamed. 'YOU MAKE MY LIFE HELL.' She reached Keith first, the veins on her neck protruding and her face contorted with anger. Keith is not a small guy, but this didn't seem to faze Diana. She was right up in his face, shouting at him. Her fists were tightly squeezed and I thought for a second that she was going to punch him. Shocked and shaken, Keith was speechless. He laid his cameras down on the ground and tried to speak. 'But...' was all he could manage.

In the meantime, Diana had regained her composure. She even seemed a bit shocked and embarrassed at her explosion and, realising the commotion she had caused, turned away. She covered her face with her hands as she strode towards the car, brushing beads of sweat from her

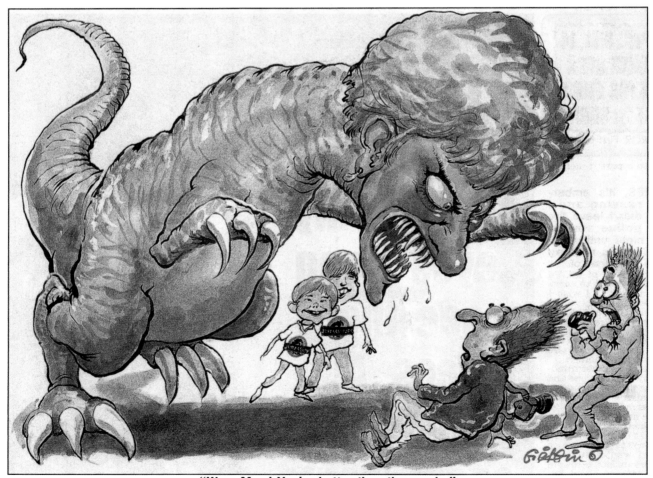

"Wow, Mum! You're better than the movie."

Below: Tom Johnston's view of the Leicester Square incident in the *Sun*.

brow, with William and Harry following on behind. They all got into the car, which sped off with Diana still holding her head in her hands.

Was it a cry for help? The pressures of her marriage separation were certainly beginning to show and she seemed to be venting them on Keith. The 'enemies' at the palace, as Diana called them, must have been turning the screws even tighter that week. Who knew what had happened in Kensington Palace that afternoon to wind her up so tightly? Or was it really the case that we *did* make her life hell?

The *Sun* newspaper ran the story on its front page under the headline 'DIANA BLOWS HER TOP!' Her message had been delivered: she wanted to be left alone.

I later found Keith sitting on a bench in the middle of the square and looking shell-shocked. He was shaking, which was ironic because his nickname was 'Shakey'. It was a moniker we had given to him a few years before, on a mission to Scotland. As it happened, Diana had been involved in that one, too.

"...AND HOW WAS DIANA WHEN YOU PHOTOGRAPHED HER THE OTHER DAY?"

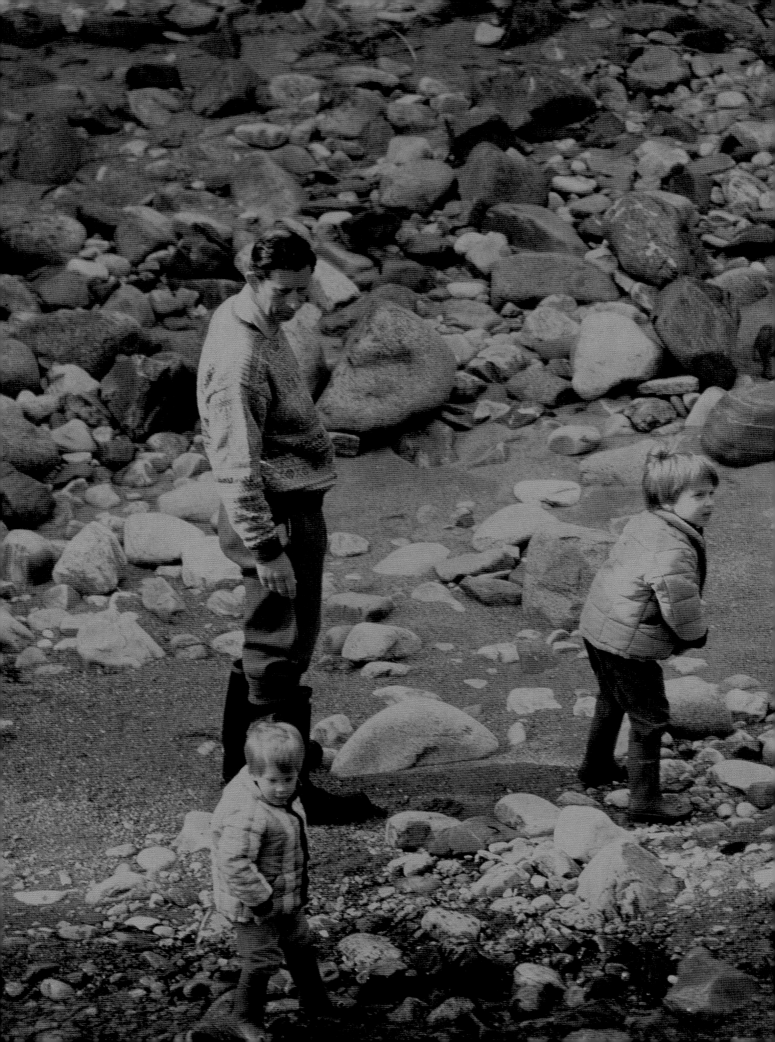

Scotch Missed

Right: It was a tranquil scene worthy of a Scottish postcard. Prince Charles with his dog, Harvey, as he reads *Victims of Yalta* on the bank of the River Dee in Scotland.

Glenn, August 1983

The 40-minute dash, as it was known, became the 30-minute dash when Keith Butler arrived in Scotland.

The hazardous car journey through the hills from Balmoral Castle to Aberdeen Airport was a route well used by the royal paparazzi. It was a windy, small road with many hump-back bridges and treacherous corners. It was even more treacherous when you were in a car with Butler driving. He would usually have just one hand on the wheel, the other one usually occupied in holding yet another of the cigarettes that he habitually chain-smoked. If Keith's driving didn't kill you, his cigarette smoke would have a damn good try.

Keith fancied himself as the best driver of all the paparazzi. He would show off with handbrake turns and all manner of stunts, and boasted about a course of advanced driving lessons that he'd completed – although we never found out if he'd passed or not.

In the days before computer technology, photographic film had to be physically taken to a newspaper office and then processed in the darkroom. For us paps, up at Balmoral Castle for the royal family's summer holidays, the 'office' meant a Fleet Street bureau hundreds of kilometres south. Packets with rolls of films were despatched any way we could get them on a flight. The favoured method was to befriend a passenger who was taking the flight back to London and ask them to take the packet with them, and then arrange for a courier to meet them at the other end. There was also BA cargo, but that was expensive and was always seen as a last resort.

Paparazzi at Balmoral mainly work in pairs: one to do the driving and the other to spot and take the pictures. The day would be spent trawling the 3km stretch of the River Dee, which runs past the castle, the spotter craning his neck out of the car, on the lookout for anything that wasn't a pine tree. A flash of sunlight reflecting off the roof of a Range Rover or the quick flick of a fishing rod seen through the trees was a sure sign that the royals were about.

On this particular day, Keith was relieving the boredom by showing me his handbrake-turn skills. We were cruising along a straight stretch of road running parallel to the river. It had been drizzling all day and the roads were in perfect skidding condition, with a fresh layer of pine sap covering the tarmac and sealed nicely with a topping of newly fallen acid rain that had drifted over from Eastern Europe. Keith was in fine form after some preliminary practice runs and we agreed that the conditions were ripe for an attempt on the world spinning record.

'Anyone coming?' Keith enquired as he prepared his run.

'No. All clear!' I answered.

Keith worked the car up to 100km/h and then gave a quick turn on the wheel. Up went the handbrake with an almighty yank, almost coming off in Keith's hand. But he had forgotten to dispose of his cigarette before he began his run. When he pulled on the handbrake, he had also dislodged the fag, which spun up into the air and landed in his lap. Without thinking, Keith took his hands off the steering wheel to flick the fag off his groin. In fits of laughter, I leant over and grabbed the wheel while Keith scrambled around, trying to dislodge the burning cigarette from his smouldering

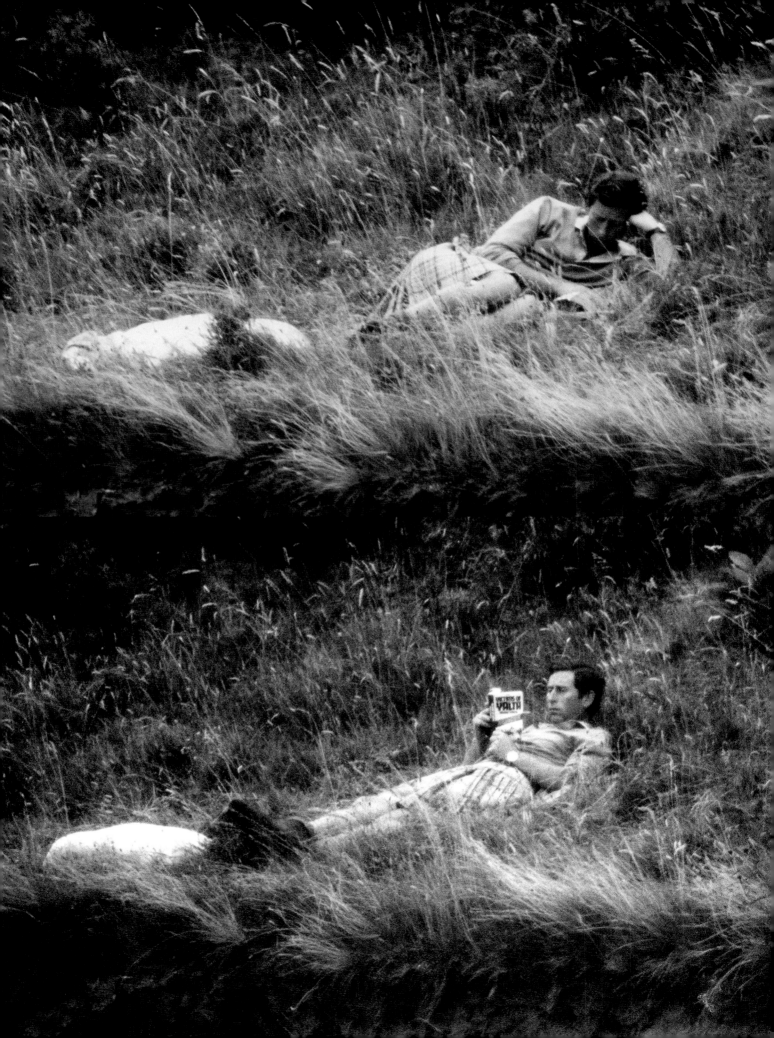

Below: Jon Hoffmann, now a priest (*left*), and Keith Butler (*right*) on the lookout for any royal activity on the River Dee at Balmoral in Scotland.

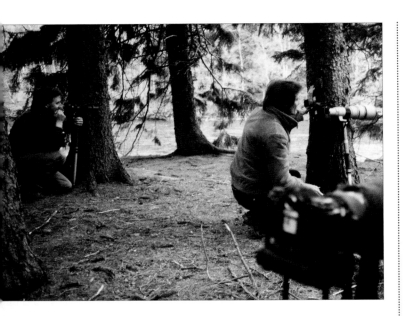

trousers. Seconds later, we had come to a halt after skidding into a ditch.

'Did you see that one?' Keith shouted at the top of his voice. 'Whoa! Whoa!'

He picked up his twisted fag from the floor by my feet, threw it in the air and caught it in his teeth. He had a smug and very satisfied grin on his face as he took in a deep drag. 'Sensational,' I said with some sarcasm. But we did agree that the world record had indeed been broken this time with Keith's double 360-degree spin. We felt that his record would be safe for some time yet.

As we were firmly jammed in the ditch there was nothing to do but wait for help to come along. So I decided to relieve myself in the pine forest. As I made my way down to the river, I heard a voice and then heard a branch crack. Interested, I crept forward slowly, using the trees as cover. When I got to the river I was treated to something special. There, in a kilt and lying on his back and reading a book, his dog by his side, was Prince Charles. 'What

a picture!' I thought. I ran at full speed back to the car to get my cameras. I could hardly speak as I told the news to Keith, who had been joined at the roadside by another paparazzo, Julian Parker. Julian was a charming, portly chap with a permanent wide grin and an even more permanent five o'clock shadow. We all leapt into action as this was the first royal sighting after a week of searching,

The three of us slowly and with some caution trod through the thick woodland towards the riverside. With the silence and stealth of three hungry cats we made our way onwards until we were in sight of the prince. The three of us fought silently for the cover of the best bush, before Julian and I agreed to share it while Keith moved off to the right. While this went on, Charles continued to read his book, totally unaware of our presence. He surely would have got up and left had he known we were skulking around on the opposite bank. As it was, we filled our boots with great photos. 'The newspapers are going to go mad for this one,' Julian whispered to me. I was mentally working out how much money we were going to make. We watched Charles for another 20 minutes, not taking any more pictures. It was just a nice tranquil scene worthy of any Scottish postcard.

But then the scene got even better. Looking beyond a stile on the far side of the river, I saw that another Land Rover had arrived and parked next to Charles's. Diana stepped out, looking sensational in a highland outfit, complete with kilt. I pushed down Julian's head and sank to the floor myself. We waited in silence, as did Diana, who pulled out a pair of binoculars and began to scour the landscape for signs of any snooping paparazzi. This went on for 10 minutes as she stood in a thistle bush, trying to spot

Below: Strolling along the Dee.
Diana gets out for some fresh
Scottish air.

us spotting her. We decided not to take any photos at that point, preferring to wait instead for the killer set when she finally joined Charles on the riverbank. We could only imagine what those pictures would be. Who knew what Charles and Diana got up to in private? Well, we were about to find out – here they were in front of us, and both wearing dresses to boot! All we had to do was remain patient.

Satisfied that no one else was around, Diana returned the binoculars to the car and then headed towards the stile that lead to Charles. Julian and I were primed and ready to go. 'They're going to give us awards for this one,' I thought. This was it! This was my time!

Diana lifted a leg over the stile and then stopped. Something was moving in the woods and she'd noticed it. Julian and I looked to our right and there we saw a small tree that was shaking violently. Underneath it, and in full view of Charles and Diana, was Keith, shaking the tree for all he was worth. He was facing Charles but hadn't seen Diana arriving from his left.

'KEITH! WHAT THE BLOODY HELL ARE YOU PLAYING AT?' Julian screamed. Before he could answer, Diana disappeared in a puff of highland mist. Charles packed up and left, too. Keith had some serious explaining to do, and, when we convened in the Green Hill hotel bar that night to give him a going over, Keith had to grovel as if his life depended on it. He told us that, as far as he was concerned, we'd got all the pictures of Charles that we needed and Keith wanted him to go. He didn't want any other paps turning up and getting pictures, too, he explained. Having to share the proceeds of this photo opportunity three ways was bad enough without having to share the cash

Left: How did they find us again? The arranged photocall soon got rid of the paps.

Below: Charles spots a salmon and wishes he'd brought his rod.

with even more paps. Needless to say, he hadn't seen Diana at any point in the proceedings and was gutted when he found out that she'd been there.

Despite his momentous mistake we still invited Keith to join us on our next mission – to discover which malt whisky we preferred best as we drowned our sorrows.

After his run-in with Diana at Leicester Square (see Chapter 1), Keith Butler left Britain to become a taxi driver in New York, no doubt putting his driving skills to the test on the streets of Manhattan!

Glenn, May 1987

The last thing this particular royal protection officer wanted to do was to make our life easier.

After all, we, the paps, had made his job significantly more difficult over the previous few years with our pestering cameras and he wasn't about to thank us for that now. But was he? He had been dispatched by his 'boss', staying nearby at Balmoral Castle, to round up all the 'enemy' he could. For he had an invitation …

He stood before the assembled group of Scottish and London paparazzi on the edge of the village green in Ballater, dressed predictably in his smart country attire and spotlessly clean green Hunter wellies and leaning on his large Range Rover.

It grieved the RPO to announce to us that HRH The Prince of Wales was offering to make a pact with the paps. In return for a 10-minute photocall,

we were to leave the area of Balmoral Castle for the remaining time that Prince Charles, Prince Harry and Prince William resided in Scotland. As they were only here for a long weekend, this was an offer we were not going to refuse. To get a set of pictures on a silver platter with the crest of HRH The Prince of Wales engraved on it within a day of arriving in Scotland would be a good result for us all; on previous trips here we could go for up to two weeks without spotting a royal in the heather.

The Highland gathering of cameramen eagerly – perhaps too eagerly – unanimously agreed to Prince Charles's deal and said 'yes' clearly before he could change his mind.

I was unsure as to why Prince Charles would want to make this offer. Surely if he needed to spend the weekend in solitude with his boys he had many square miles of countryside, mountains and remote lochs that they could enjoy on his private Balmoral estate without coming within five miles of its perimeter fence where most of our photos would be taken. I wasn't about to argue and didn't dwell too much on it as I was glad to be guaranteed an income for the weekend and to retrieve my mounting expenses.

Two hours later we were led to a pathway that ran along the bank of the River Dee.

'Wait here and you'll get what you want.' The RPO smiled then backed off a little to let us work.

A chorus of thanks and gratitude was passed his way from the 10 or so photographers who were at the same time loading films and pre-focusing lenses on the rocks on the opposite bank. The policeman nodded; I think he was beginning to enjoy his new role as Buckingham Palace press liaison officer. He spoke to his counterpart over the radio, straining to hear a reply over the thunderous noise of the river.

Prince Charles emerged from the trees moments later with Princes Harry and William following behind him. Dressed casually in his woolly jumper, Charles urged the boys forward towards the side of the river – and ultimately towards us, who were primed and ready on the other side. William and Harry must have been wondering what the hell was going on! But they did as they were asked and then began to throw pebbles into the river.

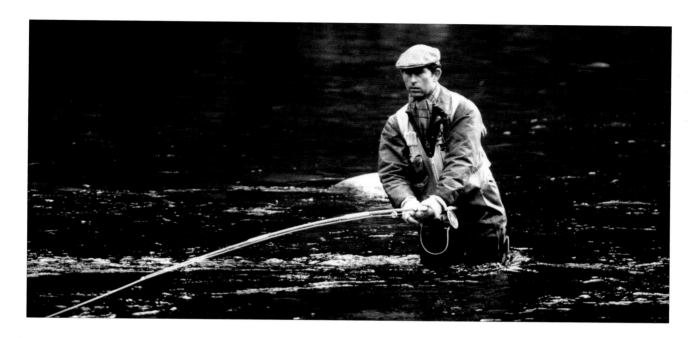

Prince Charles sat down on a large stone and grimaced at us as he does sometimes – well, mostly. He seemed to be acting as if we had just by chance discovered him here and were intruding into his private Scottish holiday. At least he was playing out his part in this show. If news of his arrangement with us had got out from this small circle of participants all hell would've broken loose 500 miles south at Buckingham Palace. After all, what were Buckingham Palace press liaison officers for? Also, the many photographers who specialised in royal family photographs and who toed the line with Prince Charles and Buckingham Palace would be livid that the paps were being rewarded for having the audacity to turn up on a 'private' royal holiday. By not being where the royals were the 'royal' specialist photographers would miss a great set of pictures that would have rewarded them financially for many years to follow. By being here in Scotland we were getting what we wanted, what the newspapers wanted and what Prince Charles wanted. An idyllic photograph of a caring and loving father having a great time on holiday in the Highlands with his two young children.

The following day, after the pictures were in all the national newspapers, you could almost feel the tension rising in London. Our telephones were red hot from all the incoming calls from our counterpart 'royal' photographers in London. The main question was 'Did you have a photo call or did you chance upon the royals?' They needed to know as the 'toe the line photographers' had to get their facts straight before complaining to the Buckingham Palace press office as to why they weren't invited. For toeing the line, they were rewarded with nothing. I could just hear their heated conversation in my head, one which I had had myself with the Palace on a previous occasion two years before. 'If you're not there you don't get.' I could imagine the palace spokesperson saying the

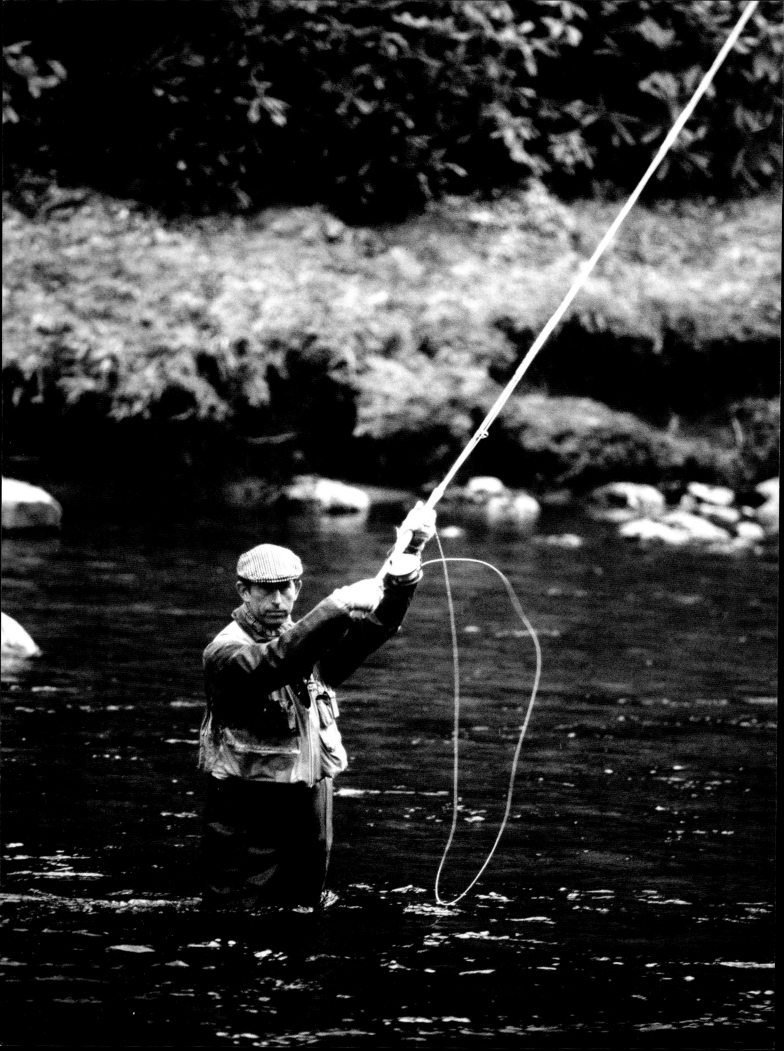

same words to the angry photographers, but this time I was not in London as before but I was where the pictures were happening.

The Scottish and London paparazzi were pleased with the day's work and were dispersing slowly from Ballater to honour our part of the agreement. It was a slow and late start for most due to a large consumption of 'celebration' whisky the night before.

On our way to Aberdeen airport, myself and fellow pap, Julian Herbert, drove to the post office for some stamps. The remote post office was located strangely about 40 metres inside the heavily fortified walls of the Balmoral estate. I drove our car through the front gates, on to the castle grounds to the post office front door and went inside and bought my stamps. The small room was loaded wall-to-wall with royal family memorabilia, some of which carried my photos on them.

Stepping outside, I spotted two green 'royal' Range Rovers speeding down the road in our direction. I dived into my car and stuck my head down low waiting anxiously for my roasting from the RPO or even from Prince Charles himself. As far as they were concerned, we should have been homeward bound as per our arrangement. Julian pretended to get something off the back seat of the car shielding his face from their view.

The cars had slowed to walking pace as they edged past ours on the small track. Prince Charles drove the lead car with the back-up car close behind. In the passenger seat of Charles's car was a woman who, because of her large hat, was unrecognisable. We presumed it was one of his many house guests and not another 'woman friend'. After all, at this time, any mention of a

crack in the Charles and Diana fairy-tale marriage would have been unthinkable, unprintable and definitely treasonable.

As the years have passed by, I have often wondered why Prince Charles had made a pact with the 'other side' that weekend but on reflection now could it have been that he was having a secret highland fling with the married Camilla Parker Bowles? It was certainly a remote place to do it and would've been even more remote without the paparazzi hanging about with our cameras. Perhaps we had missed the real story that weekend and will never solve the mystery but, after all the events in the subsequent years, the possibility that Charles and Camilla were having a romantic weekend together is not so far-fetched.

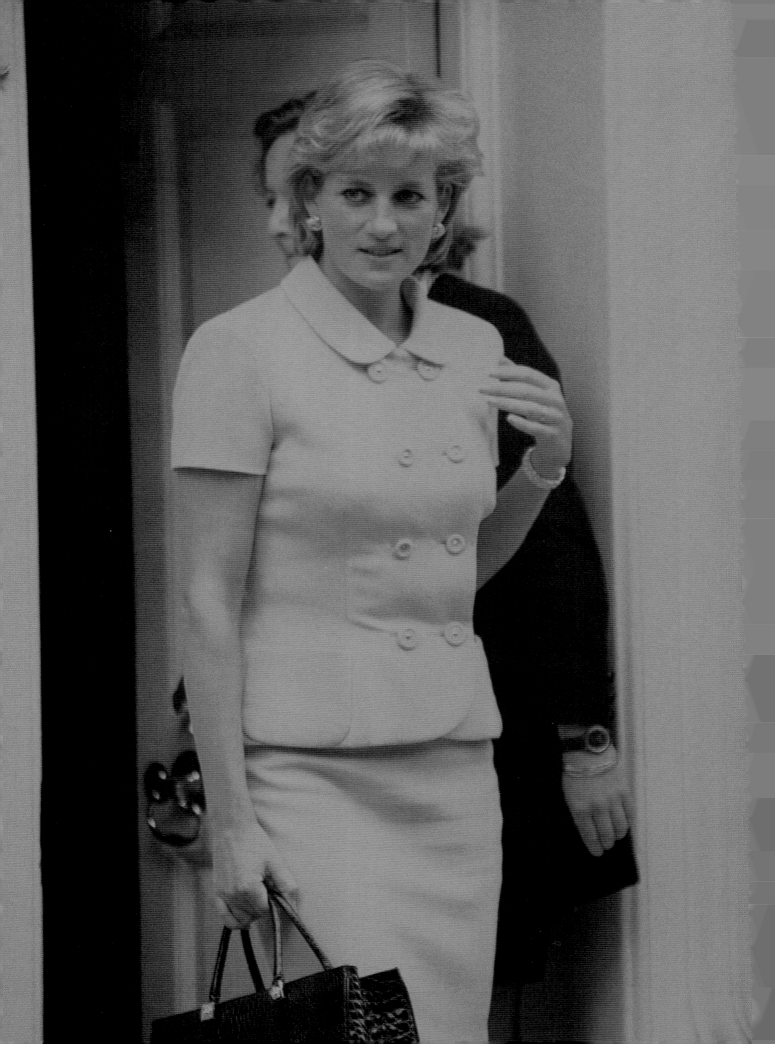

First Encounters
with Diana

Mark, December 1993

The first time I ever saw Princess Diana in private was at Pinewood Studios. At that time, I was a reporter working for the *Slough and Windsor Express*. I had recently been elevated to the exalted position of royal reporter, a title as meaningless as it was pointless. The canny assistant editor, knowing I was covering Windsor Castle at the weekends for the *Mail*, promised me Fleet Street would be impressed and it would look good on my CV. It was basically the old trick of offering someone a title to get them to do more work for no more money.

It was a boring Thursday afternoon on a slow news day when I took a call from a contact who worked in security at Pinewood, probably the most famous film studios in the world. He told me that Paul McCartney and film producer David Puttnam were on site. Macca was preparing for a world tour, a story of huge interest as it was the first time the former Beatle had toured in many years. Nobody knew where McCartney was rehearsing, so the alarm bells began to ring in my journalistic mind: if McCartney was rehearsing at Pinewood and I could get a picture, it would be a worldwide scoop.

In these days of paranoid security and Big Brother society, it's hard to believe how easy it used to be to get into Pinewood. All you had to do was drive up to the tradesman's entrance and say, 'Delivery for so and so,' and they would wave you through. There were never any checks. So, that's what I did. Once I was on the site, I drove past the *Batman* set, which was still up, even though the movie had been shot two years before. Gotham City was looking slightly dilapidated and appeared to be going the same way as the British film industry.

Even though Pinewood is home to some of the greatest movies ever made, its stages graced by virtually every major movie star in history, the studios remain unique for having no form of celebrity special treatment. The biggest Hollywood stars use the same make-up and toilet facilities as the humblest extra. And the eating facilities are no different – everyone uses the same industrial canteen, where it was not unusual to see Mel Gibson or Tom Cruise queuing alongside overall-clad carpenters and electricians and asking the tired-looking cook: 'Ma'am, what's steak and kidney pie?'

As it was just past lunch, I figured the canteen was the best place to start looking for Paul McCartney. I wasn't alone; alongside me sat Paul Turner, an Australian reporter looking for a big scoop to take back home. Paul got out of the car and walked across to the canteen entrance. There was a buzz in the air. Even though the studios had seen it all before, I had the feeling someone special was in here.

I watched Paul go in the door – and almost immediately he walked back out again. 'What's up?' I asked as he clambered back in the car. He looked like he had seen a ghost. 'What's up?' I asked again.

Paul looked at me. 'Paul McCartney is sitting just inside the door eating dinner with Princess Diana.'

'You're kidding…'

'I'm not…'

We both looked towards the canteen. Though we were both aware of the studio's legendary reputation, Paul McCartney eating lunch with Princess Diana was impressive even by Pinewood's standards. It was about a year before Diana's

Below: The Princess meets Paul and Linda McCartney at an event in Lille, France in November 1988.

separation from Prince Charles. Though the newspapers had periodically hinted at marital problems between the pair, I don't recall Diana being particularly newsworthy at that time. Of course, every royal duty she carried out was covered by the papers, but there was nothing like the worldwide media interest in her that was to follow. It all just seemed a bit bizarre when a smiling Paul McCartney emerged from the canteen with Princess Diana alongside him and film producer David Puttnam shuffling behind. McCartney was wearing a black suit jacket over casual jeans. Diana, also in jeans, wore a blue polo-neck jumper, while David Puttnam wore his familiar ill-fitting dark suit. Diana had her arms folded as they walked towards the James Bond stage, her head lowered as she listened intently to Paul McCartney, who gestured expansively with his hands as he spoke.

As silly as it may seem, neither Paul nor I knew what to do. We had doorstepped many people, we had even managed a world-exclusive interview with Mel Gibson only the month before, but Princess Diana was royalty – and you couldn't

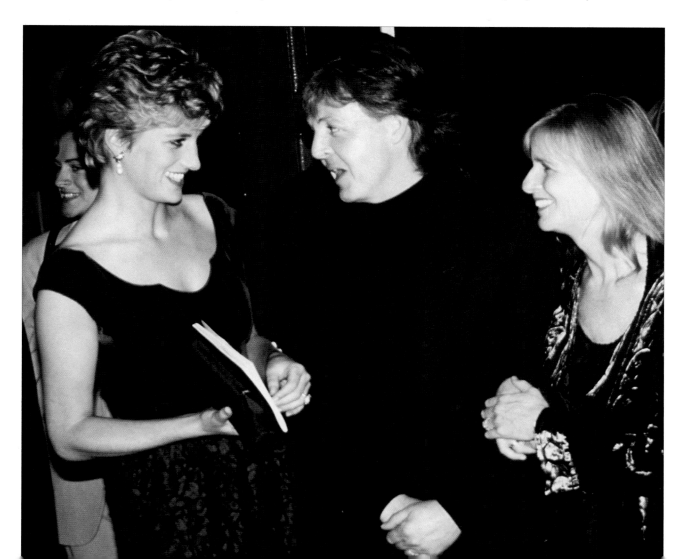

Left: Looking fabulous! Diana displaying why she was hot property for the paps.

doorstep royalty. At the back of our minds, we both thought maybe you could still be locked in the Tower for that sort of thing.

Throwing caution to the wind, and agreeing we couldn't claim any expenses if we went back to the office with nothing, we drove past the trio and parked about 30m ahead of them. Then, as the most famous woman in the world and the second greatest Beatle of all time approached us, we chickened out. Both Paul and I turned away from the duo. I can still hear McCartney's familiar voice saying '…whatever that was,' and Diana giggling as they passed just a few metres behind us.

It was David Puttnam that saved us. He had been joined by a couple of assistants and had stopped walking to talk to them. Diana and Paul also stopped walking and turned back. Paul Turner took the opportunity to stop acting like a coward and be a journalist: 'Mr McCartney sir,' he said, 'we're from the local paper… could we…'

Diana straightened up and smiled. 'This is where I leave,' she said.

'I'm sorry… I don't want to bother you,' Paul said, and he meant it.

'It's OK,' Macca grinned, 'what's up?'

I don't know where she went, but Diana just disappeared. One moment she was there, then she was gone. I can still remember vividly what Diana looked like that day: ordinary. There was no glamour about her. This was right at the end of the 'Diana' years; the time when pictures of Diana all looked the same and were used only to illustrate another royal duty. She looked like any young woman, even a touch dowdy. Today, it is hard to reconcile the Diana I saw that day to the one I was to pursue across the world a few years later. By the

time of her death, Diana was the most beautiful woman in the world. But she matured into beauty. In her twenties, Diana was quite ordinary.

Paul McCartney, using the charm that has kept him popular for four decades, gave us enough words to turn into a 'world-exclusive' interview. A world exclusive within the confines of the *Slough Express*, that is. He told us that he had played Slough with the Beatles at the very start of Beatlemania.

I asked him about lunch with Princess Diana. 'She's just a friend,' he laughed. 'You know, a mate.' And then he, too, was gone.

Paul and I walked back to the car trying to look as cool as we could. Both of us were determined to get out of the studios before we started screaming: 'I spoke to Paul McCartney! I SPOKE TO PAUL McCARTNEY!'

A green Rover drove past us with Diana at the wheel. Her detective was sitting beside her. She smiled as she drove past.

Probably the only thing royal reporters and members of the royal family have in common is their love for Windsor Castle.

Without doubt, the castle, built more than 1,000 years ago by William the Conqueror, is everybody's favourite royal residence. Perched at the top of a hill overlooking the town it dominates, the River Thames and the almost unimaginable beauty of Windsor Great Park, the castle is the queen's 'home'. By contrast Buckingham Palace is the office, Sandringham the country retreat and Balmoral the Scottish hideaway. Although each of these places has their own unique place in the

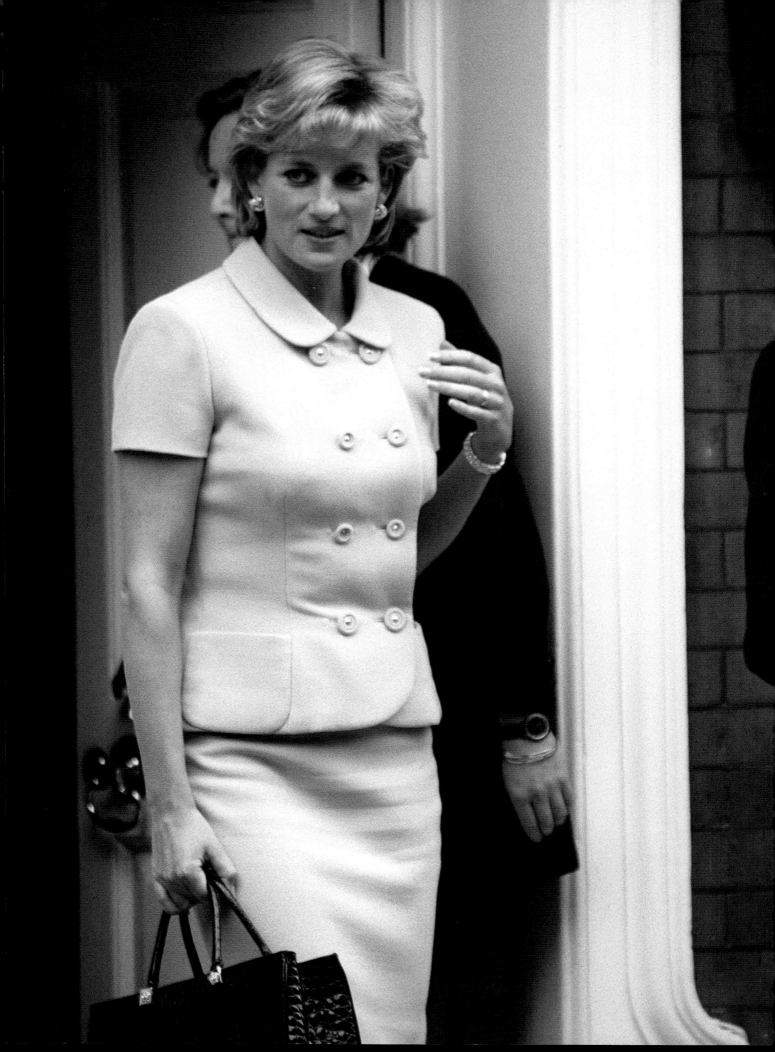

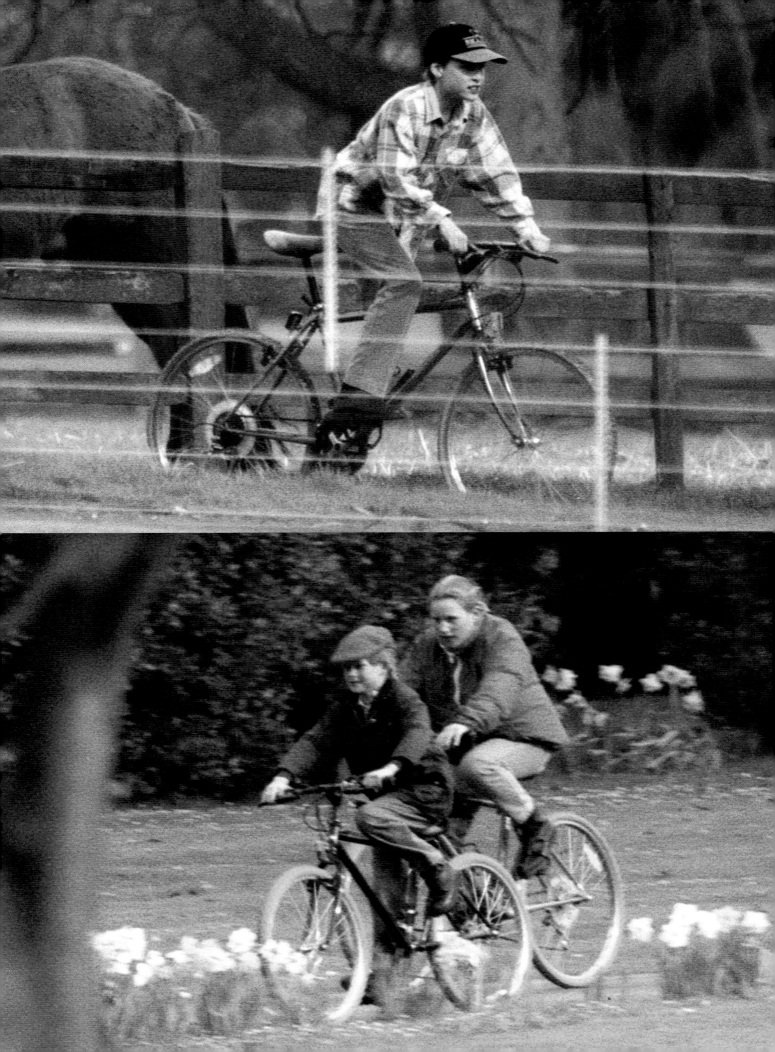

Wheeling around Windsor Castle.

Left, above: William rides out to say hello to his horse.

Left, below: Prince Harry and cousin Zara Phillips see how many of Grandma's flowers they can flatten.

Overleaf, above left: On your marks, get set, go!

Overleaf, below left: Prince Harry hurtles towards the finishing line.

Overleaf, above right: William wishes Harry would take some singing lessons.

Overleaf, below right: The boys pay a visit to the horses.

queen's heart, it is only at Windsor that she can put her feet up, order a take-away pizza and spend all evening watching the TV.

As the queen's home, Windsor Castle has none of the stuffy protocol associated with Balmoral, or the grim North Sea weather of Sandringham. For some reason, the sun always shines when the queen is in residence at Windsor – and so does the queen, which is probably why other members of her family love it so much.

Royal reporters love Windsor because of an unspoken agreement hacked out between Fleet Street and the queen's detectives some years ago. At the end of the Long Walk, a magnificent path that cuts through the heart of the Great Park, is the Cambridge Gate. Beyond the gate are the queen's private apartments. Anything that happens at Windsor Castle involving the queen can be seen from the Cambridge Gate. Whether she is riding her horse across the carefully manicured sprawling lawns or driving her Range Rover into the forest, she has to pass through or by the gate. Therefore, it was agreed the press could stand by the gate and photograph whatever they wanted. Technically, they could have been moved on at any time, as you need written permission to film for commercial gain in a royal park. But the queen, showing a tact and understanding very few of her family have, said, 'At least I know where they are now,' leaving most royal reporters believing the queen had welcomed the deal and had probably initiated it.

Throughout the late 1980s and early 1990s, weekends at Windsor Castle were a plum job for royal watchers. The queen would arrive on Friday evening and spend the weekend riding before returning to London on Tuesday. Royal watchers

would mix with tourists and sit in the cafés drinking coffee, knowing that nothing more exciting would happen than the queen slowly trotting across the lawn in front of them.

Though I was still working at the *Slough Express*, at the weekends I moonlighted as a photographer at the castle. I had never planned to be a photographer. At the time, I still dreamt of being Westminster Correspondent for the *Guardian*, but the agency that employed me had no staff photographer, so I earned double the money to stand by the gate with a camera *and* a notebook.

I was working with Roy Milligan, a genuine Fleet Street legend. Well into his eighties, Roy had been taking pictures of royalty for more than 60 years. He was one of the few press men alive to have seen four monarchs. Roy's contacts at the castle were impeccable: we always knew of any movement way before it happened. Another great source of information was the gate-keeper's walkie-talkie, which he always kept precariously balanced on the window sill of his tiny sentry box. If the queen or any other member of the royal family was due to come out, the radio would crackle into life, informing everyone nearby of any castle activity.

One Sunday in May 1990, I was at the castle as usual with Roy. We had been joined by TV cameraman Mike Lloyd and snapper Jim Bennet. It had been another lazy weekend. We had seen the queen and the Duke of Edinburgh both out riding, but nothing untoward had happened and we were reaching the point where the pub beckoned. The talk all weekend had been of the forthcoming Andrew Morton book *Diana – Her True Story*. Like everyone else, we had heard rumours of the book's sensational contents but we were in the dark as to

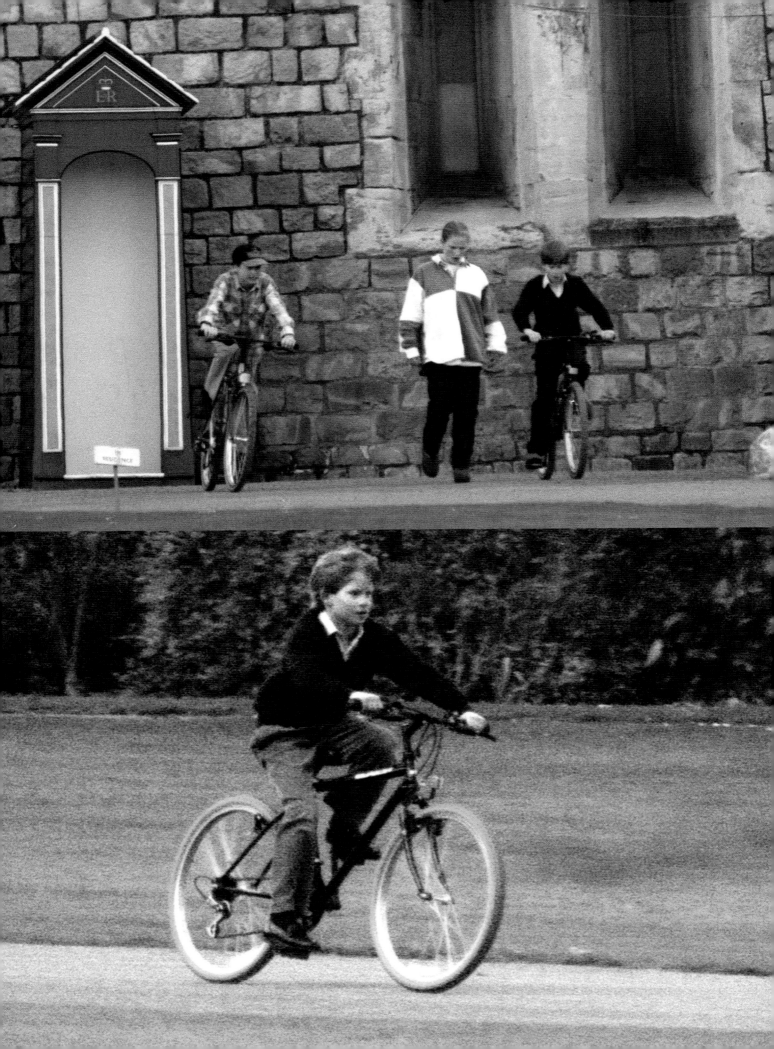

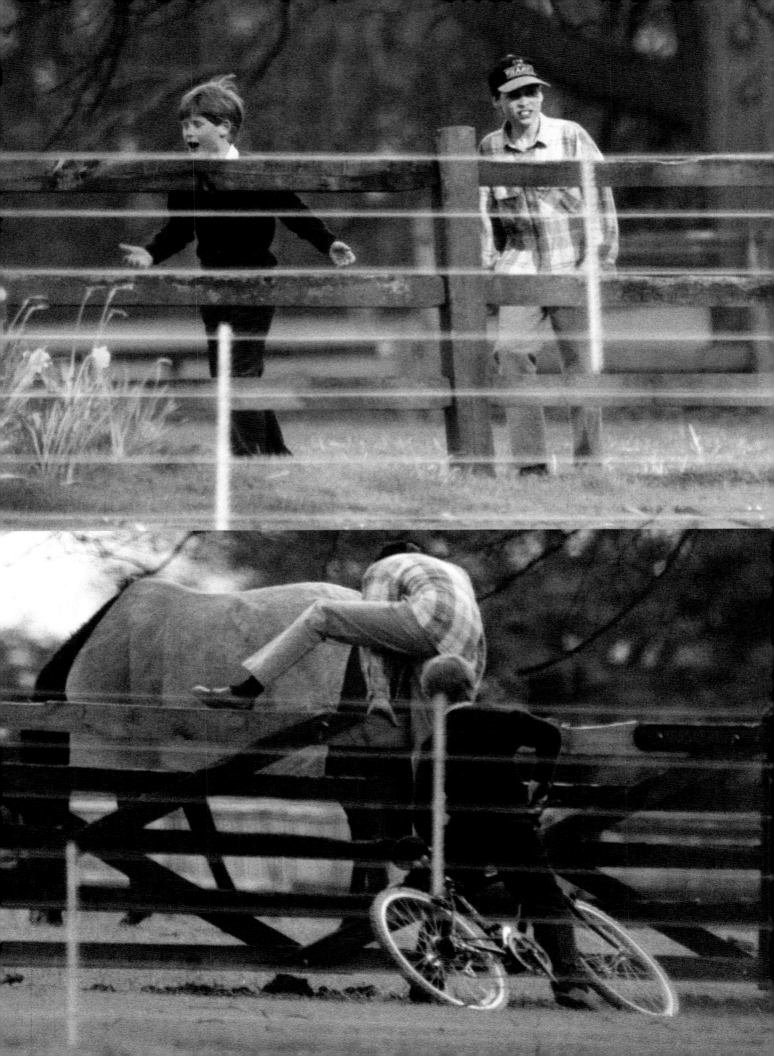

Diana and the Paparazzi

Below: Prince Charles takes his sons Princes William and Harry for a ride along the River Thames at Datchet in Windsor.

what they might be. The marital problems of the Prince and Princess of Wales had been front-page news for some time, but it was all still speculation. No one had produced any facts yet.

The book was to be serialised in *The Sunday Times* the following weekend and the word on Fleet Street was that *The Times* had bought itself another *Hitler Diaries*. None of us believed that Princess Diana would be so foolish as to collude with a journalist on a book that would effectively destroy Prince Charles and maybe even topple the royal family. And so we gossiped and hung around the gate and waited for the last of the tourists to leave the pub just across the way so that we could enjoy our sausages in real ale in peace.

It was then that Jim saw a woman walking across the lawn with two small children. He grabbed his camera, pulling the huge 800mm lens into focus

before shouting: 'F*** me, it's Diana.' We leapt up and grabbed our cameras as well. Sure enough, Princess Diana was walking towards the stables with William and Harry. The boys were still very young at the time and were wearing red shorts and T-shirts. Harry held Diana's hand as William skipped on ahead. Two detectives trailed behind discreetly.

We snapped away as Diana laughed at William's attempts to do a cartwheel on the Windsor Castle lawn. Playfully, she chased after him, holding Harry's hand as she ran. The trio made their way to the stables, where they looked at the old horse that was a permanent feature there. Diana kept the children at a safe distance, but allowed William to stroke the horse's neck. It was a beautiful sight and the perfect ending to a lovely weekend. Diana and the children seemed not to have a care in the world and we continued to snap them as they made their way away from the stables towards the golf course and out of our sight.

That was the last time we were ever to see such a carefree Diana with the children. Just over a week later came the eruption that would place her on the front page of every newspaper on earth and bring to an end the 'Diana' years.

The 'paparazzi years' were about to begin.

The publication of *Diana – Her True Story* changed the face of the British monarchy forever – and the way that the monarchy was reported.

The days of royal reporters being 'attached' to the royals, reporting only what the establishment wanted, were long gone by then anyway. They had been replaced by teams of tabloid hacks who, while still maintaining respect for the monarchy,

Below: Prince Harry gets to grips with his new royal limo.

titillated their readers with behind-the-scenes tales supplied by an army of palace insiders only too keen to supplement their meagre incomes with a cheque from News International.

But now the gloves were really off. On Sunday, 7 June 1992, *The Sunday Times* hit the streets with the sensational headline: 'DIANA DRIVEN TO 5 SUICIDE BIDS BY UNCARING CHARLES'. All hell broke loose in the world of royal reporting. Overnight, the British monarchy had turned into a pantomime, and each member of the royal family was assigned a new role. Charles was the villain, the despicable cad who preferred the arms of his ageing mistress to his beautiful young wife. The Duke of Edinburgh was the ogre, ordering Diana to 'pull herself together' and try to ignore the fact that her husband was sleeping with another woman. Prince Andrew was the layabout who spent all his time on the golf course or lounging in front of the TV. His wife, Fergie, was the sponger – completely useless at royal duties and mocked as 'vulgar', even by palace officials. Edward was ignored and Princess Anne despised.

And in the centre of this circus was the beautiful Diana, the classic fairy-tale princess trapped in her ivory tower and desperately looking for love.

Day after day of front-page headlines castigated the monarchy and sanctified Diana. The extraordinary lengths she went to to supply Morton with information reads like the story of a dissident smuggling revolutionary literature out of the Russian gulag: tapes hidden in books and midnight phone calls made the whole thing seem more worthy of John Le Carré than a tabloid hack.

Diana, who had initiated the book in the first place, played her new role perfectly. Favoured

snappers were tipped off when she went to visit close friends who had spoken on the record, thus telling the world that Diana had approved of their actions.

The royal family reacted predictably and, as history showed, correctly. They battened down the hatches and took cover, fully aware that the monarchy had faced far greater crises in the past and survived. Diana was indeed a 'problem', but this was a monarchy that had faced abdication, invasion and sectarian war without losing its nerve. If the combined might of France, Spain and the Roman Catholic Church couldn't bring down the monarchy, a former kindergarten teacher was hardly likely to.

As Diana played up to the papers in ever-increasing desperation – offering ample photo-ops and requesting various 'friends' to keep talking – the Morton backlash began. Leader comments in Britain's quality newspapers began to portray Diana in a bad light. The marriage of Diana and

Below: Licence to snoop. The Ratpack were an approachable and happy bunch... sometimes.

Right: 'Have you no respect? Take your hands out of your pockets when you're talking to royalty.' Glenn gets a private audience with Diana in Harley Street as the paparazzi years began ...

Charles may well have run into trouble, but was this really the way to solve it? Everybody knows there are two sides to any divorce and somewhere in the middle is the truth. But Diana's brilliant manipulation of the press turned the whole thing into a game of tennis where one player was refusing to return the serve. Charles didn't stand a chance.

The sorry saga carried on for over a year. Not a day went by without another front-page story claiming a divorce was 'imminent' and that Diana was threatening to set up a rival royal court to 'destroy' the royal family once and for all.

And then, suddenly, it was all over. In November 1993, Diana announced to a stunned world that she was retiring from public life after 13 years of global superstardom.

It was in March 1981 that Diana first stepped out as a member of the royal family at the Goldsmiths' Hall in the City of London. She had just become engaged to Prince Charles and as the world watched this young couple, desperately in love (or so we thought), it seemed nothing could stop the fairy tale everyone wanted. On that night, so long ago, Prince Charles stepped from the car and said to the waiting photographers: 'Wait until you see what's behind me.' Then Diana appeared – and the effect was sensational. As 1,000 camera flashes popped the greatest megastar of the 20th century was born. Then, 4,524 days later Diana made what she hoped would be her last public appearance. Waving to the crowds who had come to see her, she vowed she would not cry – and then she was gone.

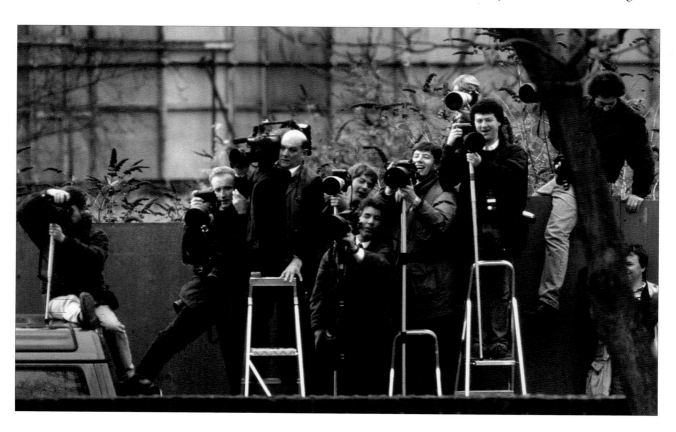

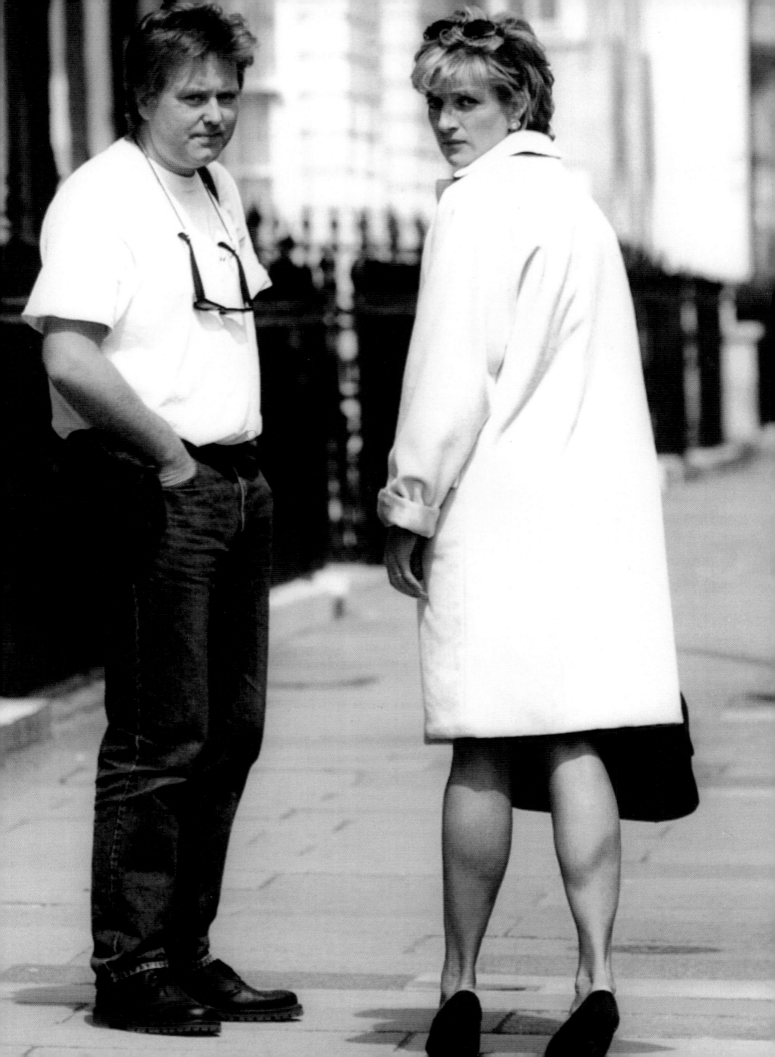

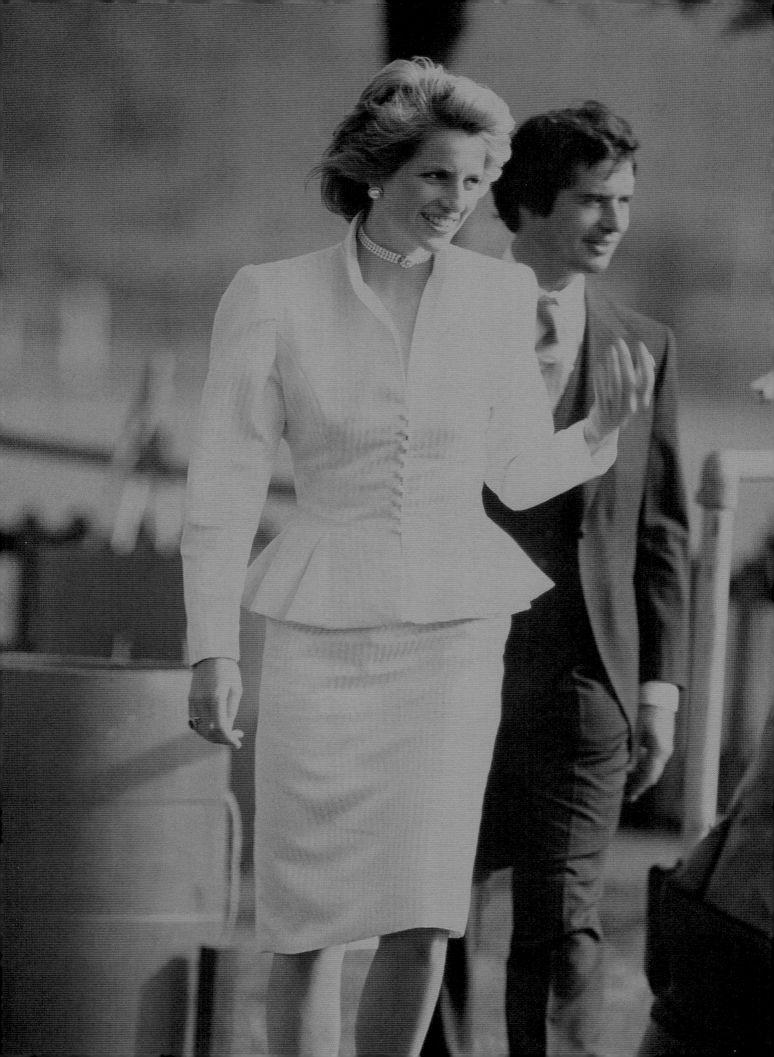

The Paparazzi Years

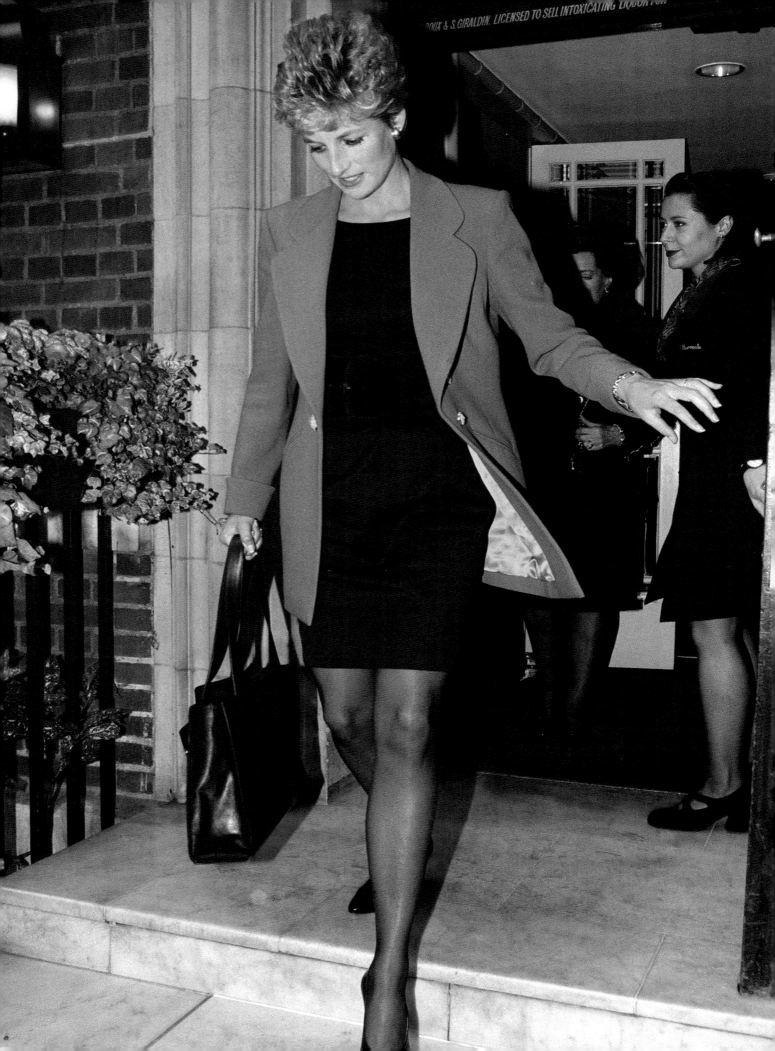

Left: This woman had style! Diana leaving another 'do lunch' date with the girls in London.

Mark, January 1994

The paparazzi years began almost immediately after Diana 'retired' from public life – and ended roughly six months before she died. Throughout that time the pursuit of Diana was relentless and, at times, quite frightening.

When I think back now to some of the crazy, hare-brained schemes we cooked up to get photos it seems hard to believe that it was allowed to go on for so long. It wasn't that the photographers were above the law: nobody knew what the law *was*. Princess Diana was both the biggest news story in the world *and* the most famous woman in the world – and yet she naïvely believed that by turning her back on royal duties she could become anonymous and lead a life like anyone else. This was impossible. Even if, by some miracle, the press had left her alone the public would not have.

Diana informed Buckingham Palace that she no longer required *any* form of police protection: that she would drive herself, shop by herself, walk along the streets by herself. Even to this day, I can't understand her thinking. Imagine if the President of the United States of America walked into McDonalds completely alone. *Every s*ingle person in the place would gawk – and *anyone* with a camera would take a picture. Now imagine that picture was worth maybe £5,000 or £6,000. How long would it be before people were standing outside the White House waiting for the next shot?

Almost immediately, *all* of Europe's major press agencies assigned snappers to cover Diana. Their brief was simple: if she moves, photograph her.

After Diana's death, the so-called paparazzi were universally castigated for their pursuit of Diana. The truth is that there were no paparazzi pursuing Diana.

The London paps are notoriously lazy – unlike their French and Italian counterparts who rule the Mediterranean. The London paparazzi tend to hang around the same celebrity haunts, waiting for the stars to come to them. And the stars always do.

There is very little point in a major star coming to London and not being photographed. Therefore, places like The Ivy or San Lorenzo are always their first port of call. Unfortunately for Diana, these were two of her favourite restaurants. When she was later to talk about turning up and finding four or five photographers jumping around her car, she didn't realise they weren't actually waiting for her. They were waiting for anyone. Jack Nicholson or Madonna would have been just as good, though obviously not worth the same money.

The hardcore royal photographers that were to pursue Diana across the globe for the next three years didn't hang around restaurants. They were professional press photographers with the finance and muscle of Europe's biggest agencies behind them – and an army of contacts from traffic wardens to royal valets tipping them off about Diana's whereabouts.

Information is a commodity that is bought and sold like any other. Prices varied from a 'drink' (roughly £20), to a percentage of world sales (which could mean thousands). With this sort of money at stake is it any wonder Diana could trust no one? Even her so-called 'rock', royal valet Paul Burrell, came under suspicion after a number of secret trips to see friends were photographed. Diana once asked us: 'Who told you where I was? Was it Paul Burrell?' I told her Burrell had never given me any information but I couldn't speak for others.

Below and right: If I do a dance maybe she'll give me a picture… Mark (*right*) and Antony Jones (*left*) have a close encounter at the Brompton Hospital after Diana emerges from her own close encounter inside with boyfriend Hasnat Khan. As Diana's infatuation with Khan became more intense, the visits became more frequent.

The relationship between Diana and the royal snappers deteriorated rapidly. To begin with, she would simply ask to be left alone. When this request was ignored, she lost her temper and rows frequently broke out. What Diana did not understand was that we were press photographers covering the biggest story in the world. We had no idea it would go on so long. Every day we assumed today would be the final day – that common sense would soon prevail – that Buckingham Palace or the police would make Diana see sense and stop walking around London on her own and at the mercy of anyone with a camera.

And yet nobody did anything. The powers-that-be made it quite clear it was no concern of theirs. Buckingham Palace issued a brief statement asking for the princess to be left alone, but that was it. It would have been so easy for them to have taken action against the newspapers that published any pictures. All they had to do was withdraw any

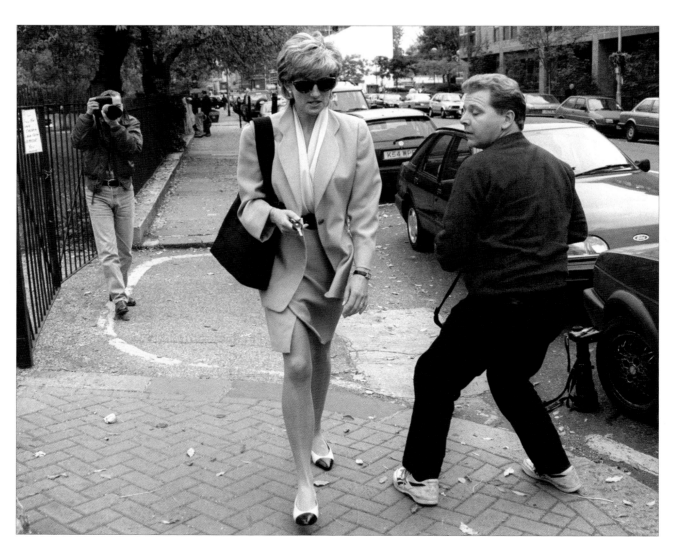

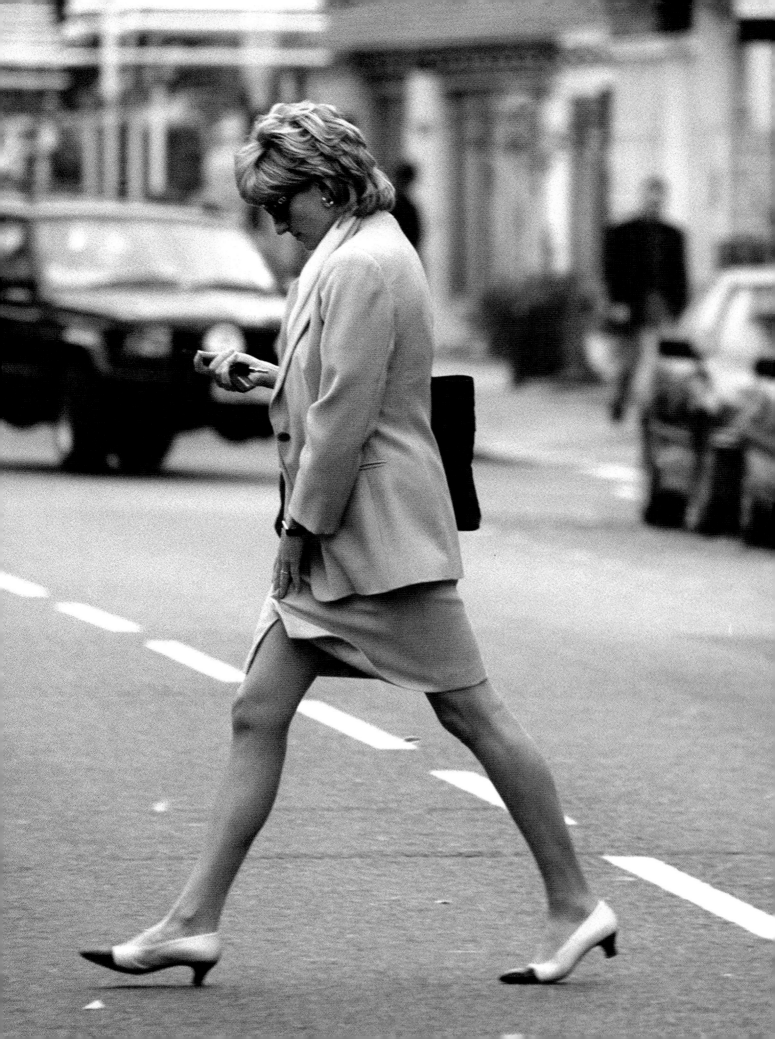

Below: Love is in the air? Hasnat
Khan makes his way to work at the
Brompton hospital.

facilities for the paper at official royal functions.
Yet they didn't, and so the papers published picture
after picture, day after day.

The police also made it quite clear it was
nothing to do with them, though one of the royal
protection squad did say he was glad the paps were
following Diana. 'These days, you are our eyes and
ears,' he told us.

Fleet Street itself remained outside the
argument by making it quite clear to every agency
that no one was to pursue the princess if she didn't
want them to.

Diana was, in effect, completely unprotected.

As 1994 began, the ground rules between Diana
and the paparazzi had been squarely laid out –
there weren't any.

Diana continued to walk around London without
any protection – and the paps continued to
photograph her, even though Diana's outbursts were
becoming increasingly hostile. She just couldn't
seem to understand the rod she had made for her
own back. She wanted to be left alone but the *world*
wanted to know what she was doing. It was the
classic catch 22 situation: the more Diana demanded
privacy, the less she got. Had she done what Garbo
or Lennon did – which was to disappear into their
apartments for years and never come out – maybe
things would have been different. But she was so
famous by this time that just walking down a street
commanded front-page news.

In any one day, Diana could be photographed
buying sweets, putting money in a parking meter,
going to the gym or waiting at traffic lights and
thousands of pounds would be made by the

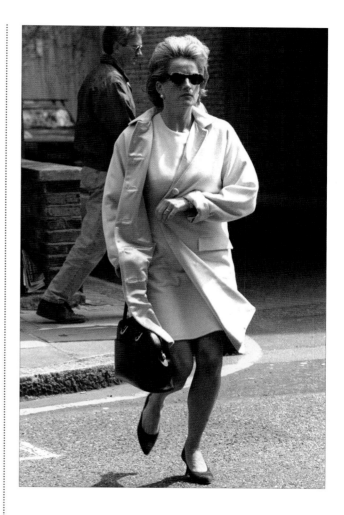

photographers and their agencies. Of course, today everybody says she should have been left alone, but hindsight always comes with 20/20 vision. Newspapers and magazines across the globe published the photos we were taking and the public loved them. A photo of Diana on the front page of a magazine could increase circulation sometimes by 50 per cent, and this in itself caused an even greater demand for photos as the other magazines raced to catch up.

Any attacks on the paparazzi always started with the old 'supply and demand' chestnut. TV shows would often portray the paparazzi in the same way as drug dealers: men who gave the public what they wanted but without any consideration for anyone but themselves. Yet this is complete nonsense. Any economist – *any* economist from Milton Friedman to Karl Marx – will tell you demand cannot be supplied without distribution, and distribution is pointless without customers. So, in the long chain of events that took place from photographer clicking the camera to member of the public looking at the picture, everyone was compliant.

Newspaper editors didn't buy photos of Princess Diana for no reason. They paid huge amounts of money because they *knew* their readers wanted to see them. The readers, avidly buying the newspapers and magazines, couldn't care less how the pictures were taken. They wanted their fix of Diana each day and if one paper refused to publish they would simply buy another.

The first time I ever encountered Diana was in Beauchamp Place – the very heart of Diana territory. Diana frequented a clinic about halfway down the street and, as she always went very early, it was relatively easy to park. It was about 8:30 a.m. and I had just grabbed a fast-food breakfast. I looked across to the clinic entrance, Big Mac in hand, when the door slowly opened. Diana's head appeared and she quickly looked up and down the street, anxiously checking for photographers. Thinking the coast was clear, she stepped out on to the pavement and began walking away from my car towards Pont Street, the quiet end of Beauchamp Place where she had parked her car.

Dumping my breakfast on the passenger seat, I

grabbed my cameras and leapt from the car. I ran along the opposite side of the street until I was level within her and began shooting. She noticed me straight away and immediately put her left hand up to her eyes. Keeping her head down, she walked at a brisk pace, her face turned away from me. I ran across the road and got in front of her. We were about 20m from the end of Beauchamp Place. I tried to speak to her as I walked backwards, shooting: 'Ma'am, can I just have one picture.'

It seems so stupid now, but we really did call her 'ma'am' – as if that really meant anything; as if we really cared about royal protocol.

Diana shook her head, which was still bowed, and snarled: 'No, just leave me alone.'

'I just want one picture ma'am,' I said.

She refused to look up: 'Just get lost!'

By now we had reached the end of the street and Diana's car was in sight. I tried a new tactic. Kneeling down, I tried to shoot up into her face but she simply turned her head, giving me an excellent shot of her left ear. Unfortunately for Diana, her refusal to look at me made her walk straight past her car. Realising her mistake, and probably feeling a bit foolish, she whirled round and screamed at the top of her voice: 'GET LOST!'

I must admit, I was somewhat taken aback by her outburst and immediately stopped shooting. I lowered my camera and looked at her. She stared straight back at me and said: 'Just get lost.' She then got into her car and screeched off.

I was walking back to my car – the pictures I had just taken were useless and I knew it – when Diana pulled up alongside me. Winding down her window, she called out, 'Ha ha… you didn't get any pictures,' and drove off.

Back at Windsor Castle, Roy Milligan had a hot tip. He had overheard a protection officer telling a colleague that Diana was due to host a party at Kensington Palace the following day. At 82 years old, Roy rarely ventured into London but he was happy to pass the information on to me.

In those days, before the low-cost airlines began bringing in the European paps on a daily basis, it was possible just to sit outside KP (Kensington Palace) and wait for any action. The royal photographers had long since broken the code the police used and, with a simple hand-held scanner, you could listen to all the radio traffic going to and from the palace. When you heard the words '52 rolling', it meant Princess Diana had just passed the security check-point inside KP and was heading towards the second check-point on the edge of Kensington High Street. This gave you about a minute to get ready before Diana's familiar blue Audi began to edge out into the London traffic.

Glenn, March 1994

It had been a routine evening. Mark and I were in Kensington, sipping much-needed coffees after a long day with no sign of Diana. We had heard that Diana had taken delivery of a brand-new Audi convertible and we were desperate for the first pictures of her driving through London in it. For this reason, we had stayed in town late, but now, as 9:00 p.m. approached, we were both thinking of knocking it on the head and heading home.

Just as we were on the verge of packing up, my phone rang. A contact from the Harbour Club, Diana's gym, was claiming that she had just seen Diana driving into Chelsea Harbour with a male friend. We immediately leapt into our cars. Mark

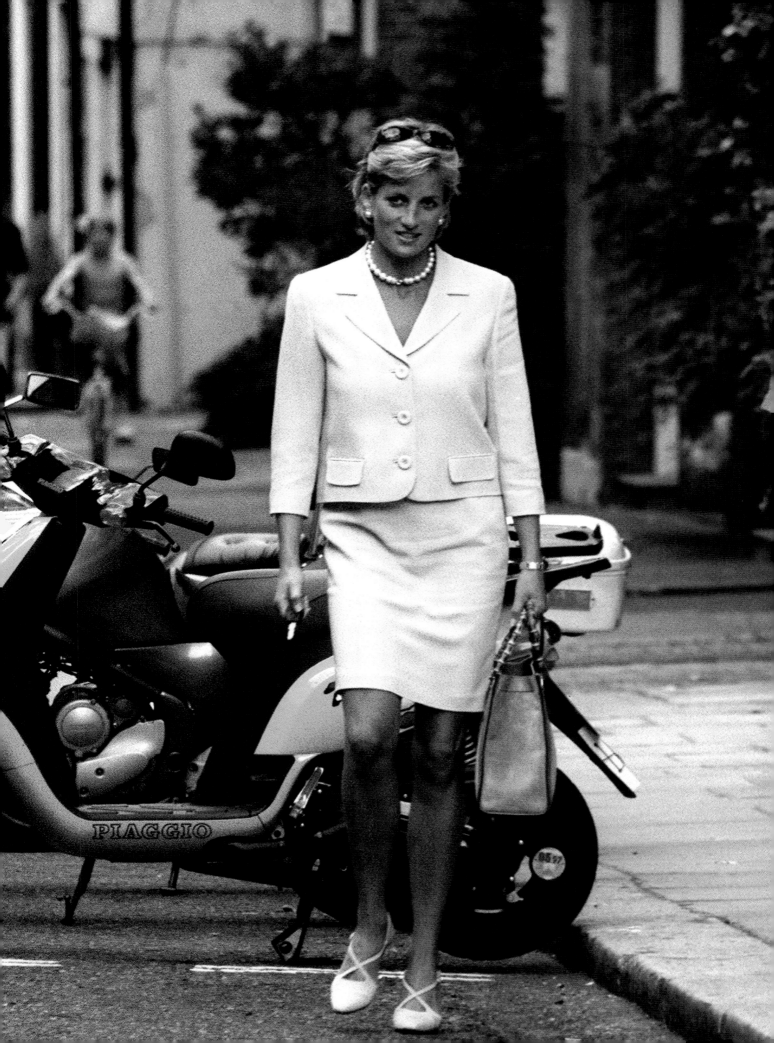

Below: Diana first met the handsome Arabian art dealer Oliver Hoare at Ascot Racecourse – ironically, he had been invited as one of Prince Charles's guests.

shouted that he would take Earls Court Road, leaving me to drive down Gloucester Road. Tyres screeching, we both raced off.

Chelsea Harbour is an exclusive complex of £1 million apartments and swish restaurants that overlook the Thames. It was built during the 1980s, when everybody had money, but since the recession it had declined a bit. Mark reached the Harbour first and called me on the phone to follow. He had been waved through the security barrier after concocting a story to the duty guard about picking up his girlfriend, but I wasn't so lucky. The jobsworth on the gate looked into my car and spotted my cameras straight away. He refused to raise the barrier and told me in no uncertain terms to depart. He then picked up the phone and spoke to somebody at the other end. 'The press are outside,' he said smugly.

Now, I know it's a cliché that most security guards are not very smart, but the simple fact is that it's true. If no one of importance had been in the Harbour he would not have had to make the call. The fact that he did confirmed to me that we were on to something. I parked the car outside and walked across a building site into Chelsea Harbour. Mark was standing by his car outside one of the restaurants. As I approached him he pointed at an L-reg green Audi convertible in a parking bay further up. Bingo!

We quickly discussed tactics. We would sit in Mark's car from where we could see the restaurant entrance. When Diana and her mystery man came out, we would blitz the pair of them. We both knew it was doubtful that there would be any difficulties tonight as Diana would just want to get the hell out of there as quickly as possible.

We thought we had it all covered. Unfortunately, we had forgotten about one of the biggest problems in our job – the busybody nosey-parker who is always on hand to screw everything up. This one seemed to be the maître d'. He watched us from the restaurant door for about five minutes before coming out to the car. 'Are you waiting for someone?' he asked.

It doesn't matter what you say when faced with this predicament, you know you've blown it. Our cameras were hidden under coats on the back seat, but no matter how hard we tried we just looked and smelled like paparazzi. We could tell immediately he didn't believe Mark's story that we were waiting for the breakdown services. With sinking hearts, we watched him walk back inside the restaurant and pick up the phone.

I looked at the door. 'Why don't we just go inside and blitz anyone who's in there?'

This made Mark laugh. 'You make it sound like a scene from *Terminator*,' he said.

And then something happened that we were to see many times over the next couple of years. A man, who we presumed worked at the restaurant, came out clutching a set of keys. He walked across to Diana's car and got in. We watched him drive off into the underground garage.

Both Mark and I realised what was happening at exactly the same time. We looked at each other. 'Get to the rear exit of the restaurant,' I shouted. Mark fired up the car and slammed it into gear. We accelerated in reverse the wrong way up the one-way street at an insane speed. The security barrier we were speeding towards was down, but a little thing like that wasn't going to stop Mark.

I closed my eyes and waited for the crash, but

Mark swung the steering wheel to the left, which sent us bumping up the pavement and on to the dirt of the small building site. Still in reverse, the car sped across the waste ground until, with a loud bang, we went down a steep kerb on to the road where my car was parked.

As I leapt from the car we saw Diana's Audi coming out of the back entrance to Chelsea Harbour. Fortunately, the security barrier was still down, which gave me time to start my own car before she pulled out on to the road. Diana drove towards Fulham Road, so I took a shorter route towards KP, followed by Mark, which led us out in front of Diana's car. She remained on my tail as we pulled on to Kensington High Street, but I was now facing a major problem: the entrance to Kensington Palace was on the right-hand side, which meant I would have to do a right turn across the oncoming traffic. If Diana turned at the same time as me there would be no way I would have time to stop and get a camera out before she was inside the gate. I slowed right down. Diana, who was already indicating right, slowed down as well. I waited until an oncoming lorry was virtually on top of me before accelerating straight across the front of it. There was no way Diana could follow now. She would have to wait a few moments until the road was clear again.

Pulling on to the pavement, I leapt from the car, camera in hand, just as Diana made the turn. I managed to dive across the bonnet of my car just as Diana pulled into the KP entrance and I fired the camera. For a thousandth of a second the area lit up a brilliant white as the flash fired off. And in that split second that Diana drove past I could see that she was not alone. A man was sitting beside her.

Panting, totally out of breath, I watched Diana's rear lights head up the long drive that leads into KP. My heart hammering, I mouthed a silent prayer to a God I did not believe in. 'Please, please, let that picture be sharp,' I said. As I leant back against my car, completely exhausted, Mark pulled up and jumped out of his car. I grinned at him, too tired to speak, and gave him the thumbs up. Mark collapsed against his car with relief and began laughing. I joined in. I had got the photo that mattered.

We didn't know at that point just how scheming Diana could be when she was keen to avoid adverse publicity. It turned out that she had a few aces up her sleeve to dispel any rumour-mongering that my photo would cause.

The problems began that same week. It was our first lesson in how shrewd Diana could be. The photo was sharp and clearly showed Diana and handsome millionaire art dealer Oliver Hoare pulling into Kensington Palace. This was the first picture of them taken together. I had sold the photo to the *News of the World* and, with publication still four days away, we had to hope that no better pictures of Diana would be taken that week, thus ruining our great scoop. What we didn't know at the time was that Diana herself was

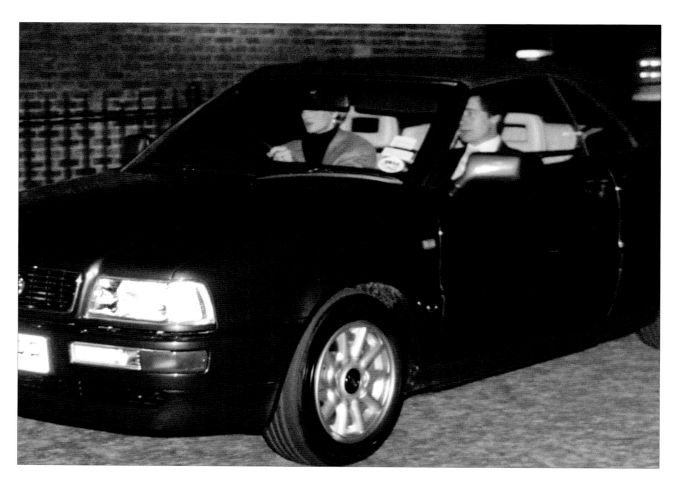

Below: Exclusive! *News of the World* centre spread, 20 March 1994.

determined to destroy our scoop through her own means. She had been alerted to the fact that the picture was due to be published after the *News of the World* routinely rang her press officer to ask for the identity of her male companion. Even though newspapers know they will get no cooperation whatsoever from Buckingham Palace, especially on a story like this, they still have to go through the motions.

On the Wednesday, with publication four days away, I took a call from the *Daily Mail*. The *Mail* was the only paper to enjoy a close relationship with Diana. She often favoured the paper with stories that showed her in a good light, stories she knew would be picked up and repeated by the rest of the papers.

The call I received was from one of the picture editors, who asked if it was true that I had a picture of Diana and a 'male friend' taken on the Monday night. 'Yes,' I replied. He hadn't mentioned Oliver Hoare so I was not going to volunteer the information. I assumed the *Mail* was trying to find the name of Diana's companion for themselves – but I was wrong.

'How many people in the car?' the picture editor asked.

'Just Diana and her friend,' I replied.

'But there were a couple more people in the back of the car, weren't there? Two of Diana's friends?'

'What are you talking about?' I said incredulously.

'We understand there were four people in the car,' he continued.

'Where did you hear that?'

'It's just what we were told,' he said.

My mind was racing. I could clearly see the

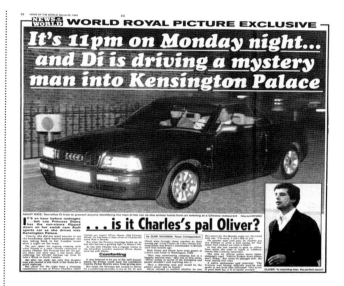

picture in my head. I had looked at it maybe 100 times over the past 48 hours. There was definitely no one else in the car. The *News of the World* had had the picture for two days now, and if there had been anything I had overlooked they would have told me. The royal editor, Clive Goodman, was an educated man and he would hardly have written up a picture story claiming that Diana was having a midnight rendezvous with a married man with two of her mates sitting behind her in the car.

'I can assure you,' I said calmly, 'there is nobody else in the car.'

'You sure you haven't Mac'd the others out?' he asked.

'So that's it,' I thought. To 'Mac out' means to remove people or objects from photos, leaving only what you want in the image. With the advent of digital computer technology in photography, it was a very simple process.

'Once the picture's been published, you're welcome to look at the negatives. No one has been Mac'd out,' I said before putting the phone down.

Below: Oliver Hoare heads for his
private club in Eaton Square,
London.

By a simple process of elimination it was easy to see who had told the *Mail* that there were others in the car. It wasn't me, it certainly wasn't the *News of the World* or Mark, and I very much doubt that Oliver Hoare would have drawn attention to himself by talking to them. Obviously, Diana had learnt from her private secretary that the *News of the World* was going to run the picture and had suggested to her friends in the press that the photo was a fake.

The attempt to discredit the photo failed after the *News of the World* showed not the slightest bit of interest in the *Daily Mail*'s claim that all was not what it seemed in the picture. So, Diana quickly

planned another plot and proved once and for all that she knew exactly how to play the media game. That Saturday lunchtime, as the *News of the World*'s presses began to run with Diana and Oliver Hoare splashed right across the centre pages, Diana's Audi convertible pulled up in Beauchamp Place about 100m from San Lorenzo's. This was unusual, as she would never normally have arrived in such a public way. Her usual entrance to restaurants would have been through the kitchen, or to have been dropped off at the door by a friend.

In fact, Diana had stopped using the restaurant altogether since the paps found out that it was one of her favourites. It was still used by many big-time celebrities and visiting American film stars, so there would always be 10 photographers or so outside, day and night, hoping to get some useful snaps. When Diana stepped from the car the paps launched themselves into a photographic frenzy, especially when they spotted a man getting out of the car with her.

Diana and her companion walked along Beauchamp Place, bathed in a continuous glow of flashes. Neither of them made any attempt to hide their faces as the crowd of snappers walked backwards in front of them, scuffling with each other and taking shot after shot of a happy, smiling Diana and a mystery man. What the paps didn't realise was that the man was William Van Straubenzee, a lifelong friend of Diana's family and a man with whom she had absolutely no romantic involvement. This was Diana at her sly best. When one photographer asked who the man was, she replied: 'He's a friend. I have lots of male friends. I'm often seen out with men friends.'

It was pure tabloid talk. Who else uses a phrase

like that? It was almost as if somebody had advised her on what to say. The whole exercise had been aimed at undermining my picture in the following day's *News of the World*. Now, all the other Sunday papers would have pictures of Diana out on the town with a man, making it appear as if Oliver Hoare was simply another male friend. But this was obviously not the case.

Ultimately, Diana's efforts were fruitless. What she had forgotten – but which was quickly picked up by the press – was that it's one thing to go on a lunch date with a lifelong friend, but it's a totally different matter to be spotted driving a married man into your home at 10:35 p.m. All she had succeeded in doing was to convince us that Oliver Hoare was a man to keep an eye on in the future. At the time, we had no idea quite how large in her life he would loom.

One bad consequence of our late-night encounter with Diana, and the subsequent publication of the picture, was that Mark and I were now marked men as far as she was concerned. She knew our cars and our faces and never lost an opportunity to frustrate us in our attempts to get pictures. As a result, we decided to change tactics. Instead of standing around like fools and letting her have a go at us, we decided simply to run away when faced with one of her outbursts. This little ruse did work, but it also led to some of the most ludicrous sights ever witnessed involving the royal family. After all, who ever heard of photographers running *away* from Diana? At least Mark and I had the comfort of knowing that we were frustrating Diana as much as she was frustrating us. We had realised that Diana was someone who thrived on conflict. By refusing to become involved with her

and just legging it, we often left her standing alone on the pavement, stamping her feet in frustration.

On one occasion, Diana was shopping in the Kings Road when I started snapping pictures from a distance of about 50m. She spotted me and came striding over. As ever, she kept her head down to stop me getting any more pictures – and by the time she got to where I had been standing, she lifted her face up to give me what for and, found that I had already gone! I had simply stepped into a nearby shop and, safely hidden behind a rack of suits, I watched her frantically looking up and down the road for me. The following day, the same thing happened in Fulham Road. This time I was with Mark and we escaped an encounter by jumping on to a bus, leaving a bemused Diana alone at the roadside.

But we didn't have it all our own way. Diana soon wised up to what we were doing and began adopting her own tactics to thwart us. Whenever she saw a snapper she no longer chased after him; she would cover her face with whatever bag she was holding. This went on for about two months and, I have to be honest, it worked well for her. Even though the pictures looked hilarious to us, they didn't sell well. A picture of a woman with a bag in front of her face was hardly what the public wanted. After all, our job was to get pictures of Diana and not her Chanel handbag.

Another trick Diana started to employ was to pull up alongside our parked cars and just stare at us. It never seemed to bother her that she would often become a major traffic hazard when she did this.

Up to this point, all of these skirmishes took place in London. But, as Easter 1994 approached, things went international.

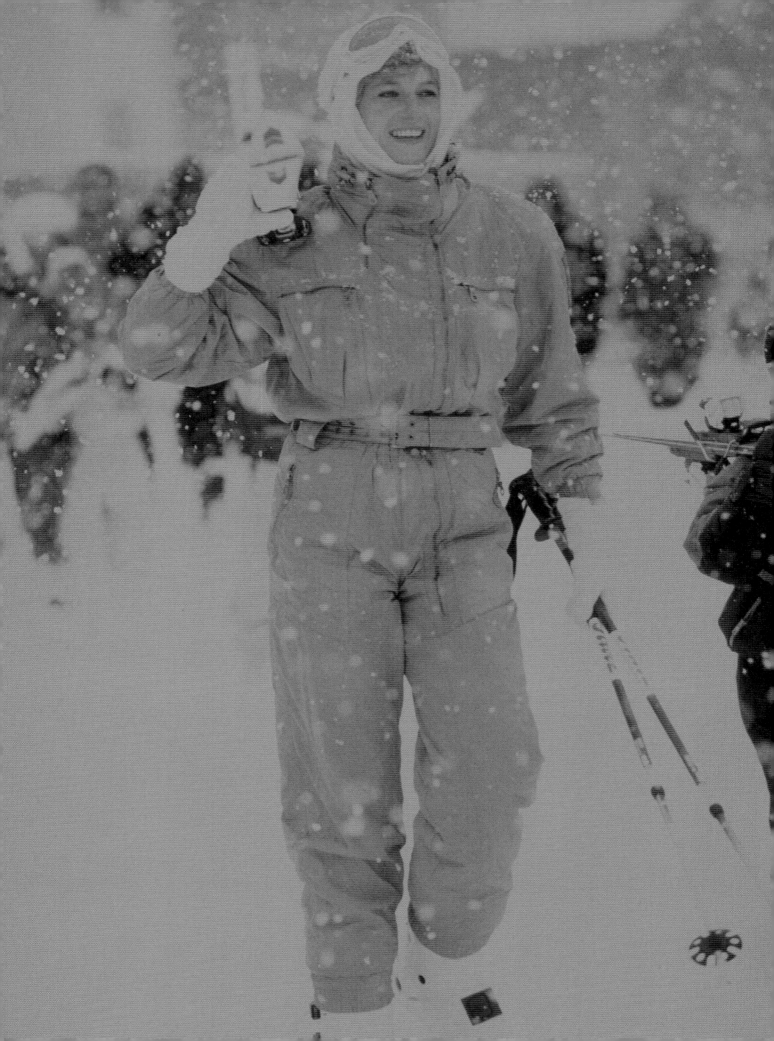

Snow Patrol

Mark, April 1994

Diana's annual trip to the ski resort of Lech was a paparazzi dream, for at no other time of the year was she so exposed to the lenses of the world's press than when she took to the magnificent, wide-open slopes of the Austrian Alps.

In April 1994, Diana flew to Lech for her first holiday since her dramatic plea to be left alone – a plea that was ignored by everyone, including Fleet Street (who cunningly held back from actively pursuing Diana, preferring to let the paps get the photos, so that if there was any trouble they could always say that they were not responsible for the images that the paps took).

Diana took both William and Harry on that trip and, as the international paparazzi gathered at Zurich Airport, it was obvious Diana was going to have no chance of being left alone in Lech that year. She was simply too big a story for the world's press to ignore.

I flew out of London with TV cameraman Mike Lloyd. Mike had been videoing Diana around the world for 10 years and was generally regarded as the best TV cameraman in the business. Also on that flight was LWT producer Mike Brennan, who, armed with a substantial budget, was making a documentary on Diana's life. Both Brennan and Lloyd were to find themselves in remarkable positions with Diana, of which more later.

The rest of Fleet Street, along with the paparazzi, were already at Zurich Airport. The facilities for the press at Zurich are excellent. Whenever a major celebrity comes in, fences are put up just on the edge of the runway and photographers are allowed to take pictures as they step off the plane. As we stood behind the fences waiting for Diana's flight, I couldn't help feeling momentarily sorry for her. When she saw what was waiting for her, she would not be very happy, I thought. Every single British newspaper had photographers and reporters there. Normally, the British press were not a problem as they had long ago deluded themselves that they enjoyed a special relationship with Diana. But there had been little communication between the princess and Fleet Street since she had retired and nobody knew what the situation was now.

Alongside Fleet Street stood the British press agencies, every one of them as ruthless and as good as their European counterparts. For more than 10 years the English had ruled the roost as far as Di pictures were concerned. The precedent had been set by Arthur Edwards, legendary photographer for the *Sun*, and James Whitaker of the *Daily Mirror*, both of whom scooped the world with shots of a heavily pregnant Diana in the Bahamas in 1982. The pictures caused an outrage, many people considering them a grotesque invasion of privacy. But that didn't stop the two men dining out on them for many years, right up until Diana's untimely death, at which point they were conveniently forgotten about.

Diana's holiday group finally arrived from London. As well as her sons, she had brought her two best pals, Catherine Soames and Kate Menzies, plus some school friends of William and Harry. As she stepped off the plane wearing a full-length red overcoat, Diana was grinning broadly. She then made her way to the waiting airport bus, a smile still on her face as she looked at the assembled photographers.

'Good morning,' she said.

'Good morning,' responded half of Fleet Street.

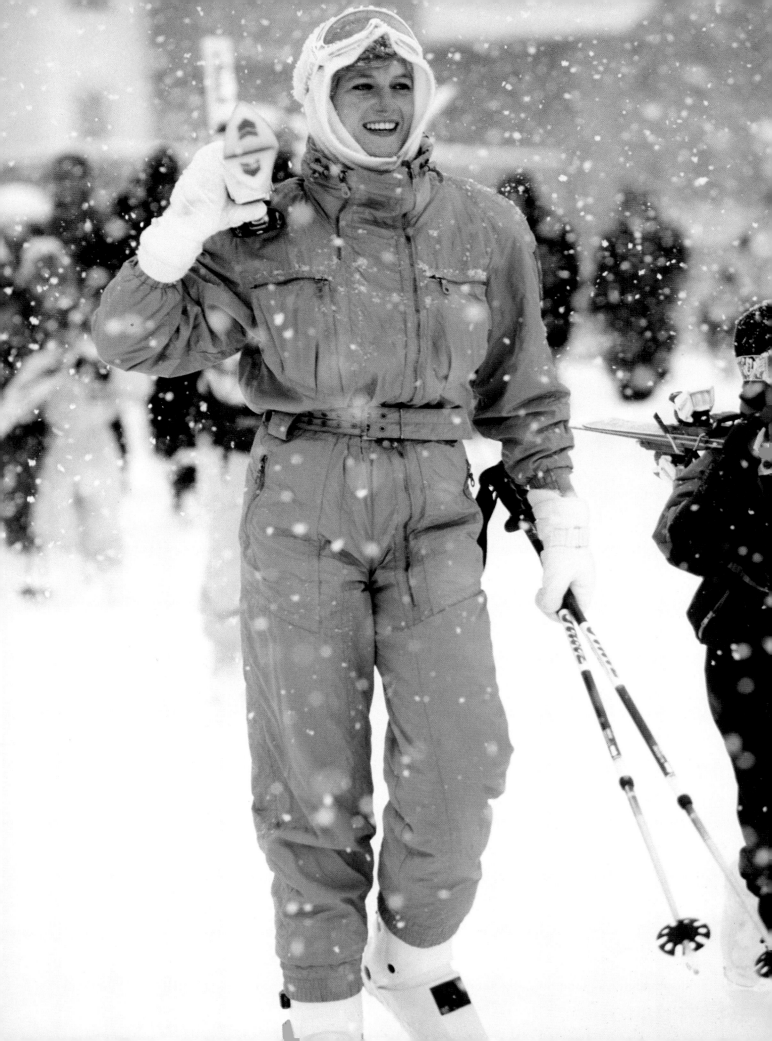

Left: 'Hey, Mum. There's a photographer down there dancing.'

'And who are you waiting for?' she asked, which was probably the funniest thing I ever heard her say.

The following morning she was no longer smiling. As she emerged from her hotel and saw the massed ranks of the world's press waiting for her, Diana groaned. She and her party began to walk the 200m across the crisp white snow to the ski-lift, every step she took was accompanied by the whirring symphony of the Canon chorus. Photographers jostled for position, many falling over into the snow in front of her. The royal detective accompanying the party did his best to keep the press at arm's length, but everyone could see that the situation was totally out of control. Even though Fleet Street had been commendable by allowing Diana and the boys plenty of space, the English agencies and the foreign press were determined to get their share of the rich pickings in front of them.

And who could blame them? After all, nobody had forced Diana to take the children to one of the most open ski resorts in the world and parade herself on the slopes with them. Even the tourists were lined up with instamatic cameras trying to get pictures. Confusion was also caused by Diana herself. Throughout that first photoshoot she remained smiling towards the veteran royal snappers of Fleet Street, yet scowling at the freelancers.

One royal reporter cynically told me the whole episode was part of Diana's ongoing PR battle with the palace. He said: 'She wants everyone to see how much fun the boys have with her. It makes Prince Charles look stuffy and boring when these sorts of pictures are published.'

I wasn't entirely convinced that was true, but he did have a point. Why go to such a public place for a private holiday? And, if Diana genuinely didn't want pictures taken, why was she sitting on a ski-lift and laughing at the snappers' attempts to run up the ski slope backwards with all their equipment?

As the week progressed, the confusion grew. Diana began teasing the press photographers on the slopes. At one point, she skied up to a French photographer and, spotting his 500mm lens, fell back into the snow and said: 'Is that close enough for you?', knowing that his lens was too large to take pictures at that distance. And when she spotted *Daily Mirror* reporter James Whitaker being interviewed by a TV crew, she deliberately walked past, throwing the whole interview into turmoil as the cameraman whirled away from Whitaker, mid-question, to Diana.

One day, with no detective in sight, she decided to visit the shops opposite her hotel. The whole of Lech came to a standstill as hundreds of tourists, and almost as many photographers, stood and watched the princess casually strolling through the shopping mall. Diana's behaviour was erratic, to say the least. On the one hand, she had demanded total privacy for the holiday, yet she was continually giving the press excellent photo ops. One minute she would be happy and smiling, the next ordering her detective to remove photographers from the slopes.

I hadn't been able to get a room in Lech for that trip, so I was staying in the small town of Oberlech, high in the mountains. One evening I arrived back late and was met in the hotel foyer by the manager. He looked concerned and, in his strong German-accented English, said that he was 'having something to tell me of the utmost importance'. I assumed I was about to be thrown out of the hotel. All paparazzi assume that they'll be thrown out of

Below: Alone at last, topping up the
tan for the next photocall. Diana at
the Hotel Arlberg, Lech, Austria.

wherever they are staying at some point. Instead,
he said: 'Tomorrow I am having the Princess of
Wales for dinner, but I am wondering if you would
perhaps not tell your friends in the press.'

I assured him that I would not spoil the world
exclusive he was handing to me on a plate by
telling my friends in the press – and then went to
bed, hardly able to contain my joy.

The following day was beautiful. Diana showed
up for lunch with her ski party. William and Harry
were in jovial mood, the laughter around the table
was infectious. At one point, Diana could be heard
singing 'We're all going on a summer holiday', as
she mimed playing a guitar. Possibly carried away
by her impromptu performance, she then knocked
a glass of water over Prince Harry. It was ironic she
had chosen to sing that song, for, as I walked back

to the ski-lift with fellow snapper Kelvin Bruce,
both of us amazed by the brilliant set of pictures
we had taken, we bumped into Cliff Richard.

'What's Diana up to?' he asked, as everyone
always did.

We had to laugh. 'She's singing your songs,' we said.

One night, following a particularly drunken
session in a local taverna, Mike Lloyd and I were
staggering back to our hotel. Our route took us
round the back of Diana's hotel, the exclusive
Alberg. The royal party was occupying the annexe
on the side of the hotel, a massive self-contained
apartment consisting of three floors and a balcony.
As we walked by, the only sounds to be heard were
our boots scrunching the virgin snow. All of the
lights in Diana's apartment were off and it looked
as if everyone had turned in for the night.
Suddenly, we heard a child's voice calling out to us
from the direction of the hotel. We stopped
walking and looked across. All of the lights were
off but we could make out shapes at the window.
We watched as the curtains were drawn back and
the window was opened wider. Convinced that we
were drunk and seeing things, we watched as
William and Harry grinned down at us from the
now open window. I tried to take a photo, but
every time I raised my camera the kids would dive
for cover beneath the window. This went on for
about five minutes: William and Harry would peer
over the ledge to make sure my camera was down,
then show their faces; as I raised the camera again,
they would dive for cover amid squeals of laughter.

It was simple childish fun for them, and a
playful and unexpected interlude late at night for
Mike and I.

Unfortunately, their mother did not feel the

Below: Diana shows the kids a new greeting for the paps when she encounters them next.

same way. Suddenly, the balcony doors flew open and Diana's familiar voice pierced the silent night air. 'What do you want?' she shouted, oblivious to the fact the rest of the world was asleep. She was standing just inside the door in front of the darkened balcony. We could make out her shape but could not see her face. William and Harry had already done the sensible thing and gone to bed.

The distance between ourselves and Diana was about 50m. In order to reply we would have had to shout, which we didn't want to do at such a late hour. It was past midnight and we thought it best not to get into an argument.

On getting no response from us, Diana launched into a diatribe about the woes of being the Princess of Wales. Standing there, on a snow-covered balcony in the middle of the night – it was pure Shakespeare.

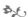

The day after Diana's midnight soliloquy on the balcony, Prince William walked across to a group of Fleet Street photographers that included Mike

The young princes in Austria with their father.

Below: Wills takes a tumble.

Right, above: Rare scenes - Prince Charles deals with Prince Harry.

Right, below: Prince William gets the boot from his playful father.

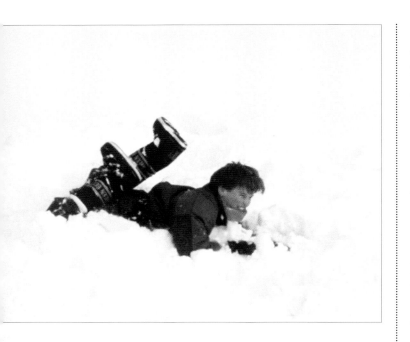

and I, and asked: 'Who were the men outside my mummy's balcony last night?'

We pointed to two snappers from a rival agency. 'Those two,' we said.

We were always cowards.

Later that day, we were drinking in a bar. For the royal paparazzi, drinking in the middle of the day was never a problem. Nor was drinking in the morning or late at night. By the middle of the afternoon we found ourselves staggering down the road that ran around the back of Diana's hotel. Mike was carrying his video camera and decided to start filming her empty balcony. Buoyed up by booze, I began to act out a Monty Python-style routine for the camera. Pointing towards the balcony, I said: 'This is Mark Saunders for *News at Ten*, standing just yards from the very room Princess Diana sleeps in.'

As we giggled like children, Mike took on the role of television anchorman: 'Mark, can you tell our viewers what the princess is doing right now?'

Before I had the chance to answer, we found out exactly what the princess was doing right now. Just like the night before, the balcony doors flew open and we watched in amazement as Diana screamed : 'GET LOST!'

We ran. I told you we were cowards.

It all seems so pointless now, but for some time Diana employed double standards when dealing with the press. She claimed that she wanted nothing to do with us, yet she ensured that information was always passed on to favoured journos – and it was always information that portrayed Diana in a good light.

A case in point happened in the small town of Zurs, when Diana shared a ski-lift with Richard Kay, the royal reporter for the *Daily Mail*. As the ski-lift rose, the pair were talking animatedly and laughing like old friends. The rest of Fleet Street watched with frustrated envy, especially those reporters who had made their name claiming to be close friends of Diana. As for us, the so-called royal paparazzi, we watched the scene incredulously. Richard Kay was in the country for exactly the same reason as us: he had staked out Diana's hotel, followed her on the slopes, ordered his snapper to hose her down in the street and followed her shopping – yet here he was with Diana, giggling like a couple of schoolchildren.

Mike Lloyd and I quickly made our way about halfway up the mountain, where a small coffee house was conveniently placed. Though we had missed Diana going up, we were hoping William and Harry would follow. Half an hour later, and with no sign of the kids, we knew we'd missed them. Maybe they had gone to one of the other slopes; maybe they weren't skiing that day.

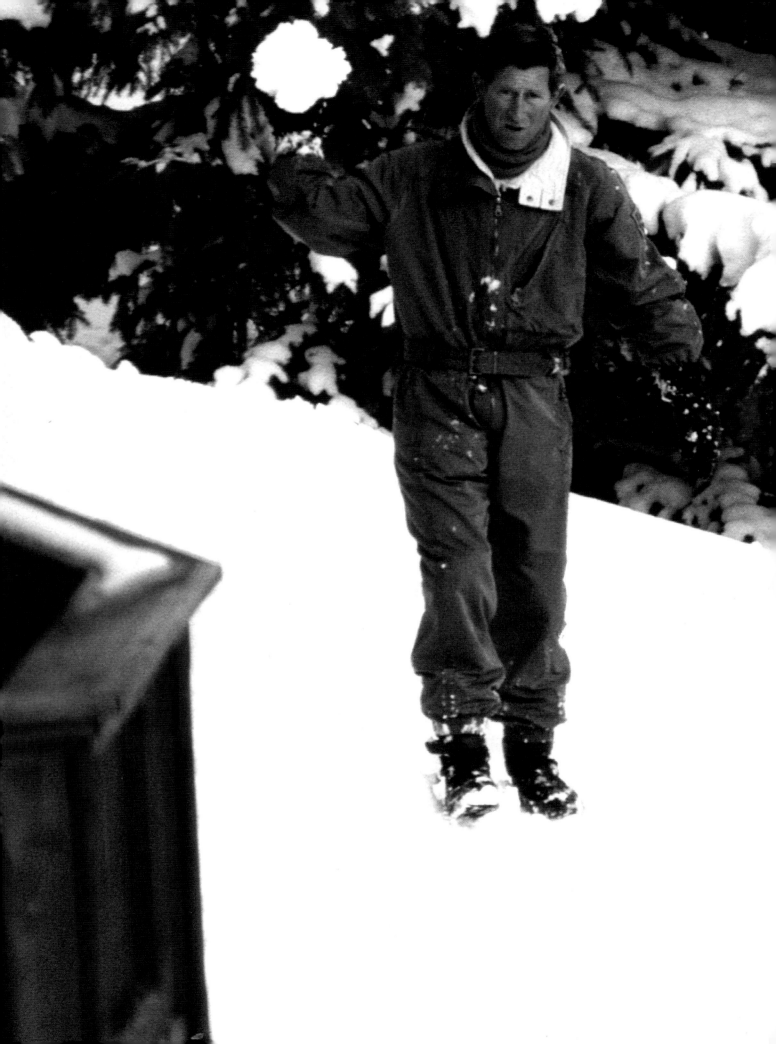

We looked down, watching the French photographers, all of whom were perfectly at ease on the slope, skiing backwards with as much skill as Olympic competitors. Mike and I decided to head down, spotting a walkway that led down to the town. Unfortunately for us, crossing a mountain full of skiers is not easy. Every time we tried to cross, a group of skiers would whizz by, narrowly missing us. Crossing the M25 in the rush hour is probably easier than walking across a mountain packed with skiers.

Eventually, we managed to get across, after risking life and limb and taking an earful of abuse in about 10 different languages. It had been a comical experience, with more than a few tumbles in the snow along the way. Once we'd reached the 'safe' side of the mountain we decided to sit down for a well-earned rest.

As we did so, a lone skier glided towards us and suddenly we were confronted by a very familiar figure. It was Diana. Wearing a blue ski-jacket and boots that always seemed to be too big for her, she asked: 'What are you doing?'

We didn't answer. We didn't know what we were doing. We weren't *doing* anything.

'Can you go away please?' she said.

'We only want some pictures,' Mike said.

'But I don't want you taking pictures,' Diana replied.

Except by the *Daily Mail*, we both thought bitterly.

Having skied down the mountain to catch us, Diana was clearly out of breath. She leant forward on her skis.

'If you didn't go looking for us, you wouldn't know we were here,' I said, somewhat foolishly.

Looking at Diana, her face flushed with the exhilaration of skiing, I knew I'd had enough of Lech that year. It had been the first holiday since she had retired from public life, a chance for Fleet Street to see what the lie of the land was concerning private pictures and how and when they should be taken. I had already heard the murmurs of discontent among the senior reporters. No one wanted these arguments and confrontations with Diana, but everybody wanted pictures. Now, with no one there to lay down the law, the whole thing was becoming a farce.

'We're going home tonight,' I said. 'We don't want to cause you any problems, honest.'

Diana looked at Mike.

'Honestly,' he told her. 'We're going home.'

She looked down at the snow and replied: 'Thank you for that.'

We were about to trudge off in the snow when it occurred to me that every meeting with Diana didn't have to end in an argument. 'Are you having a good time?' I asked, turning back to her.

'Yes, yes we are. Thank you,' she said.

I should have left it there, but I had to push my luck: 'Can we have a picture now?'

Diana glared at me. 'No,' she said emphatically.

We watched her ski off. She hadn't asked Richard Kay to leave. Far from it; they shared a ski-lift. We made our way down the hill. Ironically, the first person we bumped into at the bottom was Mr Kay himself. He had been watching our encounter with Diana through binoculars. 'Well, that was a hell of a bollocking,' he laughed, referring to our conversation with Diana.

'F*** off, Richard,' said Mike.

Richard Kay skied away. He was a man who was to feature in our lives quite dramatically later on.

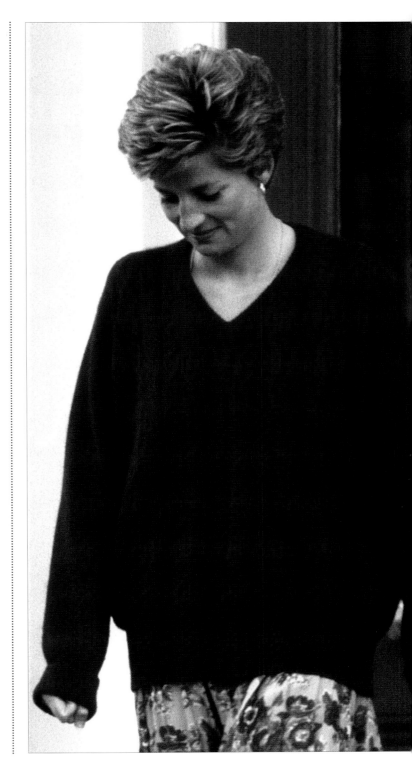

There was only one moment in my career when I saw the Diana the world loved so much – and, I have to admit, I could see why.

It was a routine Friday evening. We had arrived back from Lech a week earlier. Diana had left KP in her green Audi and was heading towards Knightsbridge. Glenn and I were having a cup of coffee in Kensington High Street when we heard she was on the move. We raced from the café, as usual screaming out to the waiter that we would be back to settle up later. He knew we would; you could not have survived in that job without regular caffeine fixes.

I found Diana's car quickly. It was parked by a meter in Lennox Gardens, the street close to both Harrods and Beauchamp Place. Although it was past 6:00 p.m., the shop was still open. It seemed a bit late in the day for a visit to the clinic, and too early for evening dinner, so I figured Harrods was the best place to start looking.

I parked my car behind Diana's. Glancing at the meter, I noticed that she had only put enough coins in for 30 minutes. This puzzled me. Diana and her gold American Express card were hardly going to spend just half an hour in Harrods.

The golden rule of being a press photographer is to never go anywhere without a camera. You never know what is going to happen, and if you don't have your cameras with you something invariably will. So, naturally, I went walking off down the street without my cameras. My intention was to walk to Beauchamp Place to see if there was any sign of Diana. If she came out of the clinic I reasoned I would have plenty of time to get back to my car and grab the cameras, which were sitting on the front seat.

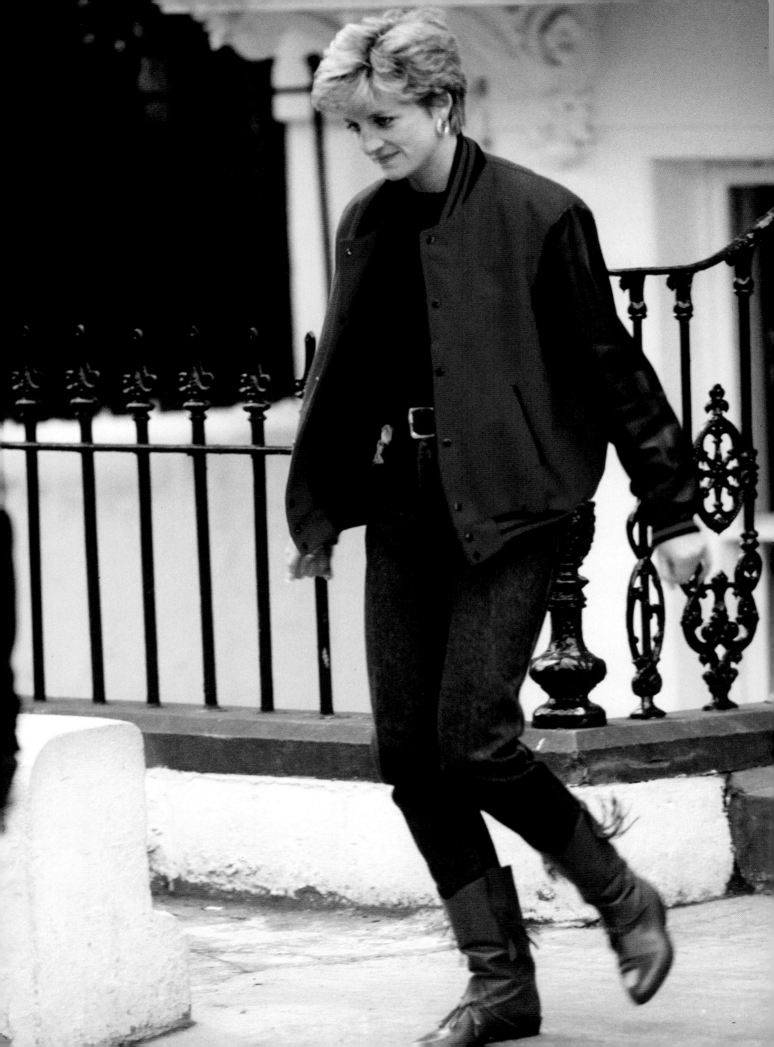

Left: The USA was becoming more important to Diana.

Big mistake!

I walked to the end of Beauchamp Place, about 20m away, and immediately saw Diana on the other side of the road. She passed me and strode towards her car. She hadn't seen me but she was a good 10m in front of me and was easily going to get to her car before I got to mine. I quickened my pace, all the time surreptitiously keeping an eye on Diana. She heard my footsteps behind her and glanced back. 'Damn!' I thought, as she looked at me over her shoulder. But Diana seemed not to have seen me. If she had, she would have said something. But she did quicken her pace. We were nearly at the cars by this time and Diana constantly kept looking back at me. I couldn't understand why she had not said anything to me but then, as I saw her face again, I saw the scene though her eyes.

This wasn't Diana being pursued by a paparazzo – this was a lone, defenceless woman in a dark London street being followed by a man in black. Although I had never instigated a conversation with her before, I felt I had to now, at least to let her know there was no danger. I stopped walking. 'Your Royal Highness,' I said, using the invalid and pointless title.

Diana turned and looked at me. 'Oh! It's you,' she exclaimed. I could see the relief in her face. Unfortunately for her, Diana's comforting realisation that I was no threat forced her into a conversation I'm sure she didn't want. She crossed the road. 'I wondered who it was,' she laughed. She was dressed casually in a blue sweater and yellow jeans. Her hair, as always, was immaculate. Though she was wearing little make-up, she was still stunningly beautiful.

People have often asked what Diana was like in real life. I've never really been able to answer that question and I don't feel qualified to, but that night, face-to-face with Diana and talking about mundane things, I could see at first-hand the elegant beauty a million pictures have never failed to capture. I don't recall a great deal about that conversation – maybe I was far too mesmerised by her beauty. She made some routine enquiries about where I sold my pictures and remarked that most of the Fleet Street editors were being kind about leaving her alone. I didn't bother to point out they were simply allowing us to do that job for them.

I asked whether she had enjoyed Lech and how her children were. It was the sort of inane conversation one has with a neighbour at the newsagents. We both knew it meant nothing; Diana was going through the motions of having a chat because she was just naturally polite.

I have to admit, I was totally captivated by her. She was charming, witty, beautiful and articulate. She also had the most incredible blue eyes I had ever seen; they had a magnetic quality. As Diana spoke, she moved one side of her hip towards me, lowering her head and looking into my face, pulling me in towards her like a praying mantis.

Managing to break free of the spell, I remembered I was a press photographer and asked her if it would be possible to take a picture. Diana looked up, her smile on full-beam, the hip coming closer, those beautiful eyes fixed directly on me. 'A picture of me,' she grinned coyly, 'now? No I don't think so.'

We chatted for another 10 minutes before she announced she had to get back to KP.

'Are you going out tonight?' I asked.

She smiled. 'Would I tell you if I was?'

'See you around,' I said.

'Not if I see you first.' And then she was gone.

I stood on the pavement and watched her drive off.

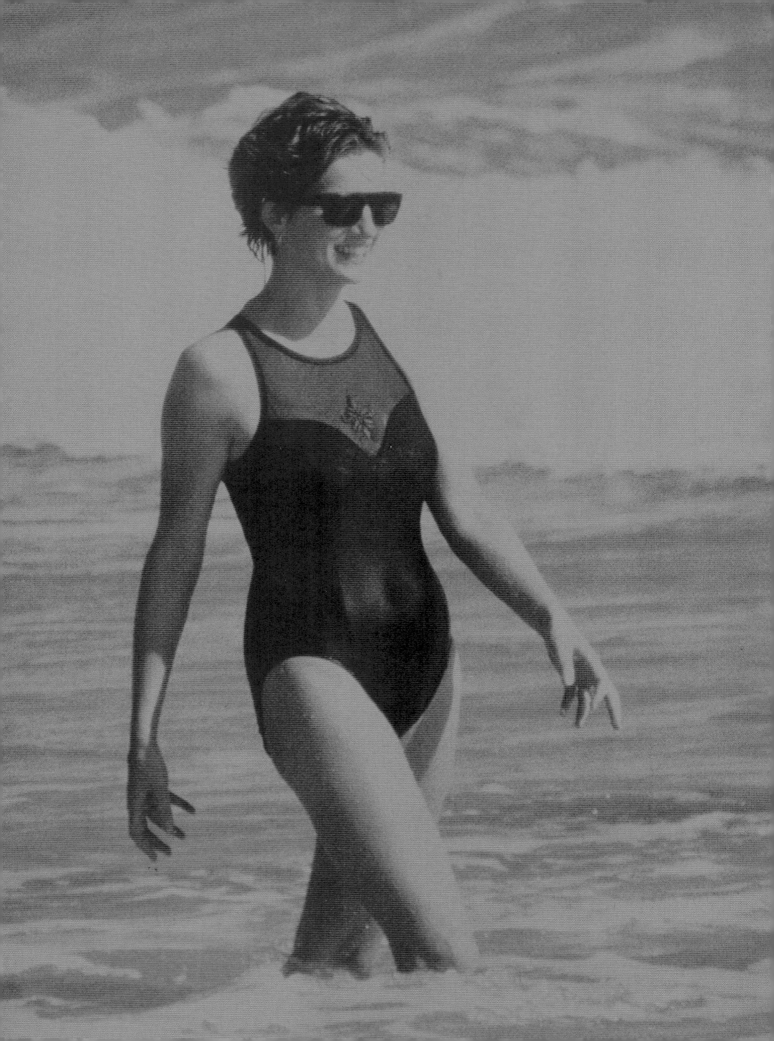

Viva Espana

Below: Luckily for us we were out of range! Gunslinger Harry spots Jim Bennett and Glenn from over a mile away... and then spots a bunny and races off in hot pursuit.

Glenn, April 1994

The highlight of the year at Windsor Castle is Easter. It is the only time when all the members of the royal family are in residence. William and Harry, free from the restraints of their mum, loved nothing better than to whizz around the grounds on their 125cc motorbikes in full view of the assembled press peeping at them through the iron gates. They were often joined by Princess Anne's daughter Zara, a tomboy like her mother. The rest of the royals, led by Prince Charles and the queen, spent the Easter weekend riding and shooting in the massive expanse of Windsor Great Park, whose 56,000 acres made it virtually impossible for us to find and photograph them.

Sometimes, however, we did strike lucky and when we did the pictures we produced were invariably highly controversial. Apart from the Cambridge Gate, the only other position for royal-spotting at Windsor was along the River Thames at Datchet, where the royals could be clearly viewed from the road as they rode their horses along the embankment on the other side.

On Easter Saturday afternoon, I was with top veteran paparazzi Jim Bennett. He specialised in photographing royals at great distances and was a well-respected paparazzo in Fleet Street. Armed with his Nikon 800mm, he could deliver impressive results, usually in remote locations such as Balmoral in Scotland and Sandringham in Norfolk. He usually worked alone, but on that day he had me for company.

We were standing by the Thames, peering at the castle through binoculars. There had been no sign of any royals since early that morning and we were getting slightly worried that we might have missed

them leaving for a hunting or shooting trip. Through the trees below the East Terrace of the castle, we could make out an estate car being driven along the road normally used for taking the royals to the stables for horse riding. Raising our lenses, both Jim and I began to take shots of the car. The distance was about a couple of kilometres, which made it impossible to see who was inside. Suddenly, a figure clambered through the sunroof of the car as it drove along at 50km/h. Through our lenses, we could see that it was a child, but the distance was still too great for a clear identification.

We watched as an object was passed up to the

child, who was now perched dangerously half-inside and half-outside the car. When we heard the first shots, we realised that the object he had received was a rifle and that he was shooting randomly into the bushes and trees around the castle as the car sped onwards. When the car finally disappeared, we raced to get our film developed. It was only then, by blowing up the pictures, that we could clearly identify the child as Prince Harry, perched on top of the car with a loaded rifle in his hand.

Who had allowed an 11-year-old child to clamber through the sunroof of a moving car in order to fire a shotgun into the surrounding bushes?

The following day, every national newspaper in Britain carried the picture on their front pages. The headlines screamed, 'THE MADNESS OF PRINCE HARRY' and 'HARRY'S GAME'.

Whether Prince Charles was responsible for allowing Harry into such an obviously dangerous situation we'll probably never know, but one thing is for sure – Diana would never have permitted it.

Mark, April 1994

The weekend after Easter, we were back at Windsor Castle. We had taken a break from Diana and were now looking for Prince Edward and his new girlfriend – and future wife – Sophie Rhys Jones.

No one really liked Edward jobs. Even if you got a picture, the chances of a show in the papers were very slim. Edward just didn't have any glamour. The only time he ever made the papers was when they routinely questioned his sexuality. With the benefit of hindsight, these barbs seem absurd. We packed up early. The job had been boring and Edward hadn't showed. As usual, we headed to the pub, where we stayed until closing time. Mike had

a large VW van and he decided to kip in the pub car park for the night. I left him with a promise to come back the following morning for breakfast before another day of 'Eddie' watching.

At about 6:00 a.m. the following morning the phone rang. It was my agent calling from Paris. Agents rarely bother with the niceties of 'good morning'. All he said by way of greeting was: 'Did I wake you?'

'It's 6:00 a.m.,' I grumbled. 'Of course you woke me.'

'Good.' He paused before saying, 'Go to Spain.'

'Why?'

'Diana arrived there yesterday.'

'Shit,' I mumbled. 'What part?'

'Costa Del Sol.'

'Where?'

'Where what?'

'Where on the Coast Del Sol?'

'How the hell do I know… Costa Del Sol. It's not that big, you know.'

'Actually it is,' I thought. The Costa Del Sol is about 300km from Malaga to Gibraltar. With no further information, a phrase involving needles and haystacks sprung to mind. I rang BA and all their flights to Malaga that day were fully booked. I tried all the other major airlines and got the same result. I sat on the edge of the bed and wondered whether it was worth going. Diana had probably popped off for a weekend break. If we couldn't get out there until Sunday it would be a waste of time. The opposition would have everything packaged and sold by then.

Just then the phone rang. It was Iberia Airlines. They had a flight to Malaga, via Madrid, later that day. Did I want it? I should have said no. All of the

omens so far had been bad. I didn't know where Diana was and we would have at most 24 hours to find her. You can't say I wasn't warned.

'Yes,' I said, somewhat reluctantly to the Iberian rep. 'Three tickets please.'

Little did I know that we were setting off on a nightmare.

I woke Mike by banging on the side of his van an hour later. Bleary eyed and deeply hungover, he opened the door and mumbled something that may have been 'good morning'. Then he asked: 'Where are we going for breakfast?'

'Madrid,' I replied.

In the 10 years he had been in the business, Mike had travelled the world at short notice, so he wasn't too fazed. 'I'll get my gear,' he said.

Photographer Lionel Cherruault was the third recipient of the tickets I had purchased that morning. We met him at Heathrow Airport with some extremely good news. From a contact in London, Mike had established Diana was staying at the Lew Hoad tennis ranch just outside Benalmádena.

As we boarded the plane we were in buoyant mood. We were finally on our way and we now knew where Diana was staying. If only we could have flown off into the sunset there and then.

Things started to go wrong as soon as we got to Spain. Because of a delay in Madrid we did not reach Benalmádena until way past midnight. Naturally, all the hotels were full and at one point it looked as if we would be sleeping in the hire car. We finally got a single room in what appeared to be Spain's most expensive hotel. This had little to do with the quality of the hotel and a lot to do with the owners knowing we were stranded. They managed to accommodate us by putting three single beds into a room that would have been hard pushed to take one. With Mike on one side and Lionel on the other, I spent a frustrating night listening to their snoring in perfect stereo. I think I managed about 17 minutes' sleep.

We were on the road at 4:00 a.m. the following day. A helpful taxi driver directed us into the hills where the Lew Hoad tennis ranch was situated. We arrived outside the premises just as dawn was breaking across the Mediterranean. Lew Hoad was a former Wimbledon champion who had retired to Spain and built the tennis ranch back in the 1970s. Whether he had ever envisaged royalty staying at his place is not known, but one thing was certain – the establishment we were now looking at was, from a paparazzi point of view, absolutely impregnable. We stared aghast at the high wire fence that prevented entry from any position other than the main gate, and that, naturally, had a security barrier with a uniformed guard.

Even if we could have got into the grounds, every tennis court seemed to be surrounded by its own forest, preventing any unwanted intrusion for the players. And, even though we drove high into the hills, there was not one spot from which we could see the small chalets accommodating the guests. Standing with Lionel and Mike on a hill overlooking the tennis ranch, I felt the chill wind of dead-end failure.

'We might as well go home,' Lionel finally said. 'There's no way we're going to get in there.'

'Why don't we just drive in,' said Mike, 'make out we're staying there?'

'You'd need proof of residency,' said Lionel. 'Look at that place. Everything about it says stay away if you're not a paying guest.'

Below: Diana enjoys some sun
and sea.

I had to admit, Lionel was right. Even with our massive lenses there was not one spot in the surrounding hills from which we could see any of the courts.

Diana had really put one over us this time.

But for once the gods decided to give us a break and Diana, patron saint of the paparazzi, was not going to let us down after all.

In a terrible error of judgement, Diana had decided that the impregnable Lew Hoad tennis ranch was not private enough. So, packing her two best friends, Catherine Soames and Kate Menzies, into the local hairdresser's car, they all moved up the coast to the magnificent Byblos Hotel in nearby Fuengirola.

The Byblos Hotel was situated in the middle of a massive golf course and had no protection whatsoever. There were no fences, no security, no cameras – it was a paparazzi dream. To make matters worse for Diana, the local paps, alerted by contacts near the hotel, were already on the scene. Spanish photographers are rarely discreet, but this was one time they didn't have to be. Anyone with a camera could just walk into the complex and snap away. Within a couple of hours of arriving, Diana had given up any attempt to stop them. Every time she tried they simply shrugged and carried on shooting.

We had learnt about the Byblos after ringing London. When we finally arrived, some two days

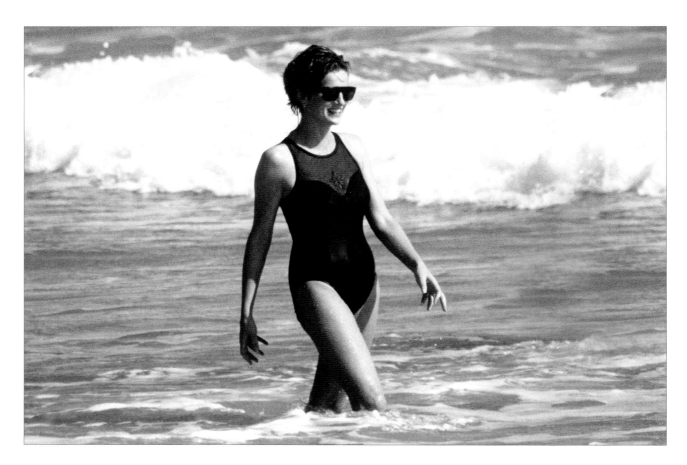

after the opposition, none of us could believe Diana had chosen the place. Mike summed it up. Peering at Diana lounging by the pool through his binoculars, he said: 'She must want to be photographed – there's no other explanation.'

Lionel took the glasses from him and watched as two Spanish photographers walked up to Diana and snapped her lying on the sun-bed. 'I never thought I'd say it, but I think you're right,' he said.

Unfortunately for us, disaster was about to arrive in the shape of a large white van that had just pulled into the hotel. It disgorged a bunch of gorillas that made up the Marbella security services. The hotel management, sick of complaints from other guests, had finally got its act together and called in help.

By now, Diana was also trying to stop the snappers. After all the photographers had been cleared from the hotel grounds, Diana ordered the management to clear them from the golf course as well. Unhappily for her, the golf course did not belong to the hotel, so this was impossible. Holidaymakers teeing off at the 18th now had to swing carefully past about 10 Spanish photographers who had set up camp there.

The farce continued for the rest of the day. Diana would sunbathe for about three minutes, look up, spot a photographer and then order the hotel waiters to move her sun-bed further back. This meant that by noon, when the sun was at its zenith, she couldn't be moved back any further as she was now sun-bathing on the concrete pavement outside the kitchens.

Disaster struck for Diana on the Sunday afternoon, when one of the Spanish photographers allegedly got a picture of her topless. The word spread through the assembled paps like wildfire and there was suddenly a full-frontal attack from the golf course. Wave after wave of Spanish photographers attempted to clear the small wall between the hotel and the golf course. The Marbella security service valiantly held them off but they were heavily outnumbered. As one snapper was thrown off the wall, another would take his place. The scene resembled the final moments of the classic film *Zulu* as the security force pulled back and closed ranks around the pool. Suddenly, they charged forward and the Spanish snappers, who just moments earlier thought a full-scale retreat was being conducted by the guards, now turned and fled, clambering back over the wall as fast as their little legs would carry them.

Once the guards had recaptured the wall, a sort of Mexican stand-off took place. The photographers, who had by now regrouped at the 18th hole, earnestly discussed tactics with one eye kept carefully on the security guards.

But security had its own problems. The charge of the Byblos wall had resulted in a number of complaints from the hotel guests. Two OAPs had nearly been trampled underfoot and were demanding the management do something. All around the area overturned sun-beds and tables littered the immaculate poolside lawns. Southern Spain had seen nothing like it since the arrival of British soccer fans for the 1982 World Cup.

It was during the chaos by the wall that I had taken the chance to slip into the hotel grounds. From there, I watched the entire scene from the hotel foyer. It was then that I discovered why certain members of the hotel staff were so keen to stop the snappers getting in. Sitting around the bar

Below, left to right: The famous lift incident at Malaga Airport featuring Mark and Diana was captured on film and shown on world television.

next to the foyer was the cream of Europe's paparazzi, the elite, who regularly pulled in £50,000 pictures along the Mediterranean coast. Rather than wasting their time climbing walls and hiding in bushes, these guys simply had the right people on their payroll. Certain members of staff at the hotel were more than happy to accommodate their new-found pals in the paparazzi, especially as they received roughly £1,000 a man to do it. If the hotel management had found out what had been going on, obviously the staff in question would have been shown the door.

It did not take long for the resident paps to spot me. Before they could raise the alarm that an intruder had entered their lucrative photographic area, I stepped outside quickly and headed towards the pool area. Diana was sitting on the side of the pool next to Menzies and Soames, her long legs dangling in the water. As I walked towards her, she turned and looked directly at me. I remember thinking how utterly beautiful she looked a split

second before something clubbed me on the back of the head and the concrete next to the pool suddenly rushed up to meet me as my legs gave way. As I fell to the floor, I was aware of harsh Spanish voices and arms grabbing me and pulling me back up. Something hit me on the head again and I fell forward. Somebody grabbed my arm and bent it up behind my back. I remember shouting and lashing out with my free hand, a big mistake as I connected perfectly with the jaw of whoever it was that was holding my arm behind me. By now, I was acutely aware of two things: (1) I was being attacked by at least seven gorillas; and (2) I was in deep trouble.

The guard whom I had hit released his grip on my arm and I fell to the floor. The beating continued, however, and this time they stuck the boot in as I rolled on the ground, trying to cover my head. Eventually I was yanked to my feet and dragged off to the hotel foyer. The manager stood by the main door and demanded that the guards throw me out.

But they had other ideas.

One guy, a particularly fat, ugly bastard, dragged me over to a small ante-room next to the reception desk. To my horror, it rapidly turned into a scene from *Midnight Express* as they all launched into me. Finally, after taking the film from my camera, they threw me out, badly bruised and beaten. As I picked myself up, I suddenly remembered that fleeting image I'd had of Diana just 30 minutes before and I couldn't help smiling. If she got nothing else out of that weekend, at least she had the satisfaction of watching me being beaten up.

When the word hit London that topless pictures of Diana might be on the market, Fleet Street went into a frenzy. What had been a routine story of Diana's weekend break suddenly turned into front-page news as picture desks frantically tried to trace whoever had the pictures.

But none of them had any luck.

There are a lot of stories out there about what happened to those pictures and they have become a Fleet Street myth. The only thing that's certain is that they never appeared. Some say they were bought by the Spanish owner of *Hello!* to save Diana any embarrassment; others said the pictures were never taken in the first place. Whatever the truth, it was a miserable end to a miserable break for Diana.

Her weekend over, she was driven to the airport by her new friend, a man known as George the hairdresser. George was many things, but he was not an experienced traveller. He mistakenly delivered Diana to the arrivals area of the airport, from where she was forced to walk the 200m or so to departures, her every step covered by an army of photographers.

Diana tried to prevent pictures being taken by holding a tennis racket up to her face. By now, she had been met by a BA representative who had run across from the departure lounge. The BA official and George started shouting for everyone to clear the way, but the situation was totally out of control. At one point, a little girl gave Diana a posy

of flowers, which she accepted from behind the tennis racket that was still covering her face.

The BA official fought a path through the crowd and opened the lift. His intention was to take Diana up to the BA office on the second floor. Unfortunately for me, I was walking backwards as I took pictures of Diana and suddenly found myself about to enter the lift, with the BA official propping open the door. I turned to face him, intent on jumping into the lift myself, but Diana wasn't having any of it. She grabbed my collar and forcefully pulled me out of the lift. It seemed everyone was pushing me around that weekend.

In an on-the-record quote the following day, Diana described her weekend in Spain as 'bloody awful'.

But there was worse to come for her.

Glenn, April 1994

The following day, every red-top newspaper carried headlines about Diana being snapped topless in Spain. Television chat shows invited royal reporters into the studios to commentate on the photos.

Parliament's ongoing debate about press intrusion and invasion of privacy was also back on the agenda, with the more right-wing MPs, possibly with an eye on their knighthoods, demanding that Diana and the royal family be left alone. The newspapers were also full of so-called close friends of Diana describing her 'anger and frustration' at having her weekend ruined by the photographers. Diana simply wanted to lead a normal life, they said, and they poured scorn on claims that she sought and encouraged all the media attention. Later, Diana would claim that the weekend had been 'like a rape'. The public was largely sympathetic to the princess who, they felt, was trying her best to lead a

private life while dealing with the ever-intrusive media. The idea that Diana was colluding with the press was simply not credible.

It all started in Hans Place. Mark had rung me the night before from Marbella, where he claimed to be recovering from his experiences at the hands of the security guards at the Byblos. Knowing Mark, this meant he was propping up a bar somewhere on the sea-front and regaling the local girls with his 'war' stories. He told me some of the tales about Diana's weekend from hell in Spain and that she was on her way home. I had to guess what Diana's first move would be on her return. Whenever Diana had a problem, her immediate reaction was to run to a clinic for help.

Starting early, I trawled all of her regular haunts. There was quite a collection of addresses to check out, her list of therapists growing by the day. But I got a break. I saw her Audi parked in a side street near Beauchamp Place. There was a chance that Diana could be inside Chrissy Fletcher's clinic around the corner from the car. I thought the best and surest way to get a picture was to wait near the car, as she would surely return at some point. After all, I wasn't certain she was in the clinic at all; she could have been shopping. The best way to photograph anyone, especially Diana, is to do it without being seen – as this story will prove.

I faced my car 20m away from her parked vehicle and opened the tailgate. The gap in the boot gave me enough cover and a great, clear view down the street. From the driver's seat, I could view the scene through the rear-view mirror. I settled down and waited, keeping my eyes fixed on her car and the

street. She could have appeared without warning from any direction and the window of opportunity for a snap was only about five seconds.

After an hour, the boredom was setting in and I thought to myself that maybe she wasn't coming back or that she'd been frightened off by another photographer and had taken a taxi back to KP. Two hours passed, then three. I was ready to cut my losses and leave. The most important virtue of a pap is not taking the pictures, it's being there when the pictures happen. You can be a really bad photographer, but if you're at a situation and get a smudge while the opposition is having lunch you can be a successful paparazzo. Patience and stamina are all-important.

'That's enough,' I thought, my patience and stamina giving out, 'I'm off to get some lunch.' As I opened the car door to close the tailgate, there she was, 3m from my bonnet. I covered my face with my left arm and slid back into my car seat. I sat low down, watching her and doing my best 'Shy Glenn' impression. She passed my car, glancing only briefly at the open tailgate. If she had seen me, the game would have been up. She would have put her head down and covered up with her handbag and that would have been the end of the story. But no, I was in the clear and she continued to stroll in the direction of her car. Elated that I'd not given myself up, and with adrenaline pumping, I picked up the camera and aimed at her. Looking down at my camera, I saw that I had taken five pictures. Best of all, I'd not been seen. 'Not bad,' I thought, and made preparations to drive off. I stopped when I saw that she had not driven off herself.

What was she waiting for?

After 10 minutes waiting and watching, I had my answer. A well-dressed man crossed the street

and approached her car. 'Richard Kay,' I said aloud, totally amazed and bemused.

Two frames: click, click.

With a furtive look around, Kay, the man from the *Daily Mail*, slipped into the front passenger seat of Diana's Audi. I had known Richard from the many overseas royal tours we covered as the infamous rat pack. We had never been great friends but had always exchanged pleasantries.

I watched as they drove off. Slowly, and trying not to attract any attention, I tucked my Golf behind her Audi and we headed north towards Brompton Road. We had not gone very far before she pulled towards the kerb and stopped. I drove past and came to a halt 50m further on. Looking through my binoculars, I could see Diana and Kay deep in conversation. She was gesticulating with her hands, but I was not in a position to take a picture as there was too much glare on the windscreen.

Jumping out of the car with my camera loaded with the 500mm long lens, I hid in a newsagent's shop doorway. Too late! She had pulled away again. I had to let the Audi pass the shop as I buried my face in a copy of *Hello!* magazine. When the car had gone, I set off after it on foot as she drove slowly towards Egerton Terrace. They were travelling quite slowly and I could see that Diana was still gesturing dramatically as she drove. Kay sat motionless, facing Diana. From their body language , I assumed that Diana was leading the conversation.

They stopped once more at the kerbside and I skulked along the street, hoping to find a decent vantage point. Finally, I got a clear view into Diana's windscreen and I went into action. Stepping forwards from my hide, and with the grace of a bulldozer, I fell face-first into a market

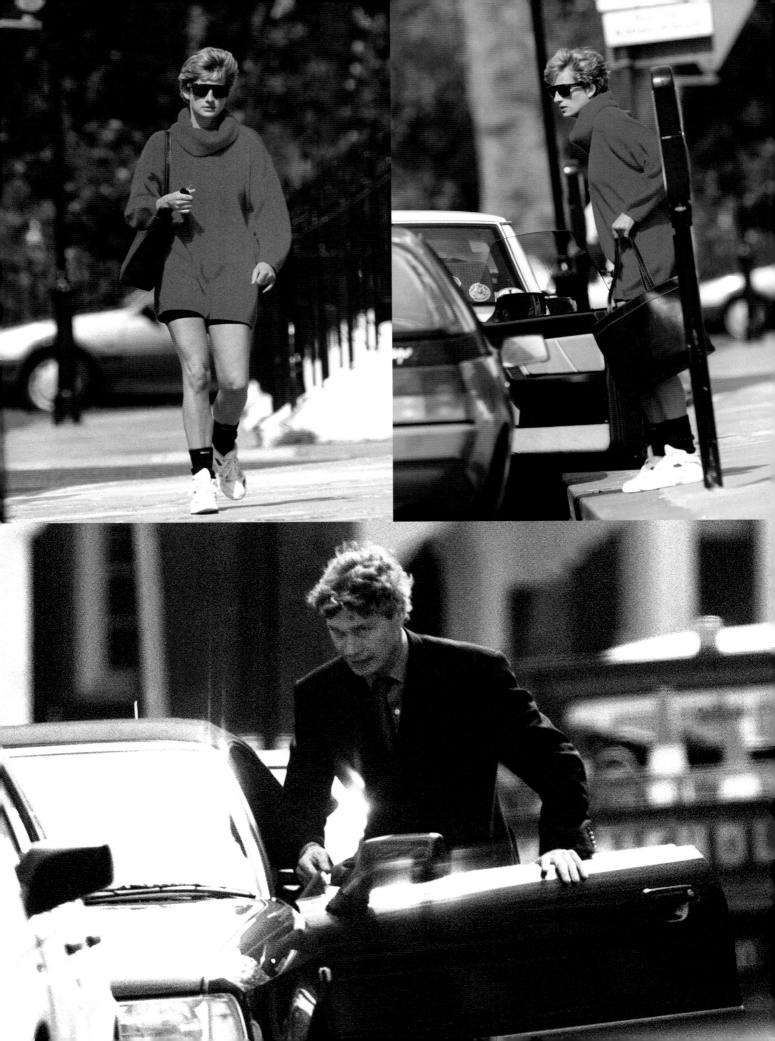

Left: Back in London after her Spanish break, Diana approaches her car and, with a furtive glance, jumps into the Audi parked in a quiet side street. Moments later, the Royal Correspondent with the *Daily Mail*, Richard Kay, climbs into the passenger seat. Diana's secret meeting with Kay came just hours after her complaining of press intrusion into her life.

Below: The splash in the *Sun* on 5 May 1994, made their thoughts on the matter quite clear.

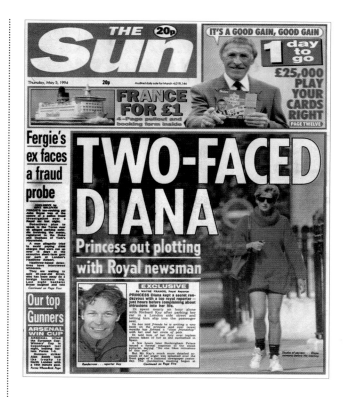

vegetable stall. Cucumbers and squashed tomatoes flying all around me, I rapidly fired off a few shots in the direction of Diana's car.

'Get out! Get out!' the large lady shop-owner screamed at me, tugging at my shirt.

'Just get off me. I'll explain in a minute,' I shouted back.

'No, go now!' She began to shake me violently, so much so that I couldn't take any more pictures even if I had wanted to.

Looking at her muscles I saw that there was no way I was going to win this one. I retreated from the stall just in time to see the back of the Audi driving off into the distance. The second she had spotted me in the midst of my debacle Diana and her companion had raced away.

Diana's double standards were perfectly summed up in a banner headline on the front page of the *Sun* the following day. Under the words 'TWO-FACED DIANA', they ran the pictures that proved, despite all her complaining about press intrusion, she was having secret meetings with the press herself.

The headline was equally humiliating for the *Daily Mail*, whose own front page the previous day had boasted an exclusive by Richard Kay describing Diana's 'bloody awful weekend' in Spain. In the story, Kay had widely quoted a 'close friend' of Diana as the source of the story. Looking at the *Sun*'s front page, the world could finally see who the 'close friend' was – none other than Diana herself. The controversy deepened when Kay ran a story in which he claimed he had simply gone to Beauchamp Place to question the Princess of Wales about the Spanish incident. He claimed she then offered to give him a lift back to the *Daily Mail* offices and that that was all there was to it.

If all Diana was doing was giving him a lift back to the office, why the detour through Brompton Road and the constant stopping at the kerbside? And why did a five-minute journey take over an hour? Diana's efforts to distance herself from any controversy and remain whiter than white had added extra humour to this particular story.

A few weeks later it was reported, again via 'close friends', that Diana suspected she was the victim of an elaborate plot to discredit her by her ex-husband's clique of establishment loyalists. It was claimed that the recent incident with Kay showed that traps were being laid and her every move was being watched. I assured the Princess of Wales that I was not one of Charles's 'establishment loyalists' and that it was only her own poor judgement that had resulted in the pictures being taken and published.

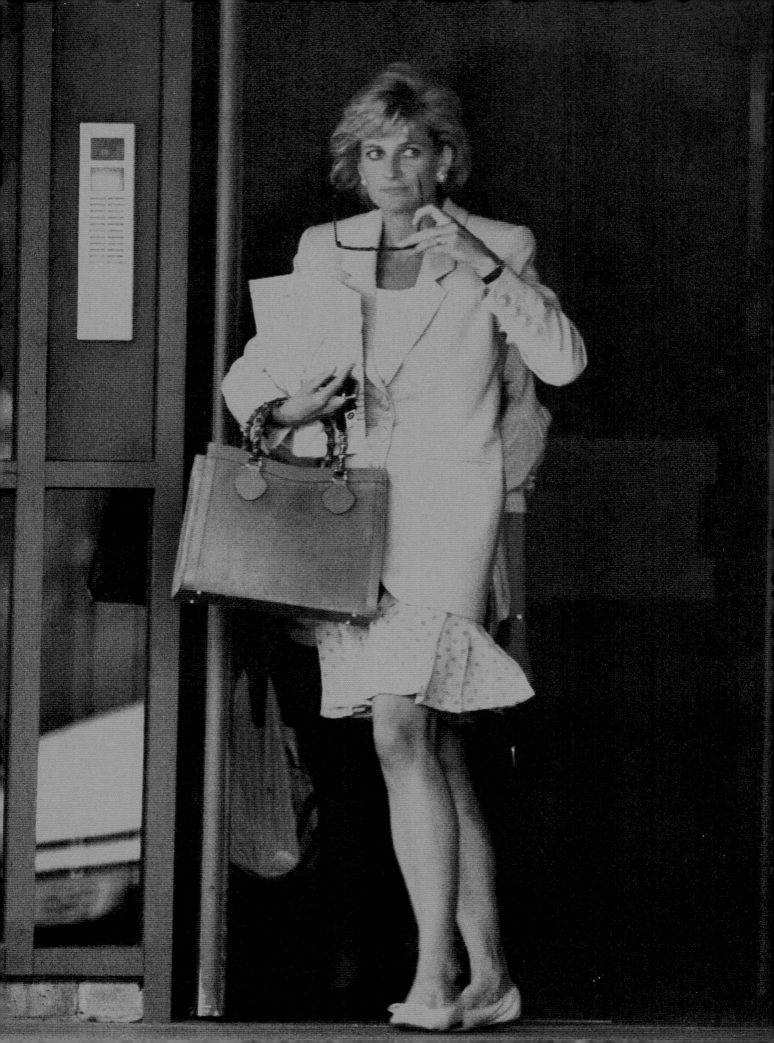

Diana's Game

Glenn, April 1994

One of the biggest problems we faced when searching for Diana was that we tended to forget just how famous she was. Everyone in the world, from presidents to road sweepers, wanted to meet her and then boast of the experience. As soon as people knew what I did for a living, they would always ask: 'What is she really like?' and 'Is she as beautiful as she looks in the pictures?'

It had been impossible for me to discover what she was truly like. But, as for her beauty, she was undeniably one of the most desirable women in the world. And that's one of the reasons why she was the most talked-about and photographed woman on the planet. She was the one person everyone wanted to see – a fact that very nearly got me arrested.

Diana had arrived outside the Euston office of one of her many clinics. I had watched as she rang the intercom and then pushed the door open with her foot and disappeared inside. I waited in prime position for an exit picture, hopefully within the hour. Mark was parked further up the street, covering the rear exit.

Suddenly, a police patrol car pulled up behind me. Looking in the rear-view mirror, I watched as two police officers got out and approached my car. I wound the window down as the WPC crouched

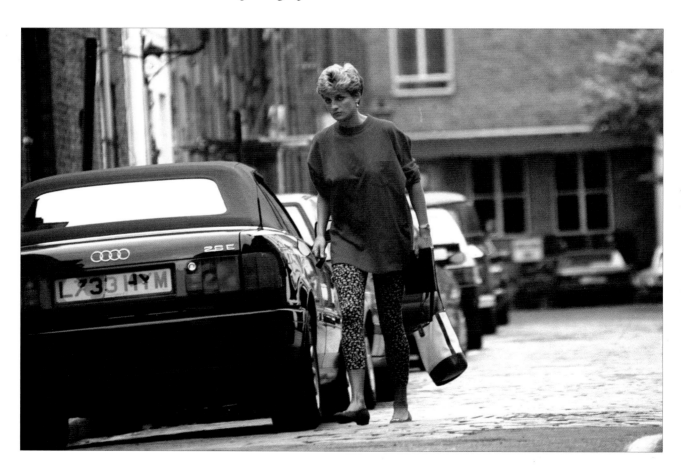

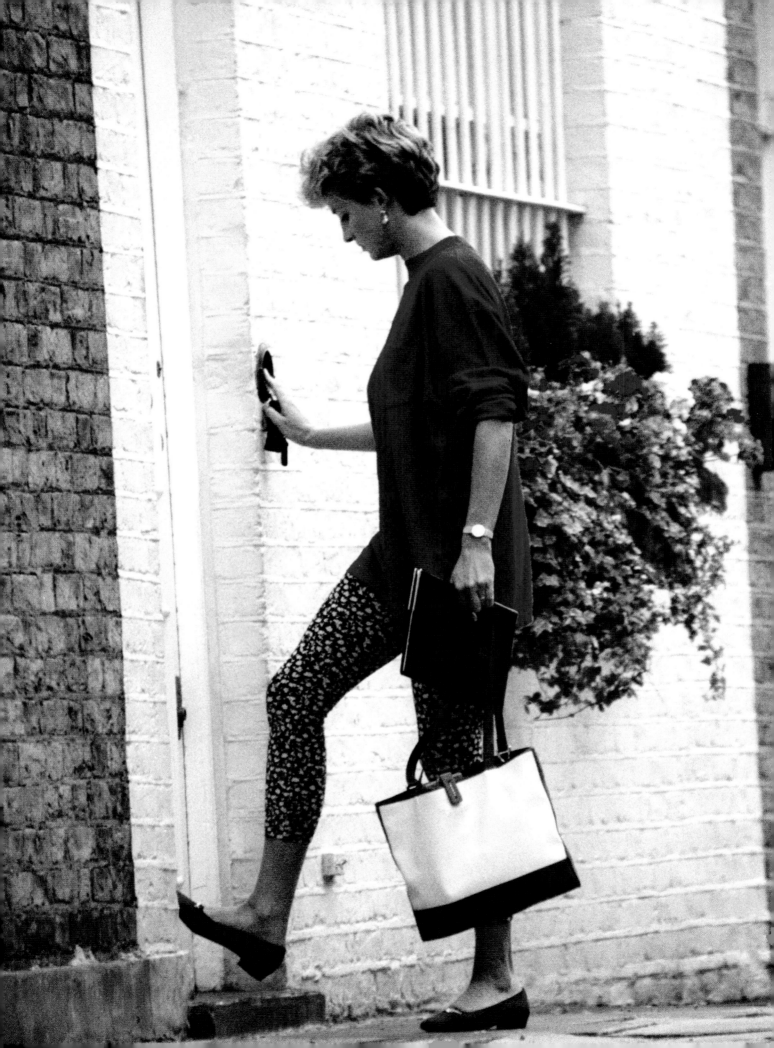

by my car, her companion standing next to her. 'Good morning, sir,' she asked. 'Can I just ask what you're doing here?'

Although getting stopped by the cops was an occupational hazard, it was always a tricky situation when they asked what you are doing. You couldn't exactly say, 'I'm waiting for the Princess of Wales,' even though there was no law against it. Every copper in London loved Diana as much as the public did; they loved to ruin your day by moving you on and away from her.

Long before, Mark and I had devised a plan: if one of us saw the other having trouble with the police, he would call him up on his mobile. That way, you could tell the police that you were waiting for a call and, hey presto, there it was. Unfortunately, on this occasion Mark's head was buried deep in the *Daily Star* and he didn't see what was going on.

'I'm waiting for a call, officer,' I replied, picking up my mobile. The cop looked into the car. My cameras were hidden in a holdall on the front seat but she noticed the ladder on the rear seat. All press photographers carry a ladder; you never know when you will need one.

She pointed to the ladder. 'Are you a window cleaner?' she asked.

Rule one: never, ever lie to the police.

'Yes,' I replied.

'Have you any means of identification, sir?' she persisted.

Rule two: never, ever keep your press card in your wallet.

'Yes,' I replied, handing over my wallet with my press card prominently displayed inside. Amazingly, she didn't see it. Extracting my driving licence, she

switched on the radio in her lapel and said those immortal words that always spell trouble: 'Can I have a person and vehicle check, please?'

Her colleague came from the rear of my car, having taken down my number plate. Both cops turned away as she read my details into the radio. A few moments later there was a burst of static and then I heard a man's voice sounding the all-clear. For a moment I thought they would go, but the woman wasn't giving up that easily.

'The reason we checked you, sir, is that there have been a number of burglaries in this area recently and we're keeping an eye out for anything unusual.'

My heart sank as she informed me that they intended to search my car and asked if I would mind stepping from the vehicle. I got out, trying to keep my now very recognisable – to Diana, anyway – face away from the clinic windows. Glancing up the road, I noticed that Mark had scarpered. Thanks a lot, mate!

'Would you mind opening the boot, sir?' said the male officer.

I reluctantly did as he asked. Both cops were standing on either side of me as the door to my hatchback flew upwards to reveal about £20,000-worth of photographic equipment strewn across the boot floor.

'I thought you said you were a window cleaner?' said the WPC, ducking her head in for a closer look.

'Sometimes I take photos,' I replied. She turned towards me. 'Right. Shall we start again? What are you doing here?'

I decided at this point that honesty was probably the only policy. 'I'm waiting for the Princess of Wales,' I told her.

The female cop was just like everybody else. At

the mention of Diana's name, her face lit up. 'Princess Diana? Where is she?'

'In that building over there.'

'Where's the rest of the press then?' she said, looking around.

'It's not exactly an official visit,' I said.

Her male colleague, who had by now discovered further cameras on the front seat, said: 'Are you one of the paparazzi then?'

'No,' I replied, 'I'm a press photographer.'

'You being funny?' he said. 'Because we can continue this discussion down at the station if you like. Can you prove this stuff is yours?'

'Of course it's mine.' I was getting agitated by now. They had blown my cover and Diana was due to emerge from the clinic at any moment.

'OK, prove it.' He was clearly upset at being lied to.

'What, now?' I almost shouted.

'For all we know, you could have just pinched it all. Have you got any press ID?'

I handed him my wallet. His female colleague, who by now I had silently christened Eva Braun, was back on the radio. I could not hear what she was saying but I heard Diana's name. About three minutes later two Sherpa vans came around the corner. They pulled up next to my car and about 14 police officers jumped out. One of them was a sergeant. He glanced into the boot of my car before turning to Eva Braun. 'What's happening, then?' he asked.

'This guy claims to be waiting for the Princess of Wales, sarge,' she said.

He turned to me. 'You a photographer?'

'Yes,' I sighed. By this point any onlookers would have thought a major criminal had been apprehended, judging by the police presence.

It was then that Diana decided to make an appearance. I groaned aloud and put my head in my hands as the 16 cops straightened up to attention. All were grinning at her from ear to ear. Diana couldn't stop smiling as she took in the spectacle of me, camera-less, surrounded by cops. She grinned back at the battalion of cops and seemed to mouth the words 'Nice work, guys', or that's what I'm sure she was thinking anyway. Then, strolling as slowly as I'd ever seen her move, she went to her car. Diana knew full well that I wouldn't be able to get anywhere near my cameras to take a picture.

I was not charged with any offence that day. But I was warned that lying to a police officer could get me arrested next time. The police left soon afterwards with a story to tell their families that night. Everyone wanted to meet Diana, including the cops. If nothing else, that's what I learned from that particular experience. Minutes later, the street was empty – except for Mark's car, which slowly pulled up alongside mine.

I won't tell you what I called him.

Glenn, May 1994

Whatever image Diana tried to create for the benefit of the general public, she was still totally unpredictable to us. As the summer months arrived in 1994, she rose to even greater heights of craziness.

Diana's behaviour around this time became more and more unpredictable. Whether this was due to increased medication to combat depression, as the papers had suggested, I didn't know, but she was still keeping her weekly appointments with a large variety of clinics.

Picture after picture in the press showed a depressed-looking Diana moving in and around

Below: All those sprints in the mothers' race on parents' day at school had not been wasted on Diana.

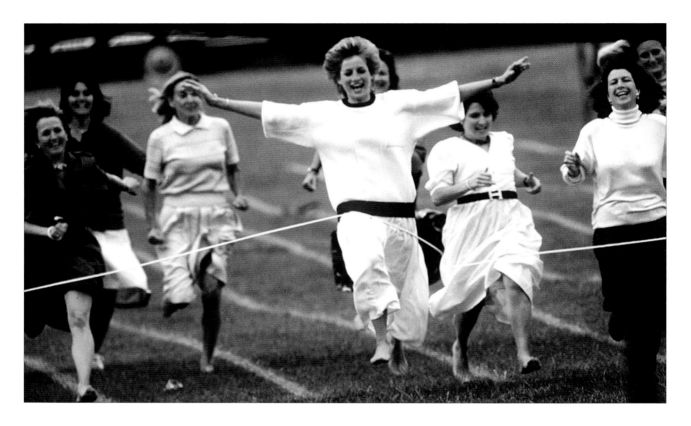

London, very much on her own. Her departure from public life the previous year had granted her a small degree of anonymity, but the general public was still intensely interested in Diana, perhaps more than ever, and it was her unpredictable behaviour which now captured the public imagination.

I was standing on the pavement, talking to a couple of other snappers and waiting for Diana to emerge from the Beauchamp Place clinic. She had been dropped off about 50 minutes earlier by her chauffeur.

Her visits never lasted more than an hour, so I was on full alert for her reappearance. By this time, a small crowd had gathered, eager to catch a glimpse of a celebrity. When people saw cameras

most of them came over and asked who we were waiting for. I always tried to move them on by telling them: 'It's a naughty businessman who has been caught insider trading.' People soon lost interest. The last thing a street photographer needs is to be hemmed in by a large crowd. But this small crowd quickly turned into a fairly big gathering. Families, shoppers and office workers on lunch breaks all stopped to see what we were waiting for.

When the chauffeur returned he had to squeeze through the horde by the front door of the clinic. The traffic had jammed in both directions. Cab drivers were happy to sit and gaze at the free show, with their meters running overtime; couriers and post office vans were not so pleased at the hold-up.

I saw the chauffeur answer a phone call and

respond by driving off up the road and out of sight. Thinking that Diana had probably seen the chaos at the front, I presumed that she had opted to sneak quietly out the back. There was no way I could reach the back door in time to snap her, so I packed up and walked back in the direction of my car. Some you win, some you lose...

A loud crash came from behind me.

'What the bloody...!' I spun round, fearing God knows what.

A woman raced towards me, her face contorted with determination. A man was lying in the gutter. Diana had escaped from her clinic bolt hole and was charging up the street in my direction, her dress flapping around her waist, exposing her thighs almost up to her knickers. There was no time to save her blushes as she flew past me. Shoppers dived for safety as she sprinted for her car at full pelt.

The man in the gutter, a photographer, pulled himself up from the kerbside and joined the chase. There was no way he was going to catch Diana, especially with a handicap of three heavy cameras around his neck. Diana seemed determined to break the 200m sprint record. She was an amazing sight. All those sprints in the mothers' race on parents' day at school had not been wasted on her. Onlookers watched, bemused, as this cartoon-like roadrunner, wearing huge sunglasses and carrying a large handbag, sped past them. On reaching the corner of the street, the flying princess leant over on her high heels at a 45-degree angle in a turn worthy of a World War II Spitfire pilot and disappeared round the corner in a cloud of dust. The following pressmen had been well beaten to the tape. If she was that desperate not to be photographed, I wasn't going to join in.

Diana reached her car ahead of us by a furlong. She opened the passenger door and, glancing back with a sly grin, jumped inside. The cameramen left behind her must have looked a sorry sight. They were struggling for breath, their equipment falling off their shoulders. Diana's vehicle had moved off down the road.

It's not easy to run with heavy camera equipment. You have to do it without bouncing up and down – like a cartoon character with revolving legs but with a body that stays on the same plane. Like Scooby Doo. You look a bit of an idiot, but it does save you a hefty camera repair bill afterwards.

Surely, on reflection, it would have been easier and more dignified to have emerged from the clinic front door, acknowledge the crowd and walk the two metres across the pavement to her waiting car. The resulting pictures would have been boring and worthless to most newspapers. But, instead, her outrageous sprint afforded us sensational and unique photos of a princess clearly at odds with the public interest in her activities, but unable to react to this interest with anything other than panic.

On the other hand, it is possible that, after losing the public relations war over the Richard Kay and *Daily Mail* sensation, Diana had wanted these pictures taken and had staged the whole affair. What a wonderful way to demonstrate that she was having her life ruined by the ever-watchful media! Her latest antics kept her on the front pages, but showed her in a new light that the public had rarely seen before. Images of a 'frightened' woman alone on the street, sometimes at night, being chased by a pack of dirty, hungry men with cameras played straight into the hands of public sympathy. The PCC was watching and waiting to

Below: 'Good morning, Glenn.'
Diana gets to the point at the
Chelsea Harbour Club.

sell a photo to a newspaper without the princess wearing anything but a big smile on her face!

Glenn, June 1994

Diana's exploits continued to cause confusion among the paparazzi. A perfect example of her erratic behaviour occurred at Chelsea Harbour Club.

Diana was playing tennis with her close friend Kate Menzies. After the game, both women left the club by the rear exit. Diana wore large sunglasses. On spotting Mark and I sitting on the wall taking pictures, she shouted loudly at us to get lost. She ran over to her car and drove off.

The following day, she played tennis with Menzies again at the same club. As the pair came out of the rear exit, she spotted Mark and I again, sitting in the same position on the wall. This time, however, there was no shouting. Diana spotted us then stood in the middle of the car park laughing and joking with Menzies and then beamed a large smile over to us. She then casually strolled across to her car, still laughing, and drove off.

It soon became apparent to us paparazzi that if a nice photograph of Camilla, her love rival, was splashed across the national newspapers that morning then we would be guaranteed an impromptu photocall from Diana that same day. Without fail, Diana took the opportunity to wipe Camilla's visage off the front of the tabloids with her own smiley face the following day. And why not? We certainly weren't complaining.

Mark, June 1994

In many respects, the paparazzi were caught in the middle of Diana's PR exercise to undermine Camilla. We were torn between not wanting to

pounce at any moment – waiting for a picture that tipped the scales and went too far.

This brilliantly contrived PR exercise worked in her favour for a couple of weeks, until the newspaper editors got wise to her new antics. They soon realised that, by publishing these kinds of photographs of a hounded princess, they were actually shooting themselves in the foot. The following months were to change dramatically for the paparazzi. It soon became impossible for us to

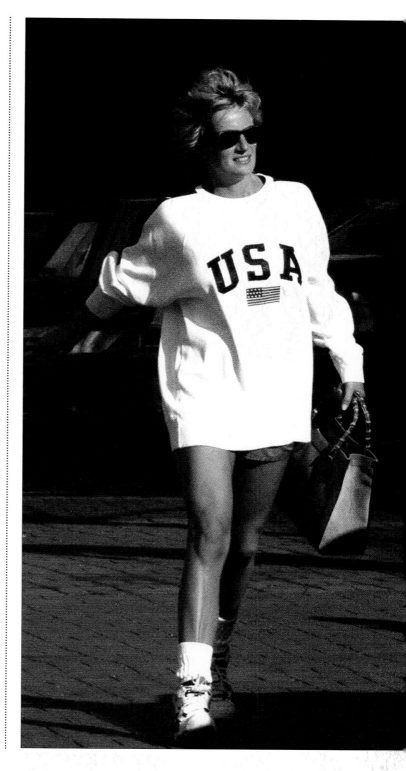

upset Diana, yet aware of the fact that if we didn't take the pictures someone else would.

In June 1994 an incident occurred that perfectly demonstrated this. I was driving through Park Lane when I spotted Diana's Audi heading towards Knightsbridge. Despite the heavy lunchtime traffic, I managed to slip my car in behind hers and rang Glenn on the mobile. As she drove past Beauchamp Place on Brompton Road, Diana peered down the street and saw three or four snappers hanging around outside the clinic. Instead of turning into Beauchamp Place, she carried on driving and took the next left into Overton Gardens.

I waited at the end of the street as she parked and got out of her car, thinking there were no photographers around. She walked briskly towards the shops on Brompton Road. I waited until she was out of sight before driving further up the street and parking.

Opposite Diana's car there was a small mews and that's where I waited for her to return. I was safely hidden in somebody's garden, my long lens peering out from the cover of a bush, when she came back to her car. Snapping away, I watched as she took off her jacket and threw it on the back seat.

I crept from the bushes to get a better angle. Unfortunately, I had forgotten that great bane of every paparazzo's life – the public. Sometimes they gave us a hard time, telling us to leave Diana alone. On other occasions, like this, they got so excited about seeing the Princess of Wales that they started to act like school kids. The first I was aware of a potential problem was when I crept from the bushes and saw a well-dressed man staring at Diana, seated in her car.

He called across to two builders working on a

Below: Who said size doesn't matter? It does when you need a clear view of the mothers' race at school sports day.

house opposite. 'Is that Princess Di?' he shouted. The builders stopped working and stepped out on to the pavement. One of them saw me kneeling by the wall and shouted back: 'It must be – there's a bloody photographer.' By now, I was holding my head in my hands. 'Oh, please shut up,' I was thinking. But the businessman was only just getting started. 'Is that Di?' he called out to me. Frantically, I waved my hands to tell him to shut up.

By now, Diana had cottoned on to the fact that she had been spotted. Figuring there was safety in numbers, I got up and walked quickly towards the suit as Diana's car screeched off. As she drove up the street, my phone rang. It was my agent: 'No matter what you do today, get pictures of Di.'

'Why?' I said, pictures of Di already in the can.

'She's just done a photoshoot for *Vogue*. It's next month's front cover but they've just released them.'

I hung up and watched as Diana's car disappeared at the end of the street. Funny way of avoiding press attention and leading a private life, I smiled, splashing yourself across the front cover of *Vogue*.

Mark, July 1994

The annual sports day at Ludgrove School, where William and Harry were both boarding at the time, was the highlight of the school's calendar year. All of the parents attended, and it was traditional for families to have picnics together on the playing fields before the sporting events began.

The press were never invited, and yet always turned up in large numbers. Therefore, a massive police presence was on hand to avoid any unwanted intrusion.

The grounds surrounding Ludgrove School are extensive and private and therefore completely out

Below: Harry limbers up for the next race.

of bounds to any member of the press. However, many years before, Fleet Street hacks had discovered a public footpath that ran along the rear of the school. The view was never sensational, but it did allow photographers a clear sight of the field in which the races were held.

There were about 25 photographers on duty that day, their massive lenses aimed at the playing fields and the families happily picnicking. We were all desperate for any sign of Charles and Di, William or Harry. As it was a hot day, I decided to take a stroll along the footpath to see where it led. The path went through a wood at the rear of the school and came out at the private road that gave access to the playing fields. A uniformed policeman was standing on the side of the road waving the parents' cars through.

I spoke to the cop and asked him if it was all right to cross the road to rejoin the footpath. He said that was OK, so long as I didn't stop on the road. As I reached the other side of the road I noticed something. Although I could not see the playing fields, I could see the car parking area. Peering through my binoculars, I could clearly see the children running past the cars and heading for the field, their parents following.

In the high-stakes world of the paparazzi, you make your luck by sometimes taking risks. It occurred to me that I was alone. If I stood where the other snappers were, no matter what happened we would all get the same picture. But if I stayed where I was, with a view of the car parking area, and something happened, I would have it all to myself.

Instinct told me to stay put – and the pictures I got because of that instinct were front-page news all over the world.

It all started with the surprise appearance of

Diana in her Audi. She pulled up sharply next to me. The top of her convertible was down and we looked at each other. She never said anything. She just gave a gentle sigh and drove off. I watched as she reached the car park and instructed a detective to park her car. She had been joined by Prince Harry and, as the detective drove away, they stood there chatting. The distance between us was about a kilometre. It was a long shot but worth a go.

I stopped shooting and peered through my binoculars again. I couldn't figure out why Diana and Harry were so far away from everyone else. What were they waiting for? And there was another mystery: Diana had just seen me and must have known I was taking pictures. I couldn't understand it at all.

Suddenly, I saw two cars approaching. Both Diana and Harry waved towards them and my

Below: Very few pictures have been taken of the whole family together.

Right: William is coaxed into the dentist by his mother after an accident at school dislodged a tooth.

stomach lurched as I realised that Prince Charles had just showed up.

Even though Charles and Diana had insisted their marriage split would never affect the children (and it never did), very few pictures had been taken of the whole family together. The press were still writing about the 'War of the Waleses' and the supposed acrimony between Charles and Di. I – and then the world – was about to see if it was true.

'Stay where you are,' I prayed as the cars pulled up alongside Diana and Harry. Charles got out of the car and Harry ran to him and jumped into his arms. Charles, grinning broadly, put Harry down and crossed to Diana.

They smiled at each other.

'Kiss her, please kiss her,' I prayed again.

He kissed her. Twice. Then, arm-in-arm, they playfully followed Harry towards the sports fields.

As they disappeared from view, my mobile phone rang. I was still shaking from the excitement

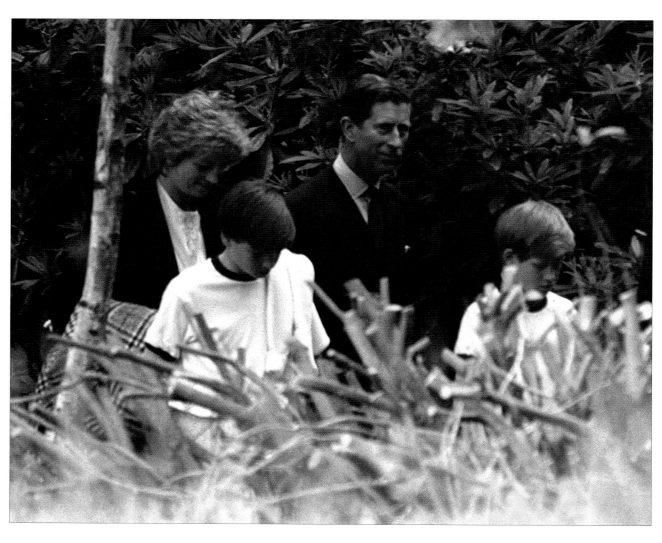

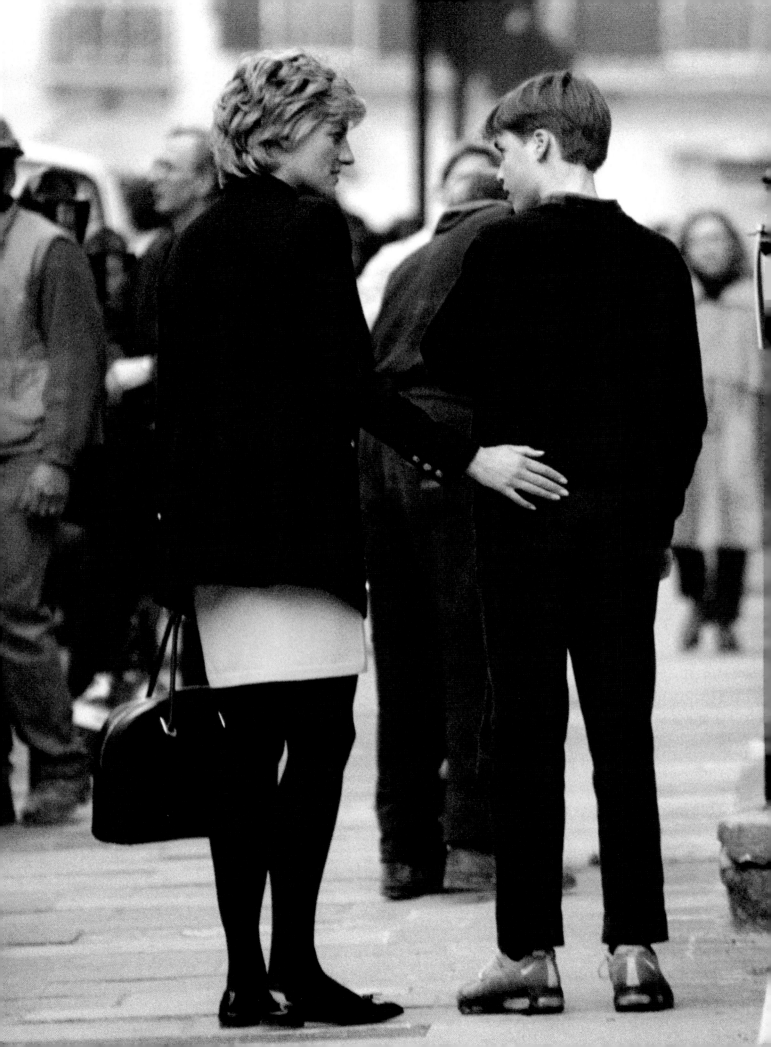

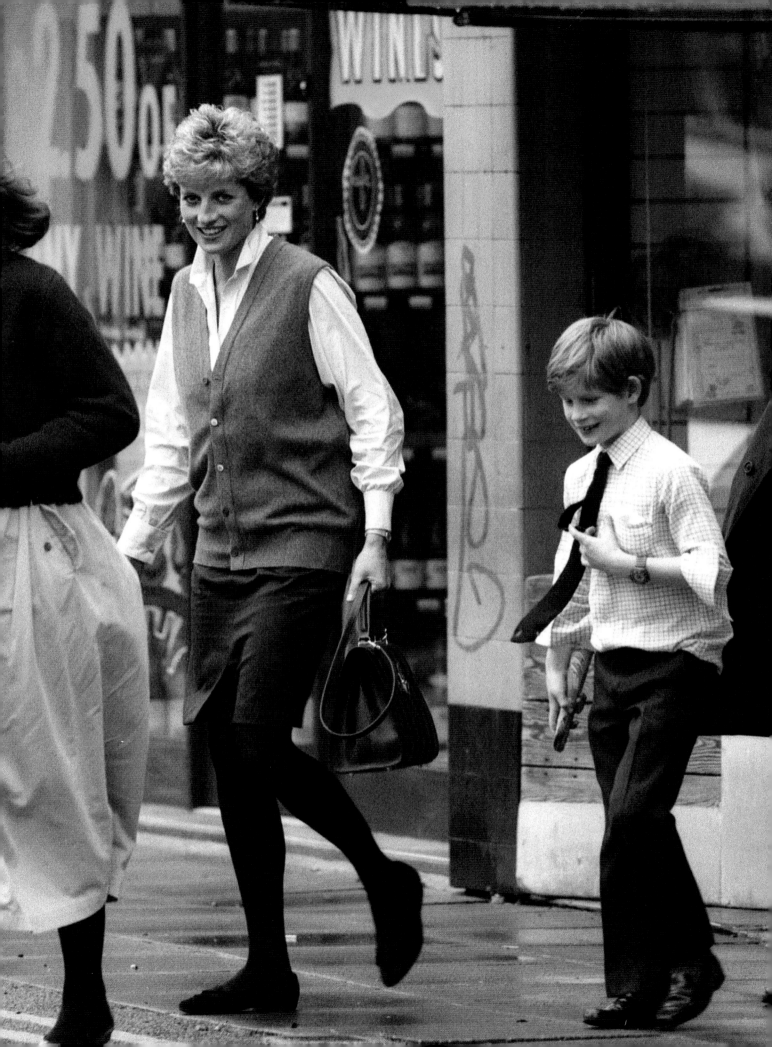

Left: 'It's great when you collect
us from school, Mum. We get ice
lollies!' Diana collects Harry
from Ludgrove School in Berkshire
to spend the weekend at
Kensington Palace.

of the pictures I had just captured, so I could barely get my act together enough to answer the call. 'Hello,' I said.

'Mark? Clive Goodman.'

Clive Goodman was a legend. He was the royal reporter for the *News of the World* and was so good at his job it was said that if Goodman had been in business during the abdication crisis he would have splashed on it before the royal family had even heard of Wallis Simpson.

'I understand you had a good hit,' he said.

How did he know that? I'd only just taken the pictures.

The *News of the World* bought the pictures before I had even got off the footpath. The following day they appeared on the front page with the banner headline: 'CHARLES KISSES DI'. Newspapers and magazines all over the world clamoured to buy them, and many royal commentators claimed that the pictures proved a reconciliation between Charles and Di was still possible. Whether or not that was what Diana wanted I'll never know. But I do know one thing: she was well aware where I was standing and she knew I would take pictures.

Just after I had taken the call from Clive, another strange thing happened. One of the royal detectives approached from the road and asked if I'd got any snaps of Charles and Di. When I said that I had got them kissing, he asked to look down my lens. He then asked if it had been a clear shot. I confirmed it was and he walked off, seemingly very pleased with himself.

🍃

Since her retirement from public life, very little had been seen of Diana by the general public. She

had undertaken no public engagements for more than six months and interest in the princess had started to wane.

But what the public didn't know was that behind the scenes at Kensington Palace Diana was preparing for one of the most challenging (and rewarding) periods of her life. She had grown tired of the 'Shy Di' tag and was equally fed up with the 'weeping princess' portrayal that seemed to be her defining image in the press at the time. She was determined to be taken seriously in her work and was preparing to launch herself as a power player on the international scene.

Earlier that year, Diana had accepted an invitation to join an advisory group of the International Red Cross. The organisation was celebrating its 100th anniversary and saw in Diana the perfect means of attracting mass publicity around the world. The first meeting of this new group was to be held in Geneva, Switzerland, away from the glare of publicity and media-hype that had always attended any of Diana's engagements in the past.

It was a noble idea, but it was bound to fail. Diana's appointment as an advisor to such a prestigious body as the IRC was major news. This completely changed the image of the world's favourite princess. Diana would now be meeting with politicians, generals and intellectuals – and she would be helping to make decisions that could literally save the lives of thousands of people.

As soon as the news was announced, the general public adored the story. Interest in Diana reached an all-time high. Even though she had retired from public life, and had pleaded with Fleet Street to leave her alone, Diana could not escape the

Right: Surprised to see us!
Below: Diana in the Red
Cross uniform.

attention of the international media that now demanded stories on the new venture.

Despite an expected lack of cooperation from KP, who insisted on a press blackout, it did not take us long to establish where and when the meeting was to be held. Diana could easily leave KP without being spotted, but it was not so easy to avoid attention at Heathrow Airport. As soon as she boarded her plane, we were alerted at our base in Geneva that she was on the way. At Geneva Airport we lucked into a friendly BA official who told us that Diana's car would pick her up on the runway, and that they would leave by a rear exit.

We had already established where the actual meeting was taking place by a devious trick the previous evening. The IRC members who were to attend the meeting were staying at the Intercontinental Hotel. Having found out which rooms they were in, we picked a name at random and rang the room. As it was 2:00 a.m., we expected the recipient of the call to be caught off guard. We were right. Disguising my voice, I did a passable impersonation of the French hotel manager and, after much apologising for waking him up, explained that the local police were concerned as to whether Princess Diana was due to arrive at the hotel that night.

Groggily, and still half-asleep, he said no, she would be going straight to the Villa Saugey in the morning. Bingo!

Word was swiftly relayed to the rest of Fleet Street that the meeting was to be held at the Villa Saugey, a famous Swiss international conference venue overlooking the beautiful Lake Geneva. When Diana arrived the next morning she was not pleased to see the mass ranks of photographers by the villa's main gate. Ignoring our attempts to say 'good morning', she shot us a glance that was the facial equivalent of flipping the finger.

The following day's newspapers chose to overlook the more serious nature of Diana's diplomatic presence. War, famine and disaster were ignored in favour of the fact that she was back to work after six months of doing nothing.

It was this sort of publicity that broke Diana's heart. Here she was, genuinely trying to find a role for herself on the world stage, and all they did was mock her.

She sometimes felt that she could never win.

Paranoid!

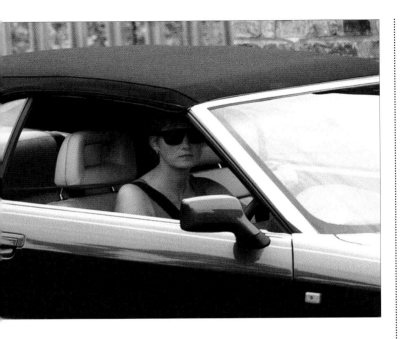

Mark, July 1994

When people ask what Diana was really like, it is hard to answer. We only saw snippets of Diana's life, usually in confrontation, but I do remember one incident that made me see Diana in a new light.

TV producer Mike Brennan was with us throughout the summer of 1994, as he was producing an LWT documentary on Diana's life. He had been invited to Kensington Palace to meet Diana's private secretary Patrick Jephson for a chat. Mike assumed it was to lay down some ground rules for the documentary, but he was completely wrong. When he got to KP, he was shown to the princess's private apartment and was more than a little surprised when Diana herself opened the door to greet him.

They went inside. Diana asked him about the documentary, just the routine questions that anyone would ask if a camera crew was going to follow them around the world for the next year.

They then had tea, whereupon Mike suffered a bad attack of hay fever, sneezing continually into the finest royal napkins. Diana, genuinely concerned, went to the bathroom cabinet and came back armed to the teeth with medicine, which she administered to Mike like Florence Nightingale, as he later revealed.

Mike recovered and Diana grinned, and said she'd always wanted to be a nurse. 'I guess it's every litle girl's dream to be a nurse – or a princess.' Then her voice trailed off and she sat looking out of the window at the perfectly mown lawns of Kensington Gardens.

Glenn, July 1994

I don't know whether Di's trip had been successful or not, but she returned from Geneva in a foul mood and for the whole of the next week seemed determined to take it out on the paps. Mark and I were hiding in the bushes at the Harbour Club, from where we managed to sneak some better-than-average shots of Diana coming out. Unfortunately, at the last moment she saw us as we dived for cover. Mark and I stayed put, expecting her to drive away, but she headed straight for us. She drove her car round to the bushes and got out, slamming the door dramatically behind her.

'Can you come here, please?' she appealed to us through a particularly large rhododendron bush.

We stayed put.

'I said, can you come here? I know you're in there.'

I wish I'd been on the other side of the road. What a picture it would have made: proof that the Prince of Wales was not the only member of the royal family who talked to plants!

Diana moved some bushes aside and, for one

crazy moment, we honestly thought she was coming in. We both looked up to see her peering down at us through the parted foliage.

'You look pathetic,' she said.

I had to agree. Any person found hiding in a bush and trying to peep, with a camera, into a building where half-dressed people were bouncing up and down getting sweaty would most definitely have been arrested. But for some reason, a press card – issued by the police, ironically – would always bail you out of any sticky situation. One flash of a press card to a policeman and you were free to go. We had been given an 'official' licence to snoop.

But snooping in hedges could kill you, especially when the one you were in had become overgrown. On an assignment in Wales I had been tipped off that Diana was going to have lunch with Oliver Hoare at a remote restaurant up a country lane. The only vantage place with a view was in a hedge opposite the entrance. I made myself as comfortable as I could and waited. As I sat there, I could hear a tractor driving down the lane towards me. It got closer and louder until it was upon me. Little did I know, but the tractor was loaded with a fast-revolving hedge cutter on an extended arm. The blades just missed my nose as they crossed my path from left to right. I jumped backwards and flattened myself on the wall behind. It was like a scene from a movie, with the baddie's blade of execution teetering above my head as I was pinned, helpless, waiting for my deadly fate. The cutter would have chopped me into little pieces if I hadn't reacted quickly. But I did lose my 300mm lens to the Welsh mangler. I'd also lost my hiding place, as the hedge had been reduced to a heap of shreds.

Back at the Harbour Club, Diana continued to address her questions at the bush. 'How long is this going on for?' she enquired.

Brushing ourselves down, we clambered out of the bushes to meet her. 'I don't know. There's a lot of demand for pictures at the moment,' I said. She stared at Mark. 'I don't know either,' he shrugged.

'I've even found a tracking device on the wheel of my car,' she continued. 'How much further will you go?'

'I think you'll find it's not the press who planted that. It was probably the MI5 or your other half,' I explained.

She nodded at that one, her chin in her hand and deep in thought. Moments passed.

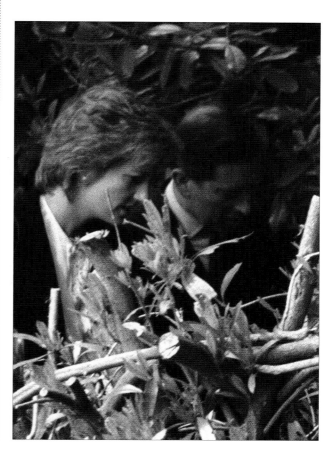

Looking over my shoulder, she spotted a person sitting in a car waiting not far from us.

'Is that Chancellor waiting to follow me?' Diana's temper was really up now. David Chancellor was a freelance photographer and paparazzo specialising in royal pictures.

'No, it's not him,' Mark replied, looking towards the car.

'Chancellor used to be a policeman, you know. I know every move he makes before he even makes it,' Diana said, keeping her voice low in case the man heard.

Perhaps she was implying that he was still a policeman, or maybe an MI5 agent assigned to stay near and watch her every move. Whatever he was, Diana glared menacingly at the poor bloke, an innocent bystander. It was a glare designed to crack even the toughest MI5 agent. 'Don't worry, that's not Chancellor,' I repeated as I tried to break her stare with a wave of my hand.

What better way I thought for an MI5 agent to keep track of Diana than to pose as a paparazzo photographer? The incident gave me a rare insight into Diana's mind at the time. The War of the Waleses was at its peak and Diana was being systematically frozen out by the rest of the royal family.

'Go away!' she shouted loudly at the guiltless man as she strode off to her car. Diana was now in tears.

The man did go away, as ordered, and must be wondering to this day what he had done to upset the Princess of Wales so much. Or was he really an agent? He did seem to be hanging around a lot longer than was necessary.

After this episode, I had a better understanding of something that I'd witnessed a few days earlier. Diana had parked her car in St Albans Grove, a quiet residential road, and it was just getting dark. She was alone in her Audi – Diana would sometimes drive unescorted across London at night, meandering for hours on end.

This night was different; she seemed to have a purpose. Diana stepped from the car and leant down over the front wheel. It was difficult to see exactly what she was doing, but from my position I could make out her hands touching the wheel. She then went to the rear of the car and did the same. She glanced over her shoulder as a house front door closed nearby. After checking all four wheels she got back in the Audi. I thought at the time that she was just checking her tyres for a flat or possibly the wheel was making a noise. It was now clear to me that she was inspecting the wheels for tracking devices. Diana drove off in the direction of Brompton, where she passed the home of Oliver Hoare four times. Each time she did so, Diana slowed down as she came to Hoare's front window. Her head was tilted over to one side, as if she was on the phone. The lights were on in the Hoare household and Hoare could be seen sitting in his lounge watching television. There was someone else with him, probably his wife.

Since Diana's split from Charles, family holidays with William and Harry were taken separately. For the first part of the summer holidays they went away with their mother, while the second half of the break was spent with their father. The arrangement had begun the year before, the first summer of the separation. The palace press office had refused to say where each parent would be taking the children but had insisted that the

Below: After telephone conversations that Diana had with James Gilbey were made public during the 'Squidgygate' scandal, Diana dumped her mobile phone for a more discreet pager. According to her, MI5 were watching her every move …

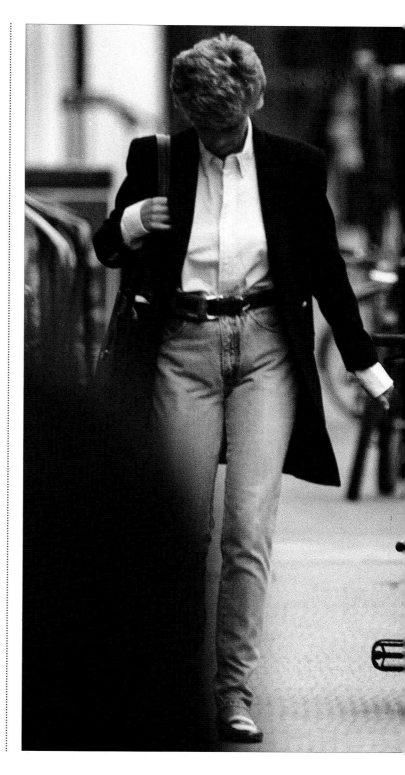

holidays were private and had requested the press to stay away.

Diana, however, had other ideas. At that time, both Charles and Diana were vying for the children's attention, both wanting to be seen as the better, more loving parent. Following Charles's admission of adultery to a worldwide TV audience, Diana was way out in front in the PR stakes and she intended to keep it that way. Word quickly spread around Fleet Street that Diana was taking the kids to Disneyworld in Florida, probably the most public holiday destination on the planet and a strange choice for a private holiday.

Prince Charles, on the other hand, was intending to take the boys on a Mediterranean cruise, making it impossible for the press pack and their intrusive cameras to follow. It was fairly obvious who was going to win this game. Diana was going to make sure that the world's magazines and newspapers were full of snaps showing what a wonderful time the children were having with their mother, while she still maintained that she never sought the publicity. It was common knowledge which flight Diana and the kids were taking to Florida and I had booked on it the previous night. Unfortunately, after arriving at the airport with plenty of time to spare, I discovered that I had forgotten my passport and was forced to go back home to collect it. Funnily enough, as I raced back to Heathrow after grabbing my passport, I passed Diana and the children being driven to the airport in a minibus. William and Harry must have been very excited about the trip as they were waving at cars, including mine, as they sped along the motorway. I gladly returned a happy wave.

I managed to board the flight just before Diana's

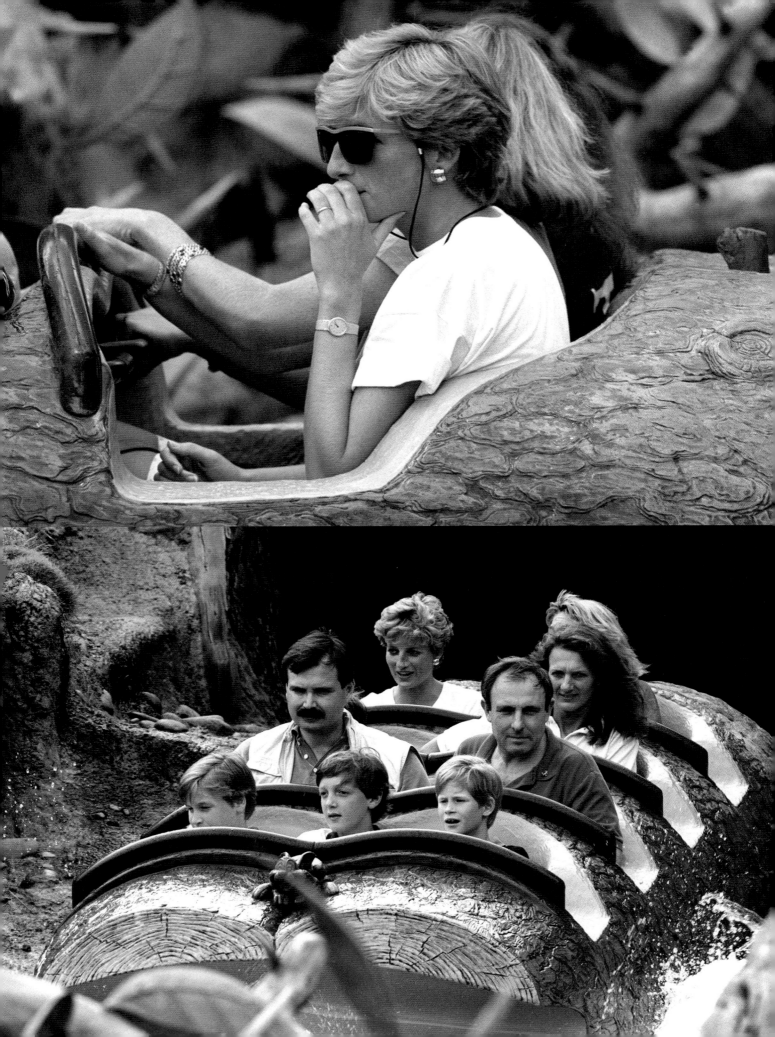

party. The whole of Fleet Street seemed to be on the plane.

Diana was booked into the Grand Floridian Hotel and so it seems was Fleet Street. I had never known a private foreign trip where so much inside information was so readily available. The following day, predictably, we were tipped off where in the park the royal party would be that morning. When Diana and the kids came out to enjoy the rides they were met by a barrage of photographers. The pictures were great. Diana was on form, laughing with the kids, enjoying the rides, posing next to Mickey Mouse. At one point, they went into a Wild West show. The press were sitting opposite and, once again, 50 cameras captured William, Harry and Diana having a simply wonderful time.

The pictures in the adventure park were fine for the newspaper staff photographers – they were really happy with their pictures and so were their offices. But what we freelancers needed were the exclusive shots of Diana in an unguarded moment. This is where the paparazzi take over. If she was going to invite the world's press on holiday with her, then we made sure that we did our utmost to get her the best coverage – while at the same time trying to recoup our expenses, which ran to around £2,000 each.

The Grand Floridian was a first-class hotel with extensive gardens and swimming pools surrounded by six-storey blocks of rooms, all with their own balconies. Hungry for a good set of exclusive pictures, I left my room early the next day and went for a reconnaissance of the hotel. I started checking out the swimming pools and the vantage points overlooking them. Diana was a keen swimmer and it was not unusual to see her

having an early-morning dip. Not today though. Walking on, I began to think of breakfast. I took a left turn by some sun beds and strolled along thinking of all those lucky people still sleeping in bed. It was still only 6:15 a.m. and I was feeling tired after the long flight and the hectic day in the park the day before.

But hang on: someone else had already woken up. On the top floor of the main block a large window was open. In the opening, Diana stood in her dressing gown, coffee cup in hand, looking directly down at me. I took my eyes away from her as quickly as possible and continued walking,

pretending I'd not seen her. If I had picked up a camera there and then, she would have gone inside before I could raise my lens. I carried on walking, trying not to quicken my pace. I thought that if I looked at all the other buildings in the area she would think I had not seen her and that I was still searching for her balcony. Walking on, I was taking a chance that I would get out of view and then get a good vantage point to take some pictures. A quick snap of her standing there with her coffee cup would more than pay for my expenses and leave me with enough for a bit of profit from the trip.

Out of view at last, I launched myself into a large clump of trees and undergrowth. Anyone watching would have thought a madman had escaped as I tore a path through to the front of the bush. My camera was up and ready just in time to see the top of Diana's head disappear back into the room. Very disappointed, I went back to my room and ordered a large breakfast, ate it and went back to bed.

Down, but not beaten, I spent the rest of the day trying to change my room for one that overlooked Diana's. It was always possible that she would do the same thing again the next morning. Checking out the best rooms for the job, I went to the hotel reception with a silly story that my wife and I had to have the same room that we'd occupied during our honeymoon five years before. I told them that my wife would be joining me later that day. They went for it, and the woman on reception handed me a new room key, beaming a huge Walt Disney smile. 'No problem, sir, suite 2006. Hope you enjoy your stay with us,' she said, winking at me. Things were going well, although I was a bit shocked at my new room rate. I hadn't expected a suite.

At 5:30 a.m. the next morning, in a room bigger than my house, I was already on red alert. I was lying outstretched on a sofa, ready for any movement at Diana's window. The curtains were pulled over my 2,000mm lens, which protruded from the open patio window. At 6:00 a.m., a maid drew the curtains in Diana's apartment and opened the window on to the now beautiful sunny morning.

6:30 a.m.: Click! Click! Click! Click! The motor-driven camera was rattling away even before I had realised she was there. It had worked; all my guesswork and scheming had worked. Diana was standing at the window as she had done the morning before, but this time I was ready for her. Totally unaware of anyone watching, she sipped away at her coffee. I could see she was enjoying the heat from the early-morning sun as she relaxed, clad only in her dressing gown. She leant her head backwards and shut her eyes to the glowing sunshine. It was a rare moment of solitude, a totally private and peaceful moment before William and Harry woke up and pestered her with the demands that children their age plague their parents with on holiday.

Then, she stepped backwards a couple of feet. She had heard footsteps coming from the gardens below. It was the opposition. A photographer was walking along the same pathway I had taken the morning before. Damn it, he'd spotted her! But, as he was lifting his camera to his eye, Diana disappeared from view, returning into her room.

Fantastic luck. He had confirmed for me what I had thought yesterday. Don't lift up the camera while she's watching you. I was pleased with my performance.

As I slid the lens slowly back into the room, my doorbell went. Christ! Maybe she'd spotted me and had sent the cops over to sort me out and take the

films. Quickly, I hid them in a bathroom cupboard and with some apprehension opened the door.

'A champagne breakfast, sir, compliments of the hotel,' a waiter announced.

'How come?' I asked.

The trolley was adorned with flowers and champagne.

'Your second honeymoon, sir,' he said as he wheeled the breakfast into the room.

It was plain for anyone to see that I was not on a second honeymoon. The bed and most of the floor space were covered with cameras, lenses, film-processing equipment and all the usual pressman's paraphernalia. There was not a wife in sight, but with a knowing look and grin he left me the breakfast anyway.

'Enjoy your stay with us, sir,' he grinned.

'I will, thank you,' I smiled and sat down to the biggest and most welcome NON-stress breakfast I'd ever seen. Paradise!

Hide and Seek

Right: Hostilities with her stepmother, Raine Spencer, were cooling enough to even 'do lunch' in London.

his arm and looked as if the problems of the world were on his shoulders. It was Dr David Owen, the British politician involved in the tortuous Bosnian negotiations. As we got in the lift, I looked at him and for some reason I just wanted to say something positive, to offer him some words of encouragement. After all, here was a man desperately trying to end the carnage in the Balkans that showed very little signs of stopping. Unfortunately my words came out wrong. 'Why don't you just give up?' I said.

He looked at me, his handsome features studying me for a long time. Eventually, he sighed and said: 'You look like a young man who gave up a long time ago.'

Mark, August 1994

Following the debacle at the Byblos and the running battles on the ski slopes of Lech, Diana was determined that that year's summer holiday would be private.

Despite massive press interest, no destination details had been acquired by Fleet Street. Even the *Daily Mail*, our usual source of information, didn't seem to know anything. We were left kicking our heels in London, bags packed and waiting for Diana to make her move. Everyone seemed to have a theory on the holiday destinations. I heard we were probably going to Bali, Phuket, the West Indies, Africa, Brazil, Arizona and pretty much everywhere else.

Mike Lloyd and I, tired of hanging around London, got a tip that Diana was heading for Disneyworld in Florida. Rather stupidly, we flew out without confirming the authenticity of the information. We found hanging around Disneyworld

was just as boring as hanging around London, though the weather was considerably better.

The call, when it eventually came, gave me a tremendous sense of déjà vu. I arrived back in England on the Saturday morning. My agent rang at midnight. Diana and the children had boarded a flight to Malaga earlier that day – so I was booked on the first BA flight in the morning.

'Any idea where's she's gone?' I asked, hoping we weren't heading back to the Byblos.

'I just told you,' he replied

'I mean – where is she staying?'

'Somewhere on the Costa Del Sol, I guess. You'll find it,' he said, sounding far more confident than I felt.

I woke Mike early the following day with the news.

'Where are we going?' he asked.

'Spain.'

'Spain?' he said, aghast, 'Oh, God, not again.'

We arrived at Malaga that afternoon and proceeded to spend the rest of the weekend driving up and down the Costa Del Sol. Everywhere we stopped somebody 'knew' where Diana was staying. So we sipped banana daiquiris in the millionaires' playground of Marbella, took afternoon tea at the luxury country club of Sotogrande, strolled through the rolling hills of Granada and brought cheddar cheese and PG tips in Gibraltar.

As usual, it was a phone call to London that gave us the correct destination. The *Daily Mail* had finally come through with the news that Diana was staying at a luxury villa next to the tiny village of Benahavis, in the hills above Marbella.

Everyone agreed: in future, we wouldn't try to pre-empt the opposition. We would just wait for the *Daily Mail* to tell us where Diana was going.

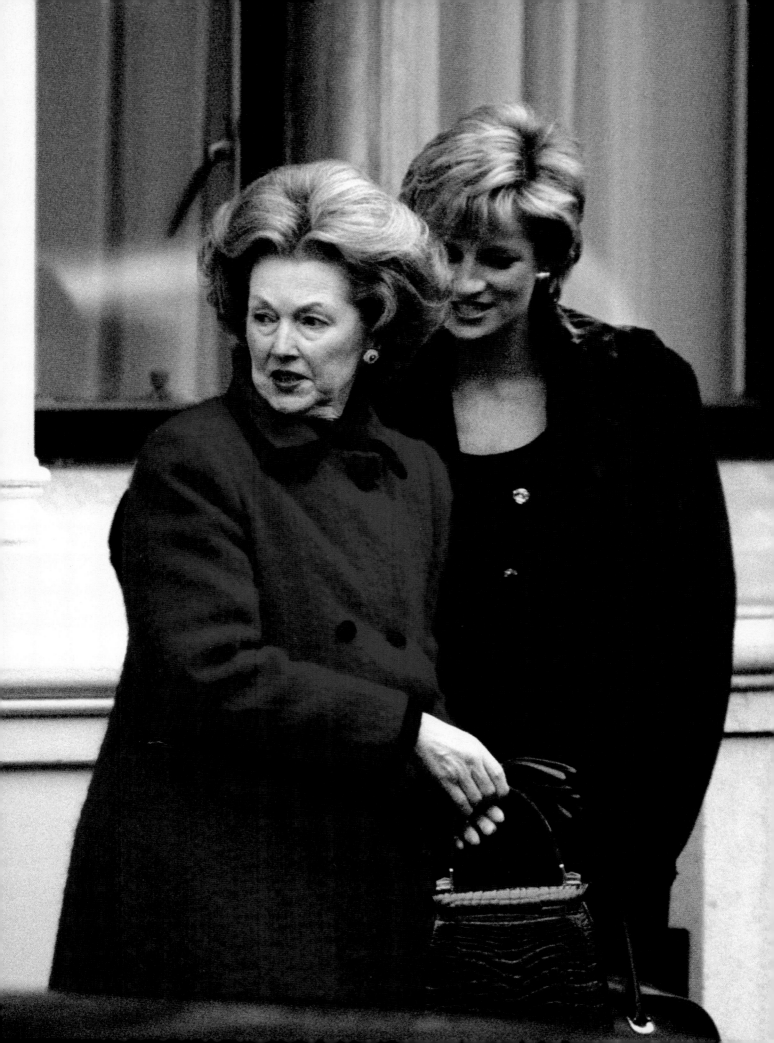

As we drove into the picturesque village of Benahavis, we were greeted by the sound of James Whitaker's booming voice coming from a small bar. The *Daily Mirror* man was on the phone to London, and when James talks the world has no choice but to listen.

Our joy at discovering Fleet Street was short-lived when we were told the impossibility of the job facing us. The villa Diana and the kids were staying in belonged to the wealthy financier James Goldsmith. It was buried in a small valley surrounded by acres of rolling hills and mountains. Goldsmith was a man of extreme wealth, and his name carried a lot of muscle in those parts. As well as the local police and the Civil Guard, Goldsmith had 'borrowed' a few members of the SAS to beef up security. The Spanish police did not concern us too much – they were as corrupt as we were – but I didn't particularly like the thought of the SAS watching us.

The week that followed was one of unmitigated boredom from which all we achieved was decent suntans. The only incident of note was a well-known photographer getting caught up in his own version of *The Crying Game* in the local brothel.

A quick recce into the hills had already established that this was a wasted trip. Heavily armed Spanish police officers were cruising the rough mountain terrain in jeeps and were quickly apprehending those snappers foolish enough to try and get pictures. As I had already learnt at the Byblos, being caught by Spanish security is a painful experience. Battered photographers coming back into Benahavis were telling horrifying tales of being beaten up, their cameras smashed and film confiscated.

Then we got a lucky break. Diana's children had become restless inside their villa and arrangements had been made to take them to the local beach. With the sort of cooperation that Fleet Street dreams of, the information was relayed to us by Dave Sharp, Prince William's personal detective. He told us to be at the beach for 2:00 p.m., when the children would be arriving for lunch, followed by some jet-skiing. William and Harry both gave great photo as they rode the jet-skis and frolicked in the water. There was no sign of Diana, but the pictures were so delightful, nobody cared.

The exercise continued for the rest of the week. Dave Sharp would come to the bar, tell us what time the kids were going to the beach and Fleet Street would be standing there waiting for them.

Some trips you win, some you lose. This one had ended in a 1–1 draw. The lack of Diana pictures was amply compensated for by the wonderful snaps we had of the children. Yet, as we boarded the plane, I couldn't help but feel that that was the last we would see of Spain for a while. As the plane banked high over the Mediterranean, I watched the mountains of Malaga disappear and wondered where we would be heading next. Once Diana had deposited the kids with Charles back in London, she was bound to take off for a solo holiday with friends. As Diana was always a sun-lover, we flew back to England, eagerly anticipating a trip to the West Indies or some other exotic location.

But we were wrong. Diana was about to begin a love affair with America, one that had us criss-crossing the Atlantic for the next four months.

With Diana's new-found status as an international diplomat came a whole host of new friends. Gone were the days of endless shopping and lunching in

Sloane Street with Menzies and Soames or giggly girly holidays in the sun. Now Diana wanted to be taken seriously, and she found the perfect location for this in the holiday home of America's glitterati – Martha's Vineyard. The tiny island, just off Cape Cod, prides itself on being a discreet location where the rich and famous can relax and enjoy the beauty of New England in virtual privacy. The restaurants and cafés that dominate the quaint, slightly old-fashioned main street are full of intellectuals earnestly discussing politics and literature as they tuck into their healthy salads and pasta.

On the Vineyard, it's not unusual to see Woody Allen wooing his latest starlet, Kurt Vonnegut and Kevin Spacey plotting film projects or PJ O'Rourke propping up the bar. It's one of those places that makes America great, for only in America are such earnest discussions carried out with such amiability.

Diana had been invited by her new best friend Lucia Flecha De Lima, the exotic and beautiful wife of the Brazilian Ambassador to America. It was De Lima who had shown Diana that intellectual discussion and stuffy embassy parties didn't have to be boring. She revealed to the princess that among the very people Diana had grown to despise was a rich tapestry of life and emotions that, if only she could see, she was also a part of.

And she had also promised to introduce Diana to an 'interesting' young man she was sure the princess would like.

Naturally enough, we heard Diana had gone to the Vineyard through the *Daily Mail*. It wasn't a trip we were looking forward to. I had been to the Vineyard before and remembered that most of the homes were mansions buried deep among thousands of acres of green rolling hillside. Nearly every house was tucked well out of sight of prying eyes and I knew that this was going to be like looking for a needle in a haystack.

On the flight out I tried to be optimistic. My erstwhile comrade Mike Lloyd, grumbling in the seat next to me, pointed out that he couldn't even find Martha's Vineyard on a map. How on earth were we going to find Diana?

'Don't worry,' I said, trying to appear confident, 'something will show up.'

They say you make your own luck in this world. I don't know if that's true, but by a billion-to-one chance something did come up – and it led us straight to Diana.

The Vineyard is remarkably similar to England. The weather in summer is hot, but not uncomfortably so, and there were enough clouds in the sky to suggest that it might rain. The terrain reminded me of Devon: acres of rolling hills punctuated by huge forests of green foliage. The hotels were quaint rather than luxurious: huge, rambling *Gone With the Wind*-style wooden houses that had traditional rocking chairs out front. In the evening, I would sit in the rocking chair, listening to the crickets in the darkness and imagine that I was Gregory Peck in *To Kill a Mockingbird*.

We had always known that finding Diana was not going to be easy, but we had no idea how hard it was going to be. The Vineyard is split into five different towns. Three of them are 'dry' towns, so we couldn't even get a drink most of the time, which added to our grief. We hooked up with New York snapper Larry Schwartzwald, on assignment for *Star* magazine. Larry was constantly angered by our blasé approach to other celebrities on the island. 'Don't you guys photograph anyone but

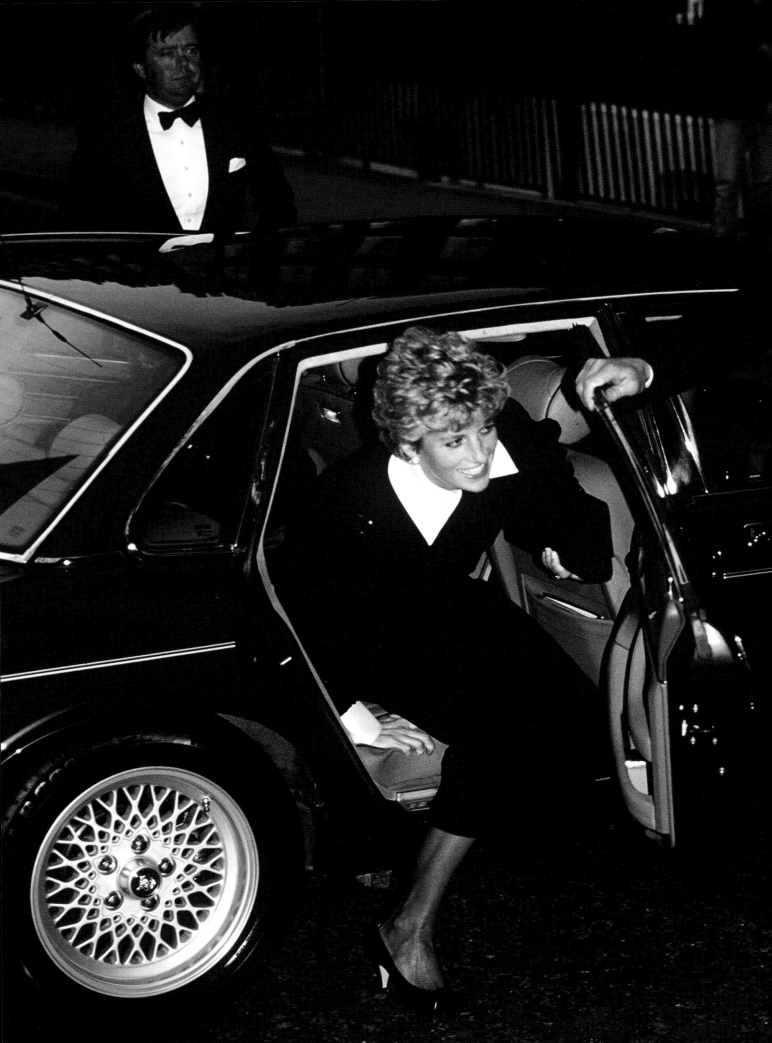

Diana?' he said, after we had spent an entertaining afternoon watching Kurt Russell and Goldie Hawn frolic in the surf on the small beach.

'No. Let them enjoy their holiday,' we said. 'They don't need us bothering them.'

We waved goodbye to Goldie and Kurt, who were with their children, and walked off. Larry sighed dramatically and watched maybe $5,000-worth of picture jump back into the water.

As it was the height of the holiday season the Vineyard was full of tourists. Everywhere we went we met two types of people: those who claimed to have seen Diana and those asking us where she was. We followed up every lead and every possible sighting but all they led us to was more frustration and the ever-growing feeling that we were wasting our time. Our desperation at not finding Diana was further exacerbated by the lack of help from the locals. Even though they made out that they were above gawking at celebrities, it soon became clear that they had no more idea where Diana was than we did. One woman who lived on the Vineyard summed it all up perfectly when she was being interviewed by one of the American tabloid shows. 'Oh, celebrities are no big deal,' she whined in one of those annoying American voices that you hear everywhere in the Hamptons. 'We never even look twice at celebrities. Even the president is just another person around here.'

'Did you know Princess Di is on the island?' asked the interviewer.

'PRINCESS DI?' she gasped, her eyes nearly popping out of her head. 'PRINCESS DI IS HERE? OH MY GOD! WHERE?'

We continued our fruitless search. We drove into woods, sneaked on to private estates, walked down the beach, hung around the harbour. Nothing. By the end of the fourth day we were ready to quit. We had made contact with our counterparts in the American media and, amazingly, they were in the same boat. There had not been a single sighting of Diana anywhere.

It was only recently that I found out why, when I met a woman in New York who had been a close friend of Lucia Flecha De Lima. She told me that Diana had been introduced to a handsome young South American called Paulie on that trip to the Vineyard and that they had enjoyed a brief, three-month romance. I have no way of corroborating the story but I like to think it is true. Diana had had little love in her life until then.

Back in the Vineyard, probably while Diana lay in Paulie's arms, we smelt the sour odour of failure in the air. So we did what we always did when the going got rough – we got roaring drunk. Unfortunately, I had to get drunk on my own – the other boys wouldn't let me near them on account of the skunk that had attacked me earlier that day.

As we drank, we decided to give it one more day. If we had no positive sightings by the following night, we would fly to New York and drown our sorrows, we said. As the boys ordered another bottle of scotch – and I drank bourbon from my lonely table outside – I knew we were hoping for a miracle. Incredibly, we found one.

The miracle wore a skimpy red swimsuit and came jogging across the beach like Bo Derek in *10*. She was beautiful and sexy and if a Hollywood agent had been with us she would have been on a plane to LA immediately.

We were driving down the coast road when Mike suddenly screeched the car to a halt and started yelling: 'Look at that!'

Larry and I grabbed our cameras and went into full Diana alert. At first we were pretty pissed off with Mike for wasting our time gawking at a blonde in a swimsuit, but, as this vision got closer, we sat there open-mouthed. Without doubt she was one of the most beautiful women I had ever seen. I had to speak to her. Telling the other two to stay put, I crossed the beach to the small lifeguard hut she now sat in.

She was the sort of girl who was used to men coming on to her: polite but formal, slightly aloof yet still friendly. However, I don't think she had ever confronted a fully paid-up member of the paparazzi before. For some reason, we always instilled fear in anyone we met. People became wary, suspicious of your motives in talking to them. I tried to disarm her, but she was way out of my league. Even Brad Pitt wouldn't have got anywhere near her.

She told me she was a lifeguard. She then pointedly told me all about her boyfriend, a great guy, she said, who was studying at Yale. I told her that Yale was a long way away. 'Oh, he works on the island during the summer,' she smiled, her eyes bright with devotion. 'He's a painter.'

'What does he paint?' I asked, imagining some romantic Van Gogh figure struggling with his genius while lying in her arms.

'Houses. He paints houses,' she replied. 'It's only a summer job. He wants to go into politics.'

To this day, I cannot look at an American congressman in Washington without wondering which lucky bastard ended up with her.

'He gets to meet lots of interesting people,' she told me.

'At Yale?'

'No, here… on the island.'

I've often wondered what is meant by 'interesting' people. I mean, Nelson Mandela would constitute 'interesting', as would Osama Bin Laden. I wondered aloud if her boyfriend was painting the houses of 'interesting' people or celebrities (not always the same thing).

She laughed. 'Not celebrities,' she said. 'Last week he painted a house surrounded by secret service agents.'

Somewhere in the back of my head an alarm bell was triggered. 'CIA?' I asked.

'No. He said they were speaking Spanish.'

'Oh my God!' I thought. 'Was he certain it was Spanish?'

She shrugged. 'I guess so… I mean, he doesn't speak Spanish or anything.'

I phrased the next question carefully, desperately trying to keep the growing excitement from my voice: 'Could it have been Portuguese?'

She shrugged again. 'I don't know. Why?' She looked questioningly into my eyes, a slight smile on her lips, a slight tilt of the head. 'Is anything wrong?'

'Have you any idea where the house is?' I asked.

She gave me directions. I swore undying love for her and raced back to the car.

'Get anywhere?' Mike asked.

'Yes,' I replied smugly. I looked at Larry, then back at Mike. 'I've found Diana.'

When we found the address, I was convinced my angel of the beachfront had made a mistake. The main entrance was just off a busy junction, from which you could clearly see the whole front of the house. A long, green lawn led up to the main house, which had tennis courts on one side. Although there was no movement inside, we could see several cars parked by the tennis courts.

Larry was certain we were at the wrong place. He argued, quite logically, that the place had as much privacy as Times Square on New Year's Eve. Though the main house itself was pretty enough, it wasn't that large and hardly compared with the massive estates we had spent the last week crawling through. But Larry's misgivings were exactly why I was sure this was the place. True, it wasn't the grandest estate on the island but that is exactly what would have been so appealing to Diana.

Diana was born on the queen's estate at Sandringham; she grew up in one of the oldest and richest families in Great Britain and married into one of the most powerful and privileged families on earth. As Dodi Fayed was to find out, the last thing on earth that impressed Diana was opulence and wealth.

With its humble and traditional appearance, the place we were looking at would have delighted Diana. Still, checking the place out properly was not going to be easy. The local police, who had been aware of our presence from the moment we left Cape Cod, had already warned us that any wandering on to private property would result in immediate arrest. And the busybody, nosey-parker locals were equally determined to prevent us finding our quarry. It seemed that, every time we stopped the car, somebody would ring the police to report suspicious activity in the area.

We waited until dark before going in. Larry and I went about a kilometre up the road, where a deserted farmhouse stood. The wall surrounding the building adjoined the garden leading to what I believed was Diana's house. We clambered on to the wall and it promptly collapsed. The still night air was suddenly broken by the sound of rocks crashing all around us. Somewhere in the distance a dog began to bark. We froze, lying among the debris. With typical American fortitude, Larry hoped his leg was broken so that he could sue. I was more concerned with that other aspect of American character: most of the locals were armed to the teeth and shooting prowlers was not considered a particularly serious offence.

We waited a few moments before getting up. Larry's leg wasn't broken and no shotguns were blasted at us. By now, we were on the lawn, soaking wet in the night dew and surrounded by the fragrant smell of roses. The area was deathly silent but all the lights were on in the house. Keeping low, we stayed close to the wall, edging closer and closer to the tennis courts on the side of the main building.

There were two cars and a space wagon parked alongside the house. Though it was pitch-black there was enough light coming from the building for us to read the car registrations – and all of the vehicles carried diplomatic plates. Using the cover of the cars, we moved closer to the house. By now we could hear voices, so we stopped. It sounded like the TV was on. As quietly as possible we crept towards the house until we were under the main front window. Lifting our heads, we peered inside. A woman sat at the table directly in front of us watching a TV set in the corner.

It was Diana.

Our joy at finding her was short-lived when we realised the following day how difficult getting pictures would be. Paradoxically, the front of the house was too visible. With a main road at the front we wouldn't last two minutes before a cruising patrol car latched on to us, and it was common knowledge that the police were just looking for an

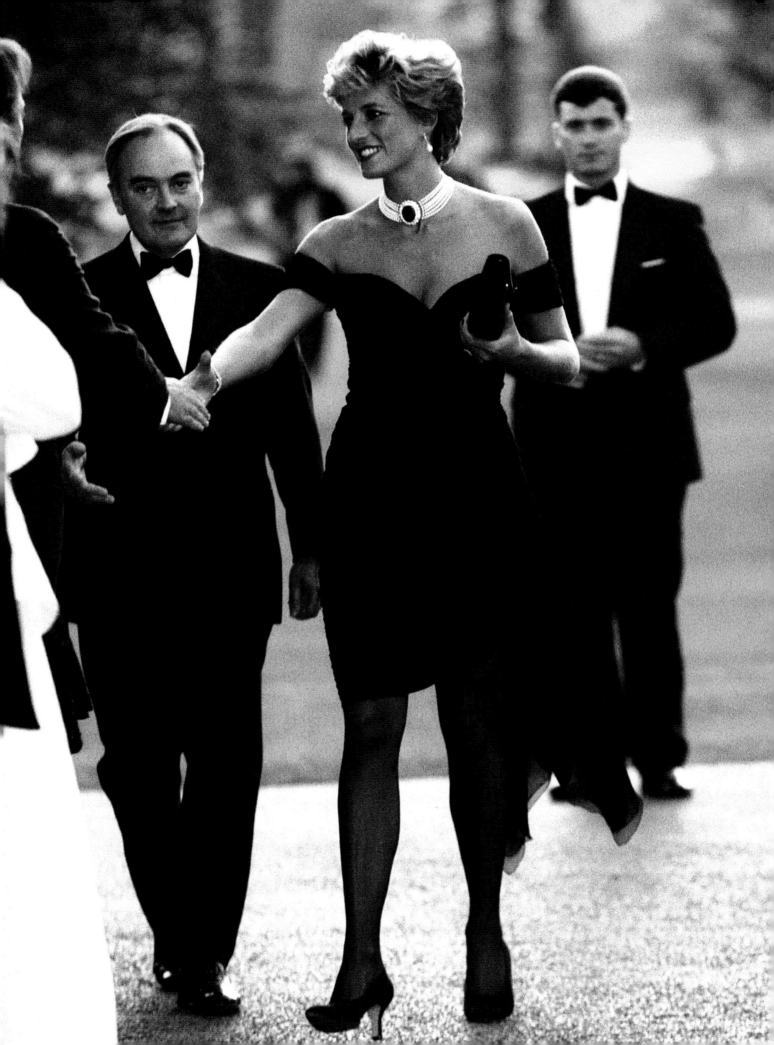

Left: Diana was used to a world
of privilege and power.

excuse to throw us off the island. And the rear of the house, where all the action would take place, was virtually impossible to get to. The garden was surrounded by trees. To get anywhere near them you had to cover at least a kilometre of wide-open fields. The chances of making it across without anyone seeing you were pretty slim.

The only way we figured we could get anywhere near the place was across a huge lake that backed on to the property next to Diana's house. Once on dry land, we guessed we could cross the neighbour's garden, scale a small hill, go through a small wood and end up looking down on the rear of the building. This would all have to be done under the cover of darkness.

Larry was called back to New York that evening, so I would have to make the trip on my own. Mike had already agreed to stay with the car further up the main road to keep an eye on the front of the house.

To cross the river I 'borrowed' a small rowing boat we had found earlier that day. The boat was loosely tied to a tree and, as I had every intention of returning it to that position, I didn't feel I was stealing it. When night fell I found myself in the forest that led to the riverbank. It's funny how things always look different in the dark. Earlier that day I had judged the river to be maybe 100m wide. If I kept a straight course to the other side, I would be able to land on a small beach that led up to the property next to the one in which Diana was staying.

Of course I didn't know what every mariner since Noah knew: you can't move any vessel on water in a straight line without something to guide you... even if it's just the stars. And in front of me was a vast expanse of black emptiness.

In the movies, lakes always shimmer in the moonlight. This one didn't; it was deathly still, dark and foreboding. I felt like I was in the middle of Loch Ness. In fact, I wouldn't have been too surprised if Nessie herself had suddenly roared out of the water. As to where I was going to land the boat, that was anybody's guess. I couldn't see my hand in front of me, let alone the other side.

The boat had no oars, so I was forced to use my mono-pod to make headway in the water. About halfway across, it suddenly occurred to me *Jaws* was filmed in Martha's Vineyard. I wondered if sharks operated in lakes. I've always had a great fear of sharks. I have a very strict policy – I will never swim in a sea or ocean that has seen a shark at any point in the past 100 years.

There were no lights on the other side of the bank, nothing to give me any sort of bearings. The first I knew I was near land was when the front of my boat bumped into a large wooden post to which several smaller boats were tied. I could just make out a landing stage about 10m in front. Using my hands, I angled my vessel alongside the other boats until I could reach the small wooden stepladder that hung alongside. After pulling myself up on to the landing stage, I completely forgot to tie up my boat. The last I saw of it, it was drifting backwards, gently knocking against the other boats.

I walked along the water's edge until I came to a small wood. By now I guessed I was on Diana's property. Sure enough, once I was through the trees I could make out the lights in the distant house. I decided to make camp in the woods and wait until daylight. What followed was a restless and cramped night that all manner of wild animals seemed to enjoy with me. Because America is such a civilised country, one tends to forget how many

wild animals they have. At one point, I was convinced I heard howling, which instigated my second great fear: werewolves. But the idea of being ripped apart by wild animals was slightly less frightening than the bloody snakes that seemed to be everywhere. As daylight broke, I found I was still alive. There were no telltale puncture marks on my throat from vampires and both my arms seemed to be where I had left them.

The main house was roughly one kilometre in front of me. Moving forwards, I found an opening between two large, prickly bushes. I could just make out the patio in front of the lawn. There were four chairs in front of the patio, all positioned for use. I decided to stay put, shielded by the trees and bushes, and see what happened.

What followed was the longest wait I've ever endured. It was 5:55 a.m. when I took up my position and four hours later there was still no sign of movement in the house. Paranoia was always a major part of hunting Diana. We were always convinced we weren't going to get anything, that Diana wouldn't come out, that she wasn't even there, that she had left the country a week ago. All these thoughts went through my mind as each hour passed and cramp turned to worry, and worry to depression.

Diana was an early riser. It was not unusual for her to be up and about at dawn. By 10:00 a.m., with still no sign of Diana, I was seriously worried. I decided to give it 10 more minutes.

I was in the process of lighting a cigarette when I saw a blur of movement next to the bushes in front of the house. I grabbed the camera. Through the trees I could just make out a figure. Whoever it was wore a bright-red top and was heading for the chairs on the patio.

Every muscle in my cramped body tightened as I focused on the chairs. The tiredness disappeared as the familiar feeling of excitement and anticipation crept over me. My finger poised on the shutter button, taking the first pressure, the other hand turning the focus ring delicately, bringing everything into sharp focus. The bright-red top sat down on the first chair and the most famous face in the world came into view. The motor wind sprang into action, shooting almost as fast as my heart was now beating. Diana stretched and yawned, looked up at the sun and lay back luxuriously in the chair. She remained still, apparently deep in thought, as my camera continued to catch every movement, every facial nuance.

Then she stood up slowly. For a moment I thought she was going back inside, but she was merely switching chairs and she sat down again.

Suddenly, I couldn't see her. The chair was in the wrong position. It was too far over for me to get an angle. I moved to the left and immediately felt the bushes prick my arms and legs. Looking back through the lens, I knew I had to get further over. The only way I could continue shooting was to get into the bushes, hardly an inviting prospect as I was wearing only a T-shirt and shorts. I closed my eyes and literally fell to the left, crashing into the thickest, prickliest bush I've ever encountered. With every inch of my bare skin now being torn to shreds, I raised the camera again. Diana was now sitting with her arms behind her head, her eyes closed. Suddenly a young child, possibly one of De Lima's grandchildren, came from behind and put her arms around her. Diana responded with warmth and hugged the child back. It was a great shot that showed how genuine Diana's love of

children was. She wasn't playing up to the cameras; she had no idea I was there.

About 10 minutes later, Diana stood up and went into the house. I stayed in position, even though I was desperate to get back across the lake and get the shots on the wire. Then I remembered: the lake. Damn! I'd lost the boat. I pushed the thought from my mind and was rewarded with a smiling Diana returning in a bikini a few moments later. She sat in the sun, her eyes closed, her head back. I had never seen her look so relaxed.

I had enough shots, so I left. At the water's edge a friendly local was untying his boat on the jetty and was preparing to get in.

'Hey, buddy, what's up?' he asked.

'I need to get across the water,' I said. 'Everyone's left without me.'

'Hop in,' he said, assuming I was holidaying with Diana's party. 'I gotta make a stop though. Some joker's released a boat into the water. I gotta get it back.'

The two cars parked outside a small restaurant in Edgartown were familiar to us. We had seen them parked outside Diana's house earlier that day. A quick check revealed the diplomatic plates. The two guys sitting in front of the first car were straight out of central casting. They wore dark suits and sunglasses, and their scowls were meaner than the pistols they so obviously packed under their jackets.

The restaurant was on the other side of the street. A small unpretentious place, homely and inexpensive. Typical of any eaterie on the island.

We took up our position next to the cars. It was

pointless hiding as we had already been spotted by the two gorillas. We watched as the driver made a call on his radio. A few moments later both men got out of the car and stood by the vehicle, looking at us. They said nothing, so we didn't either. Both groups just stood there, staring.

About 10 minutes later, a police car turned up. A sheriff's deputy got out, a huge man with a gut that hung over his belt. He was followed by a much younger man, also a deputy but far smarter than his colleague. Both officers crossed to the security guys, had a quick chat full of smiles, then came across to us.

'OK, you guys,' said the fat one, 'beat it.'

There were two police forces in the world we rarely had any trouble with, the British and American. Maybe it's because they both pride themselves on rational thinking, the ability to weigh up both sides of any dispute before making a decision. 'Is anything wrong, officer?' I asked.

'I know you guys have got a job to do, but so have I,' he began diplomatically. 'Now I don't want any hassle. Some folks are here on holiday and I wanna keep it that way.' He put his hand gently on my shoulder. 'C'mon, let's go.'

'Are we breaking any laws, officer?' said Mike.

For the first time the cop raised his voice. 'What's your problem, buddy?' he said to Mike.

'I'll tell you the problem,' said Mike. 'This is the United States, and yet the Brazilian secret service is ordering the American police to get rid of visiting Englishmen. That doesn't seem right to me.'

The cop stared at Mike. 'Wait here,' he said.

He walked back to the car and conferred with the two agents. Then he came back to us and said: 'Don't give me any trouble.'

'Who are those guys?' I asked.

The two cops walked off. 'Hey… who are those guys?' I called.

The younger cop stopped walking and came back to us. 'They're from Langley,' he said. CIA.

A couple of days later, I was back in position in the hills. I could see Diana sitting on the patio again, deep in discussion with Lucia Flecha De Lima. I had no idea what was being said, but Diana held her head in her hands and was rocking slowly back and forth. At length, she got up, walked across the garden and sat down on a wooden bench on her own. I crept forward, away from the cover of the bushes, and peered through my binoculars. Diana seemed to be deep in thought. She kept fiddling with her hands, putting them up to her face and then down again and staring straight ahead.

Something was wrong. Something was very wrong.

Glenn, August 1994

The first I knew of Diana's imminent arrival back in London was in a panic-stricken phone call from Mark in New York. He had been expecting her to leave the Vineyard on the Saturday morning, but apparently she had given him the slip and had left on the Friday instead. He told me he felt that something was up with Di, and was convinced that she had left the island early because something was amiss back home.

I was determined to make sure we had pictures that day.

What I didn't know at the time was the journalistic explosion that was being prepared for the front pages of the *News of the World*. The story

that would hit the streets the following morning was quite simply the biggest royal scoop of the decade. I also had no idea that the pictures I was to get later that day would be among the most controversial royal snaps ever taken.

The day had started fairly routinely with Diana's visit to the Harbour Club. At that point, nothing seemed particularly untoward and she returned to KP without incident. As it was a Saturday, there was every chance that Diana might be planning a spot of shopping. When she did eventually come out again it was 2:13 p.m. I took a phone call from a friend who had just seen Diana drive past him and turn into a small square not far from KP. It was fairly obvious that shopping was not on the agenda. I was with fellow snapper Antony Jones. We checked the map and sped up to the square. Diana's car was parked in front of a terrace of town houses. There was no sign of Diana so we trawled the area, looking for clues, without luck. We decided that we would lie in wait with our cameras trained on Diana's Audi.

Talbot Square is not large. It is enclosed by a one-way street which runs around a huge garden full of trees and bushes. There is a small children's play area in the centre. Antony and I took up positions in the park, behind the ever-useful bushes, and waited for something to happen. All was quiet as we lay flat with our faces in the dirt. Finally, we saw a small blue Volvo hatchback slowly cruise around the square, which then backed up into the only free space available. The doors swung open and Diana and Richard Kay stepped out. We both watched them silently, trying to see what she was up to this time.

The *Daily Mail*'s royal hack (and Diana's voice

on Fleet Street) was with her again. Diana, dressed in jeans, jacket and baseball cap, was escorted to her Audi by Kay, who opened the door for her and then got in the passenger's seat. We crawled through the dirt to get a better view of the windscreen as the reflection in the glass was hampering our view. Things seemed to be getting interesting inside the car but we couldn't see for sure. At one point, Diana seemed to be resting her head on Kay's shoulder.

'Did you see that?' I whispered to Antony.

He had seen it and his camera was shooting away madly at the interior.

We needed a better position. Leaving Antony in the bushes, I crept out of the garden on my elbows and knees and raced across the road. Somehow, I needed to get into one of the flats overlooking the cars. Trying not to attract any attention in the street, I rang the bell of the first house. Diana and Kay would be able to see me standing in the open by the door, but I had to take the chance and get inside the building. A young man answered and, keeping my voice down, I told him I was a press photographer and needed to take a picture from his front room. A strange request, but he happily obliged. From his kitchen on the second floor, it was possible to see the car, but the reflection on the windscreen was still there. Straining to see in, I could just make out their shapes. At this point, I was convinced they were having more than a chat. The dark shapes looked as if they had come together in the centre of the car, in the area over the handbrake.

Surely they couldn't be kissing? But why not? Richard was tall, handsome and also a veteran Gulf War reporter. Just Diana's type. I had been

suspicious of some kind of relationship between them the last time I saw them together in Hans Place. When those shots of Kay getting into Diana's car came out, there was a real stir. I remember that evening well. I was out having a meal with my wife when my mobile rang.

'Hello, it's Richard,' the voice said quietly.

'Hello, Richard,' I replied, wondering what he was about to say. I continued: 'Look, I'm sorry about taking those pictures of you. I was just doing my job. I was snapping Diana and you appeared.'

'I know that's what you were doing. I fully understand,' he said quietly, but his mind appeared to be on something else.

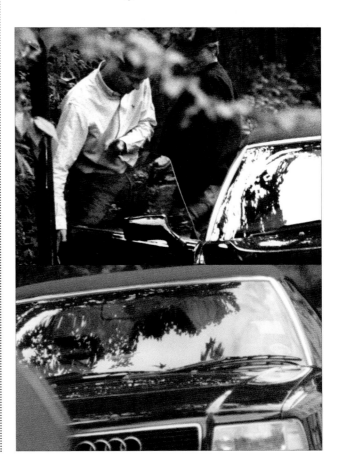

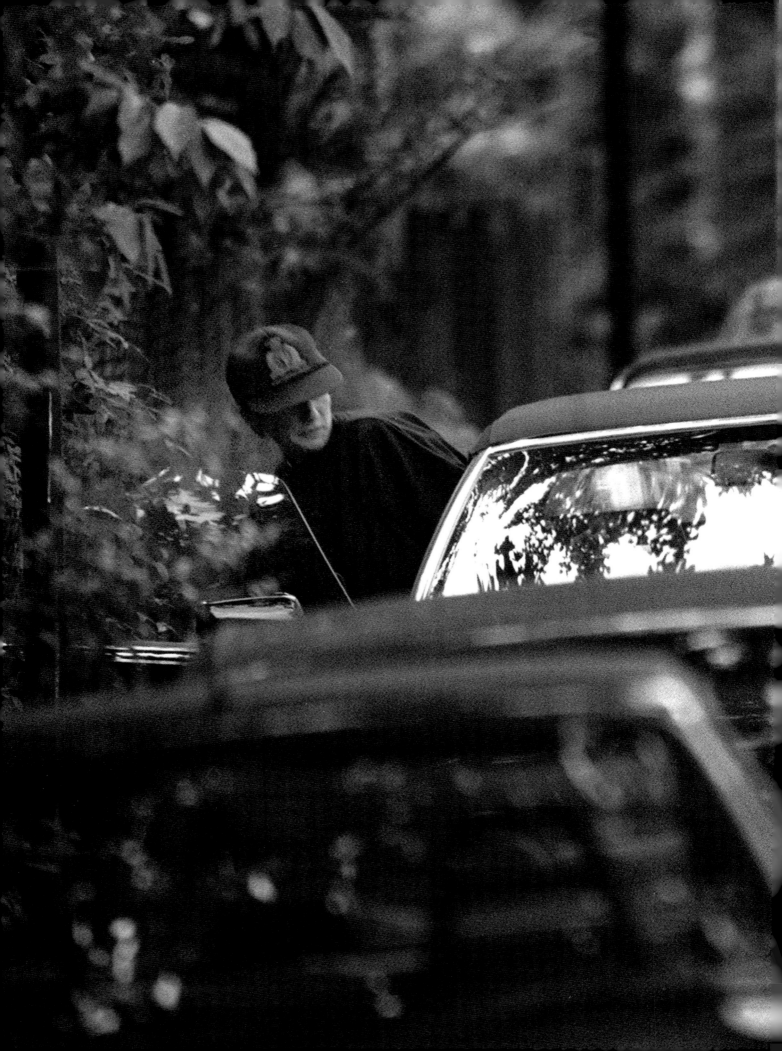

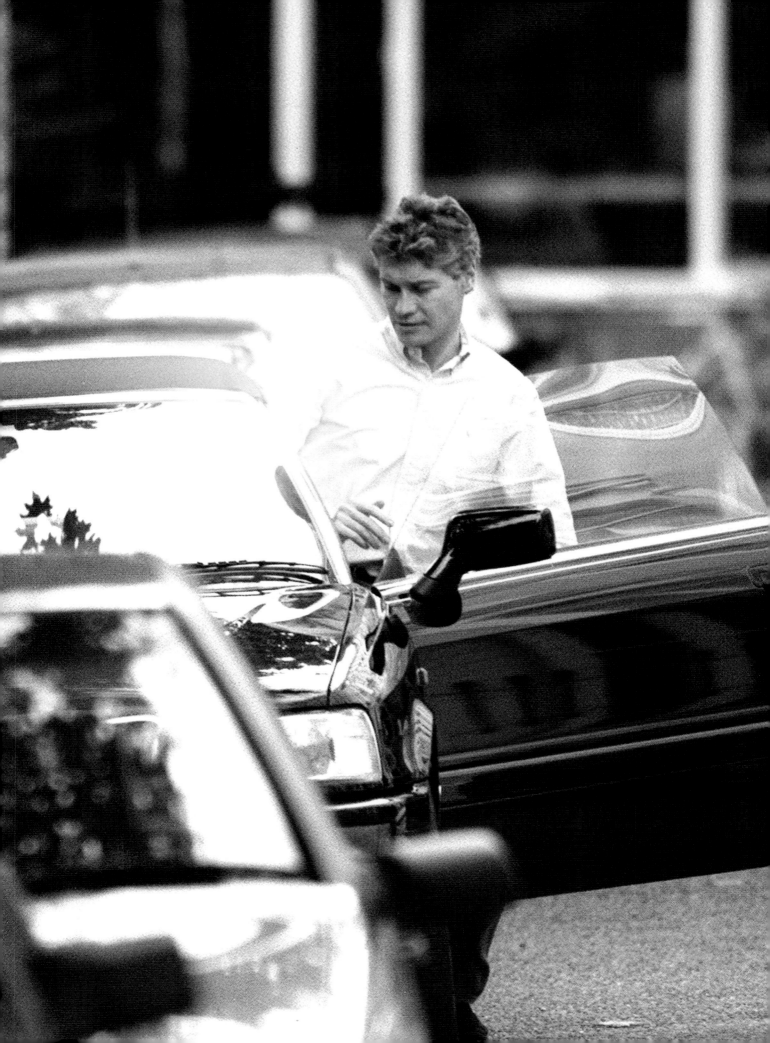

A long silence followed. I was feeling embarrassed that I had put a fellow pressman in such a difficult position. Perhaps I should have warned him that the pictures were going to appear. I didn't know what else to say to him. Breaking the long silence, at last he said something that has puzzled me to this day. 'Is there anything else to come?' he asked quietly.

After a long pause, I asked: 'What do you mean?' I was totally bemused by his question. He had caught me completely by surprise.

'Anything else to come?' he said again quietly.

'Not from me,' I blurted. I was now feeling sorry for him somehow. I could tell from his voice that he was concerned about something.

We bade farewell and I continued my meal. Thinking about the call afterwards, I couldn't help wondering why he had said what he said. Was he referring to the following morning's papers and what else they would reveal about his encounter with Diana? I was kicking myself; what had I missed that day?

Back in Talbot Square, the Audi's passenger door opened and Richard Kay stepped out. He walked around to the driver's door and opened it for Diana. He was the perfect gentleman. She got out and they stood talking. It was the first clear shot of them together so far. I rattled off a few pictures from my now perfect viewpoint. 'Give her a kiss, give her a kiss,' I pleaded under my breath. Even if they weren't having a relationship, a newspaper can insinuate all sorts of things from a goodbye kiss. They stood by the hedge, laughing together and chatting. She was looking very relaxed and happy in his company. Diana laughed some more as she got into the car, with Kay holding the door open again.

As she stepped in, her seat needed adjusting, so Kay leant in to fix it. Their faces were only inches apart as they gazed at each other ...

'Do you know you're being photographed?'

From nowhere, an old man appeared, banging on the roof of Diana's car and pointing up at my window. Words cannot describe how I felt about that old busybody at that moment. I was so livid, I nearly threw my camera out of the window at him. Diana and Kay had pulled apart the second he had interfered. Diana started the car and reversed around the square in search of an escape route. Kay had a look around the streets for a few minutes afterwards, while Antony and I watched from our hides. He gave up after a while and drove off, leaving the old man standing alone on the pavement.

We had a great show the next day in the *Sun*. 'QUEEN'S FURY AT PLOTTING DIANA' ran the headline. Television crews, cameramen and journalists crowded the small square the day after, all eager for a snippet of information from residents or passers-by. The old man had butted in just before we could possibly have known more of the true story. The world was intrigued, and so was I.

At this stage we had no idea of the *News of the World* story being prepared for the following day. 'DI'S CRANKY PHONE CALLS TO MARRIED MILLIONAIRE' the headline would scream. The story told how Princess Diana had made more than 300 nuisance phone calls to art dealer Oliver Hoare. The story further alleged that Diana had plagued Hoare with calls just to hear his voice. She was even reported to have screamed abuse at Hoare's wife. Eventually, Oliver Hoare had called in the police and a tap was put on the phone. It was discovered that the calls were coming from Diana's private line

at Kensington Palace, as well as from her mobile phone and a series of phone boxes around Kensington. It was incredible stuff and, of course, the single biggest news story in the world. In the light of Diana's meeting with Kay, we knew a denial would be coming from the *Daily Mail* the following day. It would be interesting to see how they played it, knowing we had pictures of the *Daily Mail*'s royal reporter Richard Kay meeting with Diana.

As the *News of the World*'s story reverberated around the world, the rest of Fleet Street jumped on the bandwagon. The following day, the newspapers carried accounts of Diana's 'lunacy'. Expert psychiatrists were interviewed on television to try to explain her bizarre behaviour. Her 'close friends' were asked to explain her loneliness. But nobody seemed to doubt her guilt in the matter – all except the *Daily Mail*. Richard Kay's front-page exclusive carried an interview with Diana, quoting her plaintive cries of innocence in full. The paper had decided against quoting Diana as a 'close friend', as they usually did, because of the exposure in my pictures. Diana claimed that she hadn't made the calls, coming up with all sorts of excuses as to where she was when they were allegedly made. She was hardly convincing, when you remember that the calls came from her private lines, her mobile and her sister's house. In response to Kay's question about calls also being made from public telephone boxes, Diana replied: 'You can't be serious. I don't even know how to use a parking meter, let alone a phone box.'

Mine and Antony's pictures were splashed all over the *Sun* the day after the Hoare story broke, foiling Diana's further attempts to manipulate the story via the *Daily Mail*.

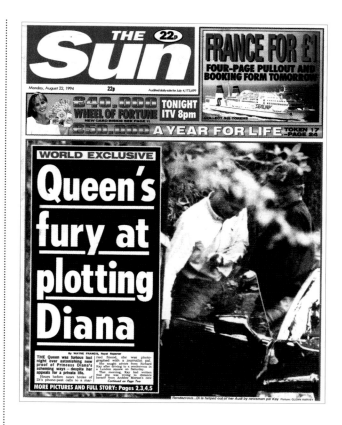

One result of the phone-call saga was that we got far better pictures at the Harbour Club the following week. Diana, thrown against the ropes by the sensational headlines, decided to show the world that she wasn't bothered by the controversy. Each day, she would turn up at the club, park her car 100m from the entrance, and walk past the assembled snappers without a care in the world. Because of the massive interest in her, and the fact that the story still hadn't died down, there was always about 50 snappers enjoying this spectacle and all captured pictures of a happy, smiling Diana.

The whole week amazed me. Both Mark and I would stand watching Diana give everyone a picture, remembering the many fall-outs we'd had with her at the Harbour Club. Now, she was more

Right: A bemused Oliver Hoare came down the road towards us, clutching a huge pile of pizza boxes. 'Gentlemen,' he said, 'I'm allowing you to stand outside my house. Do I have to pay for your pizzas as well?'

than happy to be photographed. We both knew from experience that if Diana wanted to get in and out of the club without being photographed she could do so quite easily.

Mark, September 1994

We staked out Oliver Hoare's £2 million mansion in Chelsea for the next month. Every time he came out, Mr Hoare was cordial and polite, but he never uttered a word about the allegations. Diana was said to be incensed that he refused to defend her publicly. Oliver Hoare was an extremely handsome man. Tall, with ruffled, dark hair and a boyish smile, it's easy to see where his reputation as a ladies' man came from.

One day, we were staking out the house when somebody came up with the idea of ringing out for pizza. It wasn't possible to ask Pizza Hut to deliver to a 'blue Golf VW parked in Tregunter Road', so we gave Mr Hoare's address, thinking we could stop the delivery boy at the gate. As usual, we were watching football on Glenn's tiny Sony portable, so no one saw the delivery boy go into Oliver Hoare's house. The first we knew about it was when a bemused Mr Hoare came down the road towards us, clutching a huge pile of pizza boxes. 'Gentlemen,' he said, 'I'm allowing you to stand outside my house. Do I have to pay for your pizzas as well?'

Sadly for Diana, not all her ex-boyfriends have been such gentlemen. As the Oliver Hoare saga began to die, a particularly nasty piece of work was preparing to crawl out of the gutter in the shape of a man who has haunted her, in life and death, ever since.

James Hewitt came into Diana's life when she was at her most vulnerable. Suffering terribly from bulimia and desperately trying to come to terms with her husband having a mistress, Diana met Hewitt at a party in Belgravia in 1986.

I first met Hewitt following the *Daily Express* interview, when he pompously told the world how much of a friend he was to Diana, without revealing any of the details of the affair. After the *Express* story, Hewitt fled to Switzerland. Fleet Street pursued him but he managed to evade them. Though I never considered following Hewitt abroad, I must admit that he went on to the list of potential targets. A good set of pictures on him would now be worth money.

A couple of weeks after the *Express* interview, we were at Windsor Castle. In addition to Glenn and I, there were plenty of other paps, including Jim Bennett and Julian Parker, two of the very best. Around noon, we left the castle and retired to the Two Brewers, our favourite watering hole, leaving dear old Roy Milligan on his almost permanent watch on the castle. We were just tucking into our veggie sandwiches and real ale sausages (we were all on a health kick) when the pub door opened and James Hewitt came in.

Talk about walking into the lions' den.

Hewitt, the most wanted man in the country, stood at the bar and ordered a drink, standing just yards from the cream of Britain's paparazzi – and nobody recognised him, except me.

Mike Lloyd was discussing the morals of long-lens photography. Jim and Julian were telling him to shut up, and Hewitt was standing just behind them. Incredibly, even though our cameras were all over the floor, Hewitt had not realised who we were. I saw that he was about to leave so I stood up,

Left: 'He did what with my wife!'
Charles and Hewitt square up at
polo in Berkshire.

my body shielding him from my colleagues. Even though they were my mates I was hardly going to tell them that Hewitt was just leaving.

When he went, I followed him out, making some excuse about checking up on Roy. I watched Hewitt stroll onto the long walk outside the castle. I jumped into my car, wanting to get to the end of the long walk before he did. He caught up with me about 10 minutes later. 'Excuse me, can I have a word?' I said.

He turned, immediately saw my cameras and knew that I was press. 'No,' he said and walked off quickly.

I ran in front of him and put my hand on his chest, preventing him from going any further. 'Look, pal, there's an easy way to do this and a hard way. The easy way is for you to give me a picture; the hard way is for me to make a phone call and half of Fleet Street will be here in two minutes.'

He looked around anxiously. 'I don't want any trouble,' he pleaded.

'Fine,' I shrugged, 'then give me a picture.'

He looked like a frightened rabbit. 'I don't want any pictures,' he said.

'I don't care what you want. One way or the other I'm going to get one, so why don't you do yourself a favour?'

I'd always imagined that Hewitt had the cunning of his breed, but like a fool he posed for me. Then I rang the others and told them where he was.

After *Princess in Love* was released to worldwide condemnation, Hewitt fled to France with his mum. Fleet Street was unable to find him, so the *Sun*, in desperation, ran a poster campaign throughout the country asking locals to help 'Find The Rat'. Underneath was one of the pictures I had taken on the long walk six months earlier.

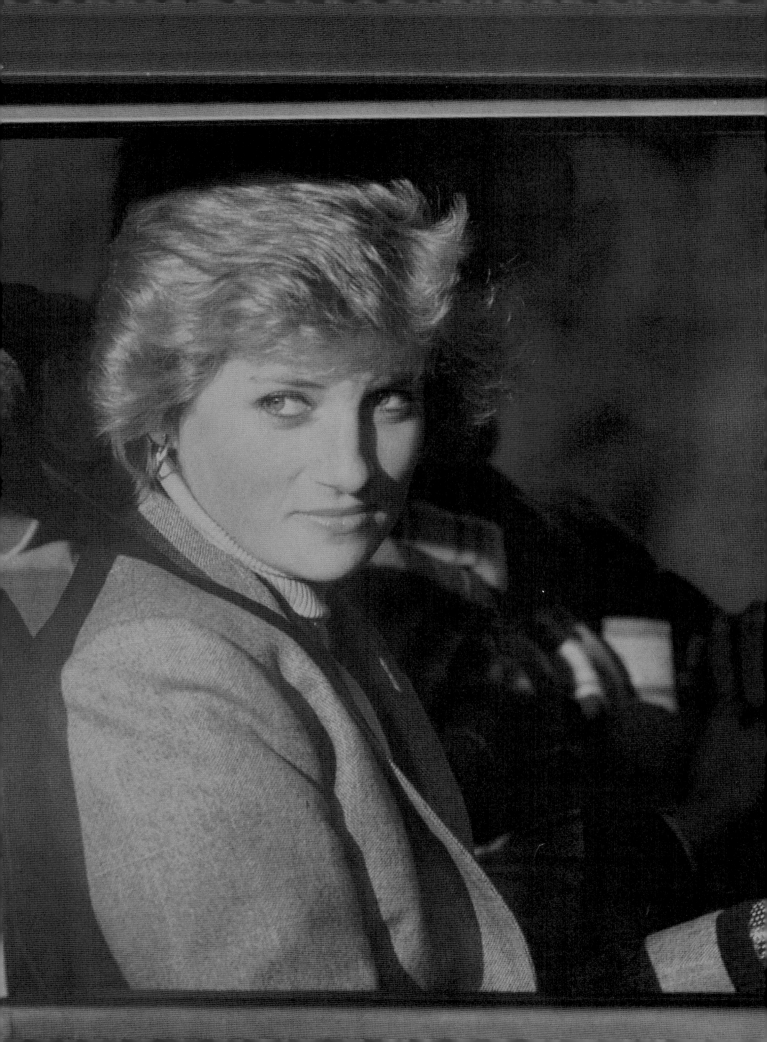

Conquering America

Mark, October 1994

Despite her problems at home, America was still hopelessly in love with Diana. So, when Prince Charles decided to go on TV and tell the world what everyone knew – that he had been unfaithful to Diana – it was to America that she fled to ride out the storm.

Diana had accepted an invitation to visit the Red Cross HQ in Washington, a canny move as it meant she could spend time with her best friend, Lucia Flecha De Lima.

The trip got off to a bad start for me. I flew to Washington with fellow snapper Andrew Murray on what we thought was Diana's flight. Unfortunately for us, Diana was on her way to New York on Concorde.

Andrew had an annoying habit of believing that planes would wait for him. He turned up at the departure desk, McDonalds cheeseburger in hand, just as they were closing the gate for the Washington flight. The in-flight movie was Danny De Vito's *Renaissance Man*. Due to some technical cock-up we were due to land before the film finished. Andrew further endeared himself to the cabin crew by asking if maybe the plane could circle the airport until the movie ended.

Arriving in DC, we had no idea that Diana was actually in New York. We hung around the airport until we heard where Diana was from the TV news, watching on a small screen in the bar. We drove to our hotel, convinced that even now the New York paps were hosing Diana down outside the Rockerfeller Center. We'd also been robbed of the chance of going to one of the greatest cities on earth. And New York loved us as much as we loved it: Saks on Fifth Avenue would stay open late when the British press arrived. I remember the first time I saw Ralph Lauren chinos on sale for $10. 'I'll have a size 34,' I said to the sales assistant.

'In what colour, sir?,' he asked.

'In every colour you've got obviously,' I replied.

On the infamous 'Squidgeygate' tape, Diana joked she had dressed James Hewitt from head to foot. We always said that she had done the same for us!

The following morning, we drove to the Brazilian embassy. The Washington press corps, that monumental tribute to media badges, were out in force, awaiting Diana's arrival later that day. There are probably more reporters in Washington than any other city on earth – and every one of them is looking for another Watergate. Though they may be capable reporters, none of them had a clue how to do a 'Diana' job. For a start, they really resented the fact that they had been forced to abandon their non-stop reporting of President Clinton and his ongoing problems with his tubby intern friend Monica Lewinsky. They kept asking the Brazilian embassy to give them full details of Diana's itinerary. When the embassy refused, they loudly complained about how the hell they were supposed to do their jobs. 'Maybe try being reporters,' we told them.

The embassy did supply endless cups of coffee, sent out on silver plates, to the pressmen camped outside the main gate.

Being far more experienced in covering Diana, us paps set up shop in the bushes opposite, enjoying take-away Big Macs.

There was a massive police presence – supported by our old friends from Langley. But despite all the secrecy and the heavy security we had already discovered which bedroom Diana was in. This was achieved by the simplest of means. All the security

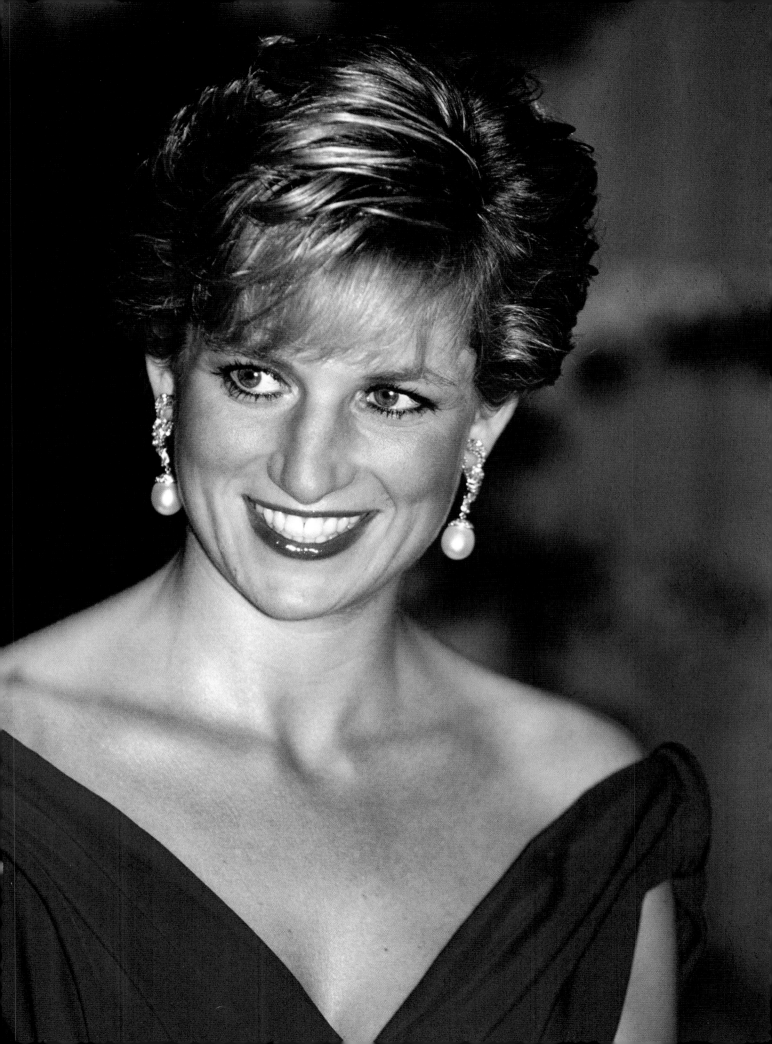

in the world cannot stop people talking. Andrew and I had been outside the embassy's staff entrance since 6:00 a.m. that morning, from where we followed a Brazilian maid to the supermarket. She was thrilled to bits that Diana was in town and obligingly told us how she had made up the princess's bed that morning. Thinking we were English tourists, she then told us which room Diana was staying in. We raced back to our bush to wait for the shot we just knew would be coming.

Every morning when Diana woke up, the first thing she did was look out of the window. Most mornings, she would see the immaculate lawns of KP. On this morning she was greeted by Andrew and I pointing our lenses at her. The pictures were good, but not sensational. Diana had on a sweatshirt and tracksuit bottoms. The only original feature of the snaps was that Diana wore no make-up.

But she was still beautiful.

The you-know-what hit the fan as soon as the pictures were published in London. Suddenly the CIA were swarming all over the place, trying to prevent any more such pictures being taken. With that typically American policy of beefing up security after the event, they decided to erect barriers behind which the press could stand. The Washington press corps embraced the barriers like an alcoholic embraces the bottle. They are never happier than when they have a place they can call their own – the 'pig pen', as it's affectionately and quite correctly called.

The chief of police made it clear to the assembled media that anyone caught in the bushes opposite the embassy would be in big trouble. We found this quite amusing, as at the time we were listening to the speech from the bushes opposite the embassy.

Later that day, Diana visited the Washington HQ of the American Red Cross, in her capacity as advisor to the IRC. The trip was memorable only for the antics of Elizabeth Dole, wife of US politician Bob Dole, whose ability to pop up in every photograph made Nancy Reagan look positively camera-shy.

Nearly 100 photographers were assembled about 20m in front of the entrance of the building, waiting for Diana to come out. We had been promised a photocall on the steps and, shrewdly, had positioned a bunch of school kids on a day trip in front of us. We knew how much Diana loved children and figured she would not be able to resist coming over to see them. However, when Diana finally came out, Mrs Dole steered her towards her own personal photographer. We kept shouting at her to get out of the way, to let us have Diana on her own, to let Diana see the children, but Mrs Dole was having none of it. Diana never even saw the kids, who by now were shouting louder than we were. Mrs Dole stayed by her side right up to the point until Diana's head disappeared inside the waiting limo, leaving behind a group of bitterly disappointed children and an extremely pissed-off press corps.

At 6:00 a.m. the following day, I was back in my favourite position in the bushes. Next to me was American snapper Ken Sadino, one of the more ambitious members of the Washington press corps. A small group of cops was huddled outside the main entrance. The CIA were nowhere in sight. Possibly they were off somewhere, taking over a small African country. Or maybe it was a bit too early in the day for them.

The pictures Andrew and I had got the previous day had again been published, which had really made the security services angry. They were

determined to prevent it happening again and had closed off all entrances to the bushes – but only after we had taken up our position. Though we had a good view of Diana's room, it was back-breaking work. We knew we would only have a split-second to take a picture. Consequently, we had to have the lens trained on the window constantly, ready to fire the motor wind at six frames a second. Apart from sending you boss-eyed, this position plays hell with the spine. Being hunched over a lens which is pointing skyward is remarkably similar to a torture improvised by the British in Northern Ireland, where a man is forced to lean against a wall using only his fingertips to support himself.

At around 8:00 a.m., I spotted a fraction of movement at the curtain. My finger was delicately poised on the shutter-button, the lens perfectly focused. 'Get ready,' I whispered to Ken. Hardly able to believe it, I saw one of Diana's eyes peering out from the left-hand side. Slowly, more of her face came into view and I realised that she was checking to see if the area was clear. She looked down at the cops, saw no press and assumed she was safe. Standing up fully in the window, she was wearing just a white towel, which covered her breasts and midriff, and taking small bites from an apple. She stayed there a while, enjoying the early-morning sun and the peaceful surroundings of Embassy Row. She must have thought how nice that moment was – a moment that was eventually shared with the 5 million viewers of the American tabloid show we sold the pictures to.

Whenever we went on a foreign trip, it was rare that we got to see any of the places we visited.

Hunting Diana was a full-time job and we had no time to play at being tourists.

One time we were in Canada and I was trying to get pictures of Diana with William and Harry. I was being followed around by an American TV crew, who were doing a piece yet again on Britain's 'Di hunters'. Desperately trying to focus my camera, I angrily said: 'If that goddam waterfall wasn't in the way this would be a great picture.'

'That's Niagara Falls,' said the TV producer accompanying the crew.

I looked up sharply. 'Is it?' I said. I had always wanted to see Niagara Falls, but at that moment it was in my way.

Therefore, it was quite a treat for us to get a whole day off at the end of that Washington trip. Andrew and I went to the Holocaust Museum, which we found as horrific as anybody would, and then we went on the official tour of the White House.

Now it's funny, but, whenever we covered the big royal estates such as Sandringham, Balmoral or Windsor, we would always be surrounded by tourists, especially Americans. We took great delight in telling them all the stories about royalty that they never read in the papers. Of course, we would also casually mention that the queen would be riding across the lawn in front of them soon. The look on their faces when the queen appeared was amazing. They were so excited. Many times we watched American tourists jumping up and down, shouting: 'We saw the queen. We saw the queen.' It always made us feel a bit smug. We would just stand there and say: 'Yeah, yeah, it's no big deal. We see her every day.'

So there we were, being escorted around the White House in a big group, and who should come

walking down the corridor but the president and Mrs Clinton. He was so nice. He asked everyone how we were enjoying the tour and told us all to have a nice day.

When we got outside we began jumping up and down, shouting: 'We saw the President. We saw the President.' The Americans just stood there smugly and said: 'Yeah, yeah, it's no big deal. We see him every day.'

Glenn, November 1994

While Mark was gallivanting up and down America's East Coast, I was doing some real work back in England. Prince Charles had taken his sons William and Harry to the queen's estate at Sandringham in Norfolk for the weekend. Sandringham is the hardest royal estate to obtain decent pictures. It is virtually impossible to know where anyone is going to be at any given time. All you can rely on is experience and luck, two things which certainly came in handy that weekend.

The only way to keep an eye on the many exits at Sandringham is continually to drive around the perimeter of the estate. It's a huge place, so this takes about 50 minutes to do. The police make a point of taking the number plates of every car in the area, so it's never long before you find a cop car on your tail and pulling you over. Once they spot you, they immediately relay the information to the central security office.

The good thing is, the cops at Sandringham are the friendliest of all the royal residencies. One day, with a flash of blue light, they signalled me to pull over. 'Good morning. Who are you after today?' they enquired with a grin. The police there were always ready for a chat. After a week on the beat

around the flat plains of the Norfolk estate, with nothing to look at but doomed pheasants, even a chat to the paparazzi seemed interesting to them.

'How far can you see with that lens?' the policeman asked, pointing at the large telephoto on the seat.

'Why don't you have a look?' I said, handing over the lens.

He nearly fell over backwards from the weight of it. The policeman peered through the eyepiece seeing if he could pick out the colours on a bird half a mile away. 'Blimey, you can see for miles. Look at this, Ted [real name changed].' Ted got out of the car and took the lens from him.

At this point, my attention was drawn up the road in the direction of the main house. Three green Range Rovers were speeding in our direction. As they reached us, they slowed down to walking pace as they passed by. I could see the three royal faces of Princes Charles, William and Harry gazing at us with much bemusement. Prince Harry was laughing and pointing from the back seat, alongside Tiggy Legge-Bourke, the boys' nanny.

'My God! Even the police were trying to take photos of us now!' Charles must have been thinking. The policemen were standing at the edge of the field, holding a massive 800mm lens and looking just like paps. The three royal cars zoomed off into the distance and out of sight. The cops returned the lens to me, looking embarrassed. I felt for them as we parted company. As I watched the patrol car turn away round the corner, I jumped back into my car and crashed my foot on the accelerator, racing away in search of the royal cars. I guessed that they were heading for a favourite royal haunt – Holcombe beach. This remote spot is

45km from Sandringham and is also well used by bird watchers and naturalists.

I was right about their destination. The Queen Mother had a lodge there that she used for summer picnics. I arrived at the beach just in time to see the gathering of royals and detectives walking over the sand dunes to the waterfront. Charles was first to reach the sea, followed by Tiggy and the rest of the party. But there was no sign of William and Harry. Perhaps they had been dropped off somewhere. I snapped some pictures of Charles and Tiggy walking together and then mulled over my options.

I decided to go and find the boys and started on the 45-minute hike back along the beach to my car, which to this day I have never done at less than a jog: to walk could result in a missed set of pictures.

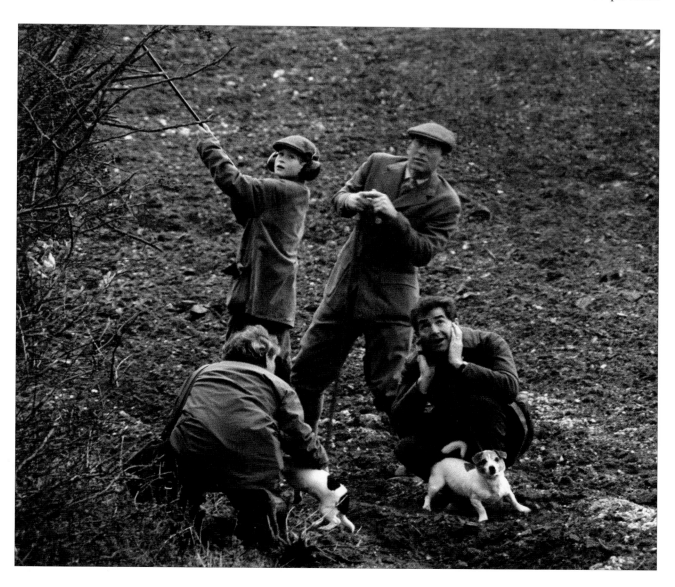

Boys and their toys. **Below left:** William and Harry figure out how to give
Harvey the dog a ride, otherwise he might not talk to them again.
Below right: Harry rides at full throttle towards the waves.

Running across the dunes, I stopped when I heard the sound of engines to my right. I climbed up the side of the dune, pulling myself up by the tufts of grass. The noise was getting louder and I could also hear the cries and shouts of children. I reached the summit and fell over backwards as I faced the spinning front tyres of two motorcycles charging towards me. Tumbling down backwards to the bottom of the dune, I was quickly followed by William and Harry riding fast and recklessly on their Suzuki motorbikes. 'Sorry, sir,' they shouted, hurtling across towards Prince Charles at the waterfront.

I'd found them, although I was in no position to snap as I was smothered from head to foot in sand, my cameras and lenses buried beneath the surface. The boys, meanwhile, were having great fun on their new 50cc trail bikes, motoring up and down the beach. I wondered what their mum would have thought of the dangerous speeds they were reaching. I picked myself up and, standing in full view of the royal protection police and Charles, took my photos.

Unfortunately, the boys' fun came to an end earlier than they had anticipated. Harry thought it would be a good idea to race close to the waterfront. William followed as they skimmed past the breaking waves, each time heading in deeper. But in their excitement they pushed their luck too far, riding their bikes into a particularly high breaker. They both tried desperately to control the motorbikes as they came to a complete and sudden halt. Steam and water filled the air as William, with a worried look, turned round quickly to see if his dad had seen what they had done. Harry didn't care. He was laughing and waving the steam away from his face. Charles had seen the whole thing happen and was already making his way towards them, walking stick in his hand. The boys would be in trouble now.

All this was making great pictures. William and Harry were helped from the water with the bikes

and were given a stern telling-off by Charles. They pushed the motorbikes back across the sand towards the royal hut as neither would start up again. Everything was soaked and sodden, but the boys were still in great spirits. They knew that the next day they'd be returning to school full of stories of the great adventures they'd had with their father and Tiggy.

Watching Charles's reaction to the media presence in comparison to Diana's, I saw a fundamental difference between the two: Charles couldn't care less who was watching when he played with the boys, whereas Diana felt she had to protect them from any media attention.

Mark, December 1994

Many times in pursuit of Diana I found myself in the wrong place – but it was rare that I found myself in the wrong country. That was the predicament I found myself in that Christmas. It

was one foreign assignment I never want to repeat.

Following the traditional royal gathering at Sandringham on Christmas Day, Diana had driven back to London alone. As William and Harry were staying on with their father, we were on red alert, waiting for Diana to go abroad for a Christmas break.

By 28 December, there was still no sign of movement from KP and I became convinced that she wasn't going anywhere. As my bags and equipment were all packed, I accepted an invitation to join a foreign news crew in the Swiss ski resort of Klosters, where Sarah Ferguson, Fergie, was arriving the following day with her children. Charles, William and Harry were expected there at the end of the week as well.

Imagine my horror on waking up in Switzerland to be told that Diana had arrived in Colorado the previous day. I rang Leon, my travel agent, in a panic, trying to recall which part of America Colorado was in. I knew Leon wouldn't know. He wasn't best pleased at having his Christmas holiday ruined by a panicking paparazzo.

'Leon,' I said, packing my gear with the phone cradled under my chin, 'I need to get to Colorado.'

'Colorado?'

'That's right. Colorado. Go to Texas on the map and turn left.'

He sighed dramatically but sprang into action. I could hear him tapping the keyboard on his computer. 'You're in luck, my boy,' he said. 'There's a United Airlines flight in two hours.'

'I'm not in luck, Leon,' I said. 'I'm in Switzerland.'

'Switzerland. What are you doing there?'

'Don't worry about it. Can you fly me from Zurich?'

After a bit of to-ing and fro-ing, we worked out that I could fly to Colorado the next day – from Heathrow.' Reluctantly, I accepted.

How I wish I had stayed in Klosters.

The nightmare began as soon as I arrived on American soil. The flight was not direct, which meant I had to pass through immigration in St Louis, Missouri, and then catch an internal flight to Denver. These days we are used to airport security being heavy handed, but back then it was unusual for a white man from England to have any problems. But I'd never been to St Louis before. The immigration officers there made the SS look like boy scouts. They took one look at me and decided they didn't want me in their country. Unfortunately for them, but fortunately for me, they had no reason to kick me out – but they were determined to find one. I was forced to undergo a severe interrogation at the hands of their chief ball-breaker, an obese female officer who acted as if the British were still raising taxes in Boston.

What was laughable about the situation was that I had no visa to work in the States and that I lied through my teeth throughout the entire interview. Happily for me, the immigration officer's brains were not in proportion to her body.

All of my cameras and lenses had been taken out of their cases and were laid out on the table before me like exhibits in a court case. It was obvious I was not going to get away with claiming to be a tourist. Instead, I told her I was a wildlife photographer on my way to Denver to take pictures of the snow-covered Rockies. After about 30 minutes of questioning, during which I contradicted my own story several times, she went into a small cubicle to confer with another immigration officer. I could see them through the small window. The woman was pointing at me and shaking her head as if to say: 'I don't believe a word he's saying.'

At length, she returned with a man. It was obvious by his manner and smart uniform that he was her superior and I knew I would not be able to get away with bullshitting him. I had to come clean if the questioning persisted. Silently, he looked at my equipment still lying on the table. He picked up the huge 500mm lens, glanced at it, then put it down. He looked at me. 'Where are you heading?'

'Denver.'

'Where are you staying?'

'Holiday Inn.'

He looked straight at me. As he spoke I felt a chill go up my spine. 'We're not dumb. We know exactly why you're going to Denver.'

'Fine,' I said, figuring the game was up. 'So why are we bothering with all these questions?'

'You should have just told us the truth in the first place,' he said.

I thought they were about to put me on the first Concorde back home but, incredibly, he picked up my passport and stamped an entry visa inside. As he handed me my documents, he smiled and said something that, to this day, I still don't understand: 'Just remember – the American bald eagle is a protected species.'

Diana was staying at the ultra-exclusive, mega-rich resort of Vail. It was the type of place where everyone looks like an extra from *Beverly Hills 90210* and where all the jocks are Ivy League.

Without doubt, it was the coldest, most miserable hole I have ever been to. Downtown Baghdad is more friendly to an outsider than Vail,

Below: Whether glammed up or dressed for the country, Diana looked the part.

Colorado. From the moment I arrived, I decided not to leave the warmth of the local Holiday Inn until I could get a flight to Palm Beach or LA – or outer-frigging-Mongolia. Anywhere that had sun and warmth and where people spoke to you without looking down their noses. I'm British, so, believe me, I know about class. In Vail all they knew about was money, and the place stank of it.

Diana had been in town for three days before I arrived. There had been some pictures taken by the local paps, but by all accounts they were pretty routine snaps. Most of the images were of a woman clad in skiing gear, complete with goggles and ski mask. It could have been anyone.

The only good thing about that poxy place was the arrival of my good friend Shane Anthony, the Yankee equivalent of Mike Lloyd. I had known Shane, who was based in Denver, for a couple of years. We had worked in LA together a few times and his presence was just what I needed to drag

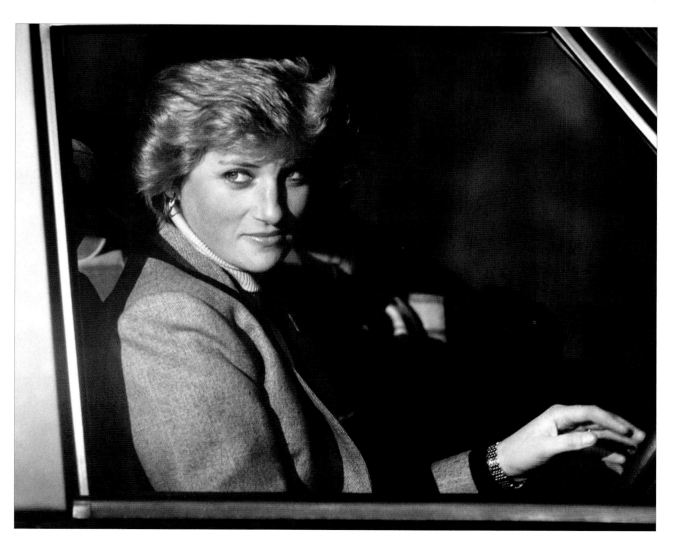

Below: Diana was not keen on shooting pheasants – she preferred to shoot with a camera instead.

myself from bed, brave the cold and find Diana. The only problem I had with Shane was his irritating habit of calling me his 'homeboy', whatever that means.

The word on the snow-covered streets was that Diana was staying with friends at a luxurious chalet further up the hills behind the Holiday Inn. This was good, as it meant I did not have to go far to find her. There were other members of Fleet Street hanging around, but none of them was convinced Diana was staying at the chalet. Their pessimism stemmed from the somewhat limited sightings of Diana over the previous three days. Already we were hearing she had left the town.

By New Year's Eve, Shane and I were the only ones left. We were parked further down the road from the chalet listening to the beautiful sound of children singing 'Silent Night' somewhere far below us. The chalet had huge bay windows in front and we could see the table being laid for dinner. It was obviously going to be an intimate gathering; so good was our view we could see the four places being set.

At around 8:00 p.m., a middle-aged man and woman came in; about five minutes later, Diana walked into the room. To say I panicked on seeing Diana would be an understatement. I was so shocked that I dropped my lens, which clattered out of the car and landed with a sickening thud in the snow. I leapt from the vehicle and, crouching in the snow, began focusing on the dining-room window high above me. Our position was pretty useless, though. We could see everyone *except* Diana, who was partially hidden behind the window frame.

Somehow, we had to get higher up the hill to get the right angle. The only way to do this was to

break Colorado's severe trespass laws and sneak on to somebody else's property. The chalet next to Diana's was perched on top of a steep slope. We jumped over a small wall at the bottom of the slope and began clambering upwards. It was not an easy journey: the snow had covered all manner of obstacles, such as rocks, bushes, a small fence – even a child's bicycle. We were continually slipping over and sliding back down in the snow. I think it took us about 25 minutes to cover less than 50m, but eventually we were at a point where we were roughly level with the room Diana was sitting in. The distance between us and Diana was about 40m. Raising my lens, but keeping low, I looked through the view-finder. It appeared to be the world's most boring dinner party. Nobody was speaking, nobody smiled. All four people sat around like zombies eating their food and staring straight ahead.

But Diana's obvious boredom was not my concern at that moment. For some reason I couldn't focus my camera. I turned the focus ring, twisted it and at one point even whacked it with the palm of my hand, but still I was getting nothing but a muzzy haze through the view-finder. Panicking, I thought about the moment I had dropped the camera earlier. Had it been damaged? Canon lenses are among the toughest in the world. It would take more than a drop in the snow to damage one. I tried to be calm. I picked up the camera, looked through the view-finder and delicately turned the focus ring. Absolutely nothing. The same muzzy haze.

As I considered picking up the lens and throwing it through the nearest window, the whole area was suddenly bathed in a flashing red and blue glow. The crisp whiteness of the snow-covered mountain was suddenly swathed in a psychedelic light show. I looked at Shane. Sometimes there are moments when you just know you are in trouble and, as the bull-horn crackled below us, we knew this was one of them.

'You people on the mountain,' a cop's voice said, 'this is the Vail police department. Come down immediately.'

'It's the cops,' Shane whispered fiercely.

'You don't say,' I replied.

The police officer repeated his words, adding that, if we didn't come down, they would come up. Briefly I wondered how on earth they would manage to clamber up the mountain as we had just done. Knowing the Americans, they would probably bring in a helicopter assault team.

'We're coming down,' Shane called.

We both got up with our hands raised. Below us appeared to be half the Vail police force, all staring up at Shane and me. The trip back down was made even more difficult by the flashing lights of all the cop cars. In the end we gave up trying to walk and just slid down on our butts. The cops were like cops all over the world who suddenly find themselves in a Diana-related incident. They were desperately trying to find: (a) a reason to arrest us, and (b) a reason to go in and tell Diana they had arrested us. Fortunately they could find neither. The trespass laws were useless. Due to the snow, it was almost impossible to see where one property ended and another began. You wouldn't need a top lawyer to beat that rap.

Reluctantly, most of the cops left. We had robbed them of their chance to meet Diana. We were left with two cops who took down our details.

Fortunately for me, they were the two most decent cops on earth. If it hadn't been for their natural concern for others and sharp observation skills, I doubt I would ever have taken another photograph in my life. As I had no gloves on, my hands were freezing cold. While speaking to the cops I kept them firmly planted under my armpits in a futile attempt to warm them. The first officer, a young black guy, noticed this and asked what was wrong.

'Cold,' I muttered, 'really cold.'

'You should have gloves in this climate,' he said. Moving closer, he asked to see my hands. I held them out to him and his buddy shone a torch on them. In the torch's beam it was easy to see that my thumb, index finger and middle finger on my left hand had turned green. The cop's concern was genuine and terrifying at the same time. 'Frostbite,' he said, looking into my face, 'and it's serious. We've got to get you to a hospital.'

Later that evening, after I'd undergone the intense agony that comes with curing frostbite, a young doctor told me how close I had been to becoming permanently disabled. 'Another 20 minutes and those fingers would have just snapped off,' he said.

I remembered trying to focus the lens. The camera wasn't busted – there was simply no feeling in my fingers. The focus ring hadn't even been moving when I'd tried to use it.

The following day I left Vail on a flight to Palm Beach. As the plane came down in glorious sunshine, I thought about the next American trip Diana was due to make, where the snow-covered slopes of Colorado were to be replaced by the glittering skyscrapers of New York.

Already, people were saying she wouldn't find the Big Apple as easy as DC. New York was harsh, made up of real people, not politicians desperate for publicity.

Diana had no worries. The chattering social classes of Manhattan, with their arty fashions, gallery openings, Fifth Avenue shopping and apartments overlooking Central Park would fall to her more easily than they had fallen to the Beatles.

And, like the Fab Four, all it took was a change of hairstyle.

Diana's trip to New York lasted just 24 hours, but it was a triumph and so consolidated her position as the most famous and glamorous woman on earth. You could have put every A-list Hollywood star on one side of the scales and Diana on the other, and they would still have balanced in her favour.

From the moment she arrived, Manhattan was buzzing. Everyone wanted to see her, even the notoriously harsh New York cabbies managed to be excited. 'My wife loves her,' one said. 'Get me an autograph, bud, signed to Angela.'

Diana was staying at the prestigious and ridiculously expensive Carlyle Hotel, which overlooks Central Park on the Lower East Side. It's impossible to walk those streets without feeling Woody Allen's angst. Spotting a clutch of photographers outside the hotel, Robert De Niro laughed a quick 'Hello'. John Malkovich sipped coffee with us and Steven Spielberg waved. Even Sean Penn lost his permanent scowl and smiled.

It was a trip for meeting the stars – but not always in the best of circumstances. I had hooked up again with Larry Schwartzwald. I hadn't seen Larry since Martha's Vineyard and it was great to be working with him again. Larry is pure New

York: tough, loud, brutal sense of humour, but a big cuddly softie inside.

Diana was staying at the hotel on that first night, so I went downtown with Larry. Mickey Rourke was due at a party near Wall Street, so for want of anything better to do I tagged along. We stood on the cold street outside a warehouse. The party was being held in the basement. The street wasn't well lit. The snow had started to fall and I had the feeling that I was in a *Death Wish* movie. As we stood there, alone on the street, a car cruised by. Two men inside looked at us. A few moments later the car came back the other way. Again, the two men inside peered at us.

Mickey Rourke duly showed up, his once-handsome features ravaged by years of hard drinking and bad plastic surgery. Then the car cruised by again. After it had left the area, Larry turned to me. 'I think there's gonna be a hit,' he said ominously.

'What are you talking about?' I answered, aghast.

'I think there's gonna be a hit. That's three times he's been by.'

'Four,' I corrected.

'Better get ready…'

'Better get out of here…'

I wanted to run but had no idea where to go. I looked around. There was very little cover. I had come to photograph Diana, yet here I was waiting to be cut down in a hail of drive-by bullets.

A car pulled up and the rapper Tupac Shakur got out, surrounded by bodyguards.

'Oh no,' I groaned, 'not you.' It was a well-known fact that Tupac had a contract out on him. Indeed, he had been shot in Las Vegas a few weeks before.

'Hi, guys,' Tupac said.

'Go away,' I thought, expecting a machine gun to open up at any minute. Tupac showed us his tattoos and the bullet scars on his stomach. I stood there trembling as Larry photographed the rapper and they chatted like old mates. Eventually, he went inside. I thought that Larry would be pleased with his pictures, but instead he seemed disappointed that no one had shot Tupac. However, they did a few months later – and they killed him.

The following morning we were cruising Fifth Avenue. There is a great newspaper shop just past Saks. It sells newspapers from all over the world, and in those pre-internet days it was our main source of information from back home. I went inside and Larry waited on the sidewalk. As I was glancing through the British newspapers, I was aware of a young man standing next to me. He was looking at the cameras hanging around my neck.

'Why don't you guys leave me alone, maaaaaaaaan!' he said aggressively.

I had no idea what he was talking about. All I wanted to do was read the papers. I looked at him. It was Brad Pitt. 'Huh?' I said.

'Just leave me alone maaaaaaaaaan,' he repeated.

'I'm just reading the papers mate,' I said.

'Yeah, sure…'

I looked away from him. He stood there looking at me. I thought he was going to hit me. To be honest, I was scared. He may be a Hollywood superstar, but he looked like he could handle himself. Had he not opened his mouth, Larry wouldn't have spotted him. But, as Brad Pitt stormed out of the shop, Larry was waiting. The actor was wearing a small ski-hat, which he pulled down to cover his entire face. This gave Larry a great picture: Brad Pitt walking down the street with a ski-mask covering his handsome

features. Pitt complained all the way down the street, but it was his own fault. As I looked at the photos, published the following day, I began to realise the world of celebrity was changing. People were no longer interested in glamorous studio shots. Brad Pitt ranting and raving with a mask over his face was the future.

From that moment, I knew our days were numbered. We were the last generation of British journalists touched by Fleet Street. We'd caught the tail-end of the most famous newspaper street in history. Most of us had come up the traditional way: trained on a local newspaper, weekends spent freelancing (where the hours were brutal and the money was terrible), shifts on the *Daily Star* and then the lucrative jump into a staff job on a national or an agency.

Now there was a new breed on the street – titarazzi. Ruthless and brutal, they don't have the wit to do the job as we had done it, and they have no respect. Their job is to make the stars angry – and they do this in the most despicable way possible – knowing that the pictures will sell to any number of American TV tabloid shows and celebrity magazines. George Clooney is big enough to take care of himself – and I would consider him a legitimate paparazzi target – but can anything justify two men with cameras insulting his mum to try and make her lash out at them?

The purpose of Diana's visit was to attend the prestigious New York Fashion Awards, to be held at the Columbus Building. The cream of Manhattan society and the world's fashion industry turned out in force, vying with each other to wear the most elegant clothes and sport the most stylish haircuts. Everyone wanted to out-do Diana.

They never stood a chance.

From the moment Diana had set foot in New York there was only one question for the media: could Diana, still trying to carve out a name for herself as an international diplomat, compete in the designer-clad world of *Vogue* supermodels? Could Diana make an impression in the cut-throat, bitchy world of fashion?

The collective gasp of the crowd as Diana walked from the hotel proved not only could she compete with these people, she would wipe them out.

Her hair was heavily gelled and slicked back in a boyish cut that wowed not only the crowds but also every photographer in Manhattan. As Diana came into view, a veritable battle broke out among the snappers to get the best shot. The NYPD desperately tried to hold them back – while looking over their shoulders to get a look themselves.

When Diana arrived at the Columbus Building, the effect was the same. To cheers and gasps from the massive crowd, she posed for photographs, the smug smile on her face told me she knew she was a sensation. There was only one person whose face would be in newspapers throughout the world the following day. At one point, Naomi Campbell and Kate Moss strolled into view and the photographers screamed at them to get out of the way.

Diana was triumphant that evening, proving once and for all that, despite her recent run of bad publicity and her retreat from public life, she was still the world's number-one cover girl. Adored by millions, feted by the press, she walked into that building as simply the biggest star in the world. Manhattan had fallen to her as easily as Washington had. She was back on top and nothing, it seemed, could go wrong.

The Great Escape

Left: Top-shelf stuff! WH Smith in Kensington High Street gets a royal visitor. It's a tough choice as Diana ponders about her choice of video: *Moby Dick* or *The Great Escape*? As she picks up a copy of *Newsweek*, she seems to have done a good job of shopping incognito …

Below: Who writes this stuff? Another brilliant headline from the *Sun*.

Glenn, January 1995

Following Diana's triumphant visit to America, it occurred to me that I hadn't had an encounter with her for over two months! Even her regular visits to the Harbour Club were now passing without incident. I was feeling a bit neglected. Could it be possible that whatever had inspired Diana to pursue photographers all over London had been dealt with by all those visits to the clinics?

In this frame of mind, I came across Diana entering WH Smith in Kensington High Street. Because of the time of year, it was dark even though it was only 4:00 p.m. I observed her from the pavement through the huge plate glass windows. Diana walked slowly through the book section, stopping occasionally to read a magazine. At one point, she picked up the *Evening Standard*, which had a story concerning her on the front page. I could see her smiling to herself as she read the text. Amazingly, nobody in the shop had recognised her. The other customers in the store casually milled around, totally oblivious to the fact that Princess Diana was there, leafing through the magazine racks next to them. Diana then walked through towards the video section, blending into her surroundings like any other person strolling through a department store. Diana must have dreamt of days like this, where she could do normal things like normal people. It was a million miles from her usual world of fame and royalty. Her dream had become reality, for the moment anyway. Arriving at the video section, she glanced up at the top shelf, packed with feature films. She pulled down two movies: *The Great Escape* and *Moby Dick*. After reading the film notes on the boxes, she decided to buy *The Great Escape*. Was

this what she was planning to do? A great escape to the USA? There were rumours circulating at this time that she was to leave England for New York. Or did she just fancy Steve McQueen? Taking her video, she sauntered back to the magazines and stopped to glance through a copy of *Newsweek* before making her way to the till. The lady cashier didn't seem to recognise Diana as she handed over her change.

This was the first time I had seen Diana relaxed since her retirement. Usually, she walked around constantly looking over her shoulder, her eyes darting this way and that. But that day she was totally relaxed. Watching her a little longer strengthened my theory that she had crossed some

Below: Surely she couldn't be taking the boys to meet Carling? Oh yes she could! Ex-England rugby captain Will Carling waits for William and Harry to join him for a team training session.

kind of bridge in her turbulent private life, that from now on things would be different.

I suppose I should have known better.

Glenn, March 1995

'How come you guys never take my picture?' Will Carling asked, looking up at us.

Mark and I were perched once again on the wall at the Harbour Club when the then England rugby captain strolled over. 'Because you're not worth any money to us,' replied Mark, with the greatest understatement of the year.

Carling grinned and walked off.

What we didn't know, proving once again that we didn't know much, was that Carling and Diana were already 'good friends', regularly sharing coffee and chats after training together inside the club.

Diana's muscles were growing fast. When she showed up that morning, she wore her usual Lycra shorts and stars and stripes sweatshirt. The female Adonis strolled into the club and for the first time we saw how well her body was developing. She was looking well toned, unlike Mark and myself. While she was inside getting fit, we were outside, sitting around eating our stress sandwiches and junk food.

That weekend, both Harry and William were home from school. As it was now becoming the norm for Diana to treat the boys to a special day out when they stayed at KP, I phoned my usual contacts for any information regarding outings. I had found out that something was due to happen that Saturday afternoon at Twickenham, the home of English rugby. My mind was racing. Twickenham is the national rugby stadium and the place the England team train most weekends during the season. Surely she couldn't be taking the boys to meet Carling?

Oh yes she could. Diana's car drove straight into the stadium followed by the police back-up. As soon as they were inside the huge complex, the massive iron doors clanged shut behind them. The place was sealed, leaving us paps outside.

With me that day was fellow photographer Antony Jones. He was almost 30 but looked a lot younger. In fact, in all the time I've known him he's never seemed to age a day. It hasn't stopped him from taking great pictures, though. Antony and I drove our cars around the stadium, desperately searching for an entrance, an opening, any way to get inside. The place resembled a fortress and seemed impenetrable. Eventually, we got out of our cars and went on foot. At one point I seriously considered hiring a helicopter. The rumours about Carling and Diana had only just begun and here, inside the stadium, would be positive proof that they were having a meeting – to which she'd also taken her children.

Antony called out to me. He had found a gap in the fence just big enough to slip through. We climbed through and then ran across some open land and sneaked through an open door into a stairwell at the back of the grandstand complex. Our best bet was to get as far away as possible from the ground level, so that if we were spotted it would take whoever pursued us more time to reach us, giving us more opportunity to take pictures. The nine flights of steps nearly finished me off. The youthful-looking and sprightly Antony was already in position when I arrived atop. We were to be well rewarded for our climb.

The English rugby team were having a very private training session down on the pitch below. Diana, William and Harry were watching from the sidelines, enjoying their privileged view. The team practised their scrum and line-out tactics. Carling was finding it hard to concentrate with Diana standing on the edge of the field. He walked over to her and chatted at every opportunity. At one point he spent too much time explaining to her how their scrumming down would work and one of his team-mates, registering the rest of the squad's impatience, called him over and told him to get back on the field.

But, suddenly, he had other things on his mind. Carling began to gesture up at the grandstand to where we were hiding. We had been spotted. Without waiting for an invitation to leave, Antony and I were on the move. We darted from our position towards the stairs. Crashing down the third flight I heard the noise of our hunters. Three huge burly security men were charging up the stairs towards us, talking wildly on their radios.

'Christ, we've had it,' I shouted to Antony.

'Quick, this way!' He was already running along the back of the empty hot-dog stalls. He found an open doorway and we slipped inside. We were in the ladies' loo, vacant, fortunately. I stood with my foot against the back of the door as we tried to regain our breath. I began to think of our next move. The scoop of the year was just within our grasp and we were holed up in a toilet.

The game was up. With one shove, the door came smashing inwards, sending me reeling into the sink. The first big hairy monster came in and grabbed my camera. He was wearing a T-shirt emblazoned with the words 'Rugby players do it rougher'. He was angry and in no mood to mess about. I put on my best 'what's the problem?' face.

'Come on out, you two. Mr Carling wants you out,' he said sternly. His two mates entered and found

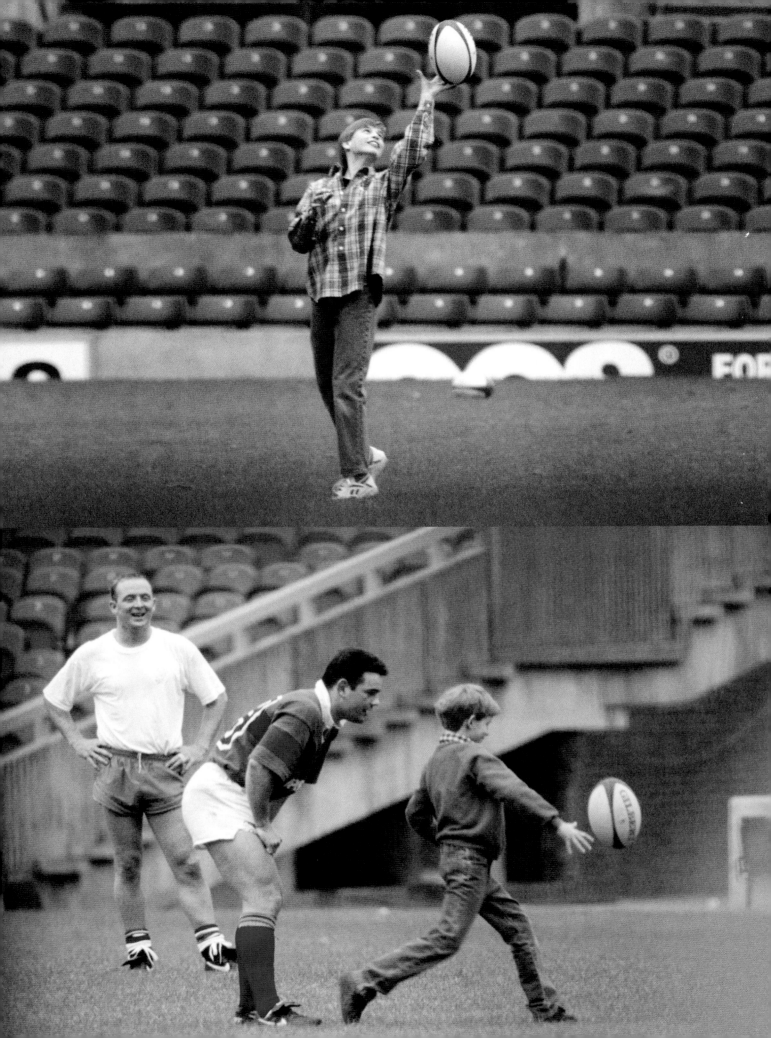

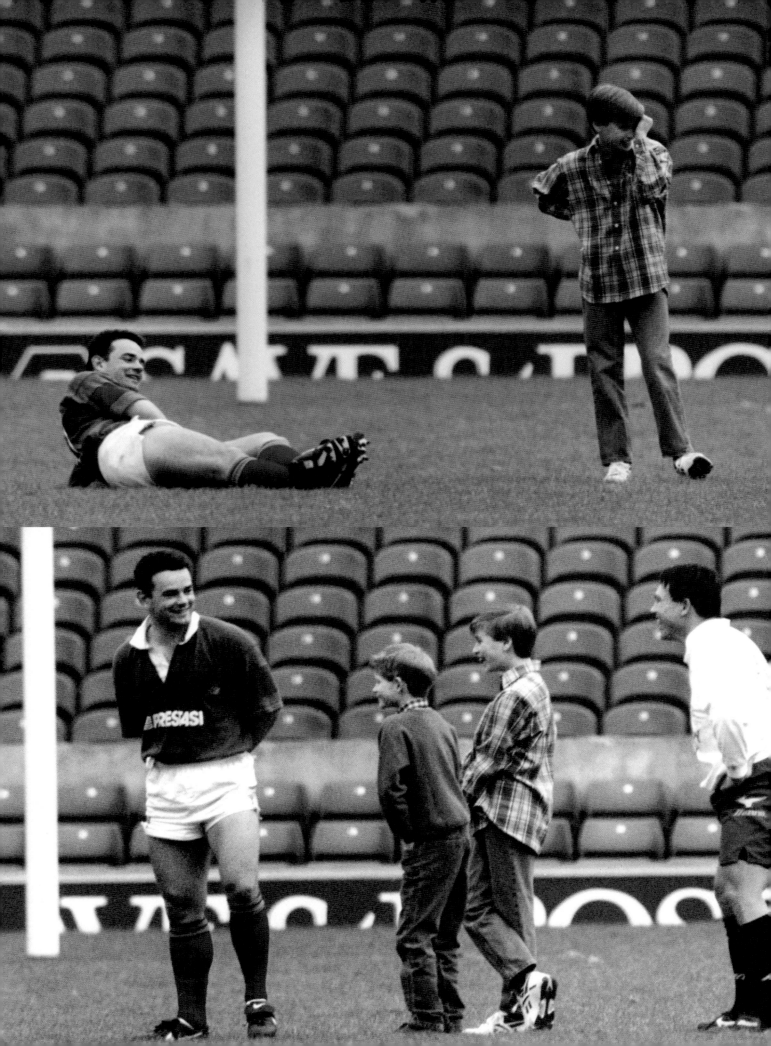

Below: Di gets flirty on the pitch.

Antony hiding in one of the cubicles reading the graffiti, trying to take his mind off what was shortly to become of him.

'Why does he want us to leave?' I protested calmly. 'We're not doing any harm.'

'It's a private session,' answered the bouncer.

My suspicions were now fully aroused about Diana and Carling. Why was he scanning the grandstand for pressmen? Surely he had more important business on the pitch to be getting on with? Rumours were rife in Fleet Street at the time that Will and Di were getting closer, but no newspaper had any proof as yet.

Our polite protests lasted the duration of seven flights of stairs, the length of the car park and along the street to our cars. 'We're only doing our jobs, mate,' the hairy T-shirt explained, now quite friendly.

'Yes, so were we,' Antony told him.

The clash was over and the minders had won the battle of the grandstand. Antony and I tried to wrap up the pleasantries as fast as we could and find another way to return to our photo position to watch Diana's meeting.

We finally got rid of the minders – and 10 minutes later we were back up in the stands and

snapping away. However, about 11 minutes later the same three guards were on our tails again. We had to get rid of them permanently – which we finally managed to do by a combination of subterfuge, deception and sweet talk. We got back inside to see that the flirter and the flirtee were getting flirtier. Even though we already had some great pictures in the bag, we were hungry for more.

The training session had ended and Carling was now enjoying a kickaround on the pitch with William and Harry. 'Go on the field with them,' I begged Diana from the stands. 'Get in a ruck with Will!'

As if reading my mind, Carling beckoned for Diana to join then, but she had now reverted to blushing 'Shy Di', with her head tipped forward and eyelids fluttering. She flicked her hair back from her face as she stared towards the hunky England captain.

William and Harry were looking with awe at Carling as they walked on to the pitch. So was Diana. This was, for any young boy, a childhood dream to play at Twickenham with the England rugby team and Will Carling. William was the most skilful with a rugby ball. He was soon running, kicking and jumping across the field with glee. Harry was finding it a bit more difficult and needed some expert tuition, which Carling gladly gave. The boys were getting the best rugby lesson of their lives. Carling seemed to be very at ease, laughing and joking with the princes. At one point, he lay on the ground next to William and cracked jokes. Probably asking if his mum had a boyfriend at the moment.

Diana cheered them on from the touchline. It was always a great amusement for Diana to show off her sons in front of her male friends. She also took William and Harry to play with James Hewitt during their five-year affair. They played soldiers with the tanks and armoury at the training barracks while a joyful Diana watched with Hewitt at her side.

Carling showed Harry how to execute a drop-kick. Poor Harry, every time he had a go he would miss the ball completely or fall over, so that William was forced to come over and help him up. Eventually, they all began to tire and Carling called the fun and games to an end. The excited boys ran to their mother and thanked her for a great day. Carling stepped towards Diana but, knowing the paparazzi could still be watching, stopped short. Diana gazed at Carling, who was now doing his own 'Shy Di' impression. He looked up and waved in the air at Diana, which looked a bit unusual and inappropriate from only a couple of metres away. There would be no goodbye kiss. Who knew what the papers might have made out of a goodbye kiss picture? It would have been a field day for Fleet Street. As long as a tabloid hack had the photo in front of him, he could have written what he liked: 'Their eyes met, blazing with passion for each other. Eventually, unable to control their desire, the lovestruck pair fell into each other's arms, all caution thrown to the wind as they lustfully gave into the forbidden temptation that had tormented them for so long…' You couldn't make it up!

Mark, March 1995

The sun-kissed paradise island of St Barts in the French West Indies was the destination for Diana's winter vacation. As usual, she took just one friend, Catherine Soames, and borrowed a luxury villa,

this time belonging to her favourite photographer, Patrick Demarchelier.

Demarchelier's pictures of Diana had been seen all over the world. So had my pictures of Diana, but the big difference between us was that he took pictures with her permission and earned tens of thousands of pounds in the process.

Flying out to the Caribbean, I was more than a little concerned about our chances of success. St Barts, with its white-sand beaches, swaying palm trees and exotic hotels, is the winter retreat of the international jet set. It's also home to the French paparazzi, probably the most ruthless snappers in the world. We in the UK were trained by veterans of Fleet Street; they were trained by veterans of the Algerian war. And not only were we playing away from home with no local support, the French had at least two days' head start on us. Indeed, one snapper had already got pictures of a naked man strolling past Diana as she sunbathed on a public beach.

I travelled to New York in style, using what we called the Bug, otherwise known as 'The Branson Upgrade'. The Bug was easy. All you did was show your press card at the Virgin check-in desk and say you were a friend of Richard Branson. This virtually guaranteed you an upgrade, as the Virgin staff knew how much their boss loves publicity.

I spent the evening in New York before catching an American Airlines flight the following morning. Unfortunately, this meant I arrived in the 90-degree heat of the Caribbean dressed for the sub-zero temperatures of Manhattan.

Things began to look up the following day when Andrew Murray finally arrived from England. As usual, his time-keeping had been impeccable: he had arrived at Heathrow so late that he had not been allowed to board the flight. Once on the island, we made contact with Fleet Street and established the exact location of Diana's villa. It was a familiar story. The villa was situated high up in the hills, offering spectacular views of the ocean. It also offered all-round security in the shape of the local police force, once again drafted in to act as Diana's personal bodyguard.

St Barts is a tranquil, beautiful place, the closest I've ever seen to paradise. How could you not fall in love on an island where the local radio news begins: 'And here are the main stories today: somebody has left a bicycle outside Mrs Thomas's house.'

As the spectacular dawn broke over the hills of St Barts, Andrew and I found ourselves perched on top of a mountain about a mile from the villa. We had been led to the spot by a local man called Franco, who had spotted us killing time in the harbour the previous day. He claimed he knew of a great spot where we could get great pictures and for a fee of just '200 American dollars' he would take us there himself.

I told him he would only get the money if we saw the spot first.

He told me to f*** off.

Andrew paid him.

We met Franco about an hour before dawn the following morning. He had already warned us that the position was a long way up the mountain, so we had come armed with water, bread, fresh fruit and a massive supply of sun cream and mosquito repellent. We were so loaded that we hardly had room in the bags for our cameras.

Like a commando unit preparing for an assault, we set off up the mountain. The whole area was

covered with a huge forest so there was no danger of being seen. At regular intervals, we tied bits of torn bed linen, stolen from my hotel, to trees to help us find our way back down. It took a good hour to reach the top, by which time we were bathed in sweat. Franco halted our ragged column and ordered us to stay low. Crouching, he quickly covered the final 10m to the peak, where the ground levelled out, and peered over a small wall that had once been part of a gun emplacement. He motioned for us to follow him. Dawn had not yet

broken, but in the Caribbean dark we could see the villa in the distance. Everything was deathly silent.

Franco departed almost immediately, leaving Andrew and I to gaze in awe at the magnificent sunrise that heralded the dawn. We looked through the binoculars and could easily make out the swimming pool and the area around it. Some beach towels were on the concrete with two sun-loungers next to them. As the sun began to blaze down we loaded the cameras, mounted the huge lenses and placed extra film on the ground in front

of us. We focused through the intense heat haze on the swimming pool and prepared for a long wait.

Despite the fact we were thousands of miles from home, we were on familiar territory. Once again we were waiting for Diana.

The motor-drives sprung into action at 9:00 a.m. when we first saw Diana walk from the villa. She slipped off her white towelling robe to reveal a slinky, two-piece bathing suit. Even through our lenses at that incredible distance, she looked sensational: fit, tanned and very sexy. As the film shot through the cameras, I knew we had some great pictures.

By the end of the day we had gained great tans ourselves, fed the mosquitos and shot 20 rolls of film of Diana sunbathing and swimming in the pool. As we made our way back down the hill we bumped into some old friends. They were three French snappers we often saw around the world. They had been on the wrong mountain. They were dressed the same as us, NATO camouflage, baseball caps, army boots and loaded down with lenses and cameras. Cheerfully, we headed towards a country club for a drink, looking like a bunch of out-of-work South African mercenaries.

It was always amusing to see how people reacted when they saw the paparazzi kitted out like that. It was like the scene in a Western when the Mexican bandits ride into town: the shutters are closed, doors are slammed shut and a mother always runs out into the dusty street to retrieve a child.

The bar of the country club was open and a group of English tourists were propping it up. Two small children gaped at us as we walked past, our heavy tread thudding on the sand-covered concrete, cameras jangling against the webbing

that held our back packs and film. Just inside the bar was a pool table. It is a fact that, anywhere in this world you see a pool table, you'll find the Yanks – and this place was no different.

A tall black man, elegantly dressed in Ralph Lauren chinos and blue shirt, was racking up the balls. A younger man, obviously his son, was chalking a cue. I've always found that mature black men, especially Americans, have a kind of dignified handsomeness. Sydney Poitier, Arthur Ashe, Denzel Washington. This guy had the same look.

He smiled at me as we walked in and dumped our gear on the floor as we ordered a well-earned beer. I nodded 'Hello' to him and he nodded back. 'You wanna match?' I said. 'Pool championship of the known world: England v America?'

'Sure, why not,' he grinned, revealing a perfect set of white teeth that could only have belonged to an American.

As he racked up the balls I stood next to him and leant in closer. 'You know we're the paparazzi, don't you?' I said.

He grinned again. 'A fellow's gotta earn a living,' he said.

'Yeah, but… you're Bill Cosby aren't you?'

He laughed. Then he leant over to me and whispered: 'Yeah, but I don't think anyone knows.'

I looked around. The bar was full of English tourists. If they did know, they certainly weren't showing it.

Bill Cosby and his son won the pool championship of the known world 5-1. But Mr Cosby wasn't the only star we met that day. As I made my way down the dusty main street, a woman in a surprisingly large summer hat and a long flowing dress stopped me. 'Is Princess Diana on the

island?' she asked in a familiar American voice that had sold out Broadway theatres. She was hiding behind her sunglasses, but I knew who it was.

'Yes,' I replied, 'I saw her today.'

Barbra Streisand didn't pursue the conversation. She simply grinned and walked off.

On the day Diana was due to leave St Barts, the press had gathered at the tiny island airport. There were only two entrances: the main one, which was basically a small shed housing the customs officials, and a side gate that led directly on to the runway. Fleet Street was in a dilemma. They couldn't decide which exit Diana would use and, as the distance between the shed and the gate was about a kilometre, they decided to stand halfway between both.

Andrew, Mike Lloyd and I were positioned by the small gate that led on to the runway. We knew from experience Diana would not go through the main exit and, with the rest of the press further up the road, it was beginning to look like we'd have her departure all to ourselves. Sure enough, a few minutes later a small jeep came down the hill with Diana and Soames inside. A local police car followed them. The jeep came to a halt directly in front of us. Diana was sitting in the passenger seat. She was wearing a small white tank-top and white jeans. Both Andrew and myself realised immediately that she wasn't wearing a bra. We raced around to the other side of the vehicle just as Diana jumped out.

Diana groaned, but we kept our distance. It wasn't every day that we got to photograph Diana bra-less. The driver got the bags out of the back of the jeep and Diana stood just in front of us as we continued to snap away. These were front-page pictures and we knew it. And so did she.

St Barts is a tiny island and there was nowhere to get our film developed. All of the shops were shut by the time Diana's plane had left. We were forced to develop our photos in the bathroom of Andrew's hotel room. Somewhere in St Barts today there is still a maid trying to clear up the mess we made.

Ecstatic, we Mac'd the pictures back to London with the wonderful by-line 'WORLD EXCLUSIVE BY ANDREW MURRAY AND MARK SAUNDERS' and then set off to celebrate. I showered and changed and raced back to Andrew's hotel to find him sitting at the bar with the model Jodie Kidd. Today Jodie is a superstar, but back then she was just starting in the business. Andrew was regaling her with stories of Diana. He had a laptop on the bar in front of him and was showing Jodie the pictures we had taken that day. I sat like a gooseberry next to them, watching their body language and consumed with envy. Every time Andrew said something funny, she would raise her bottom from the bar stool and gently nudge him. Mike had left, but I wasn't going anywhere. Eventually, I took the hint and left as Andrew ordered more drinks at the bar.

The following morning I was woken by a call from my girlfriend in London. I had rung her the previous evening to tell her of the pictures we had taken. 'Mark,' she said, 'there are pictures of Diana all over the *Sun*.'

'I know,' I said, 'we took them.'

'Yes, but it says: "World exclusive by Andrew Murray".'

'WHAAAAAAAAAAAAAAAAAAAAT?'

I raced back to Andrew's hotel. It was just like him. He had changed the by-line to get all the glory. I banged on his door but there was no answer. Jodie Kidd was staying two doors up. I knocked on her

door. She answered in a nightdress; I had obviously
woken her up. 'Where's Andrew?' I said angrily.

'Who?' She was still half-asleep.

'Andrew. Where is he?'

'Well, he isn't here,' she replied.

I was so angry I thought about storming into the
room but Jodie pre-empted me: 'Can you please
f*** off?' she asked politely.

A few weeks later Diana surprised us all by
returning to Lech. She had spent all her time the
previous year complaining about press intrusion,
yet here she was returning to the same slopes – and
facing virually the same paparazzi.

Her attempts to frustrate the snappers were
futile. On the first day, she came out with a ski
scarf and goggles over her face. She sat on the ski-

lift with Harry and Wills, resolutely keeping her
head down to prevent any pictures. But most of the
press had anticipated this move and were waiting
at the top of the mountain. Diana pulled off the
scarf and goggles on her way up, rewarding all the
snappers at the top with the pictures she had
prevented at the bottom. Things went from bad to
worse for her on that first day. At lunchtime she
was forced to abandon a meal at a small tavern in
the village of Zurs when it was discovered the
French paparazzi were sitting at every available
table. As she left the tavern she slipped over in the
snow and used a profanity not usually associated
with a princess.

By the third day, Diana's holiday was a shambles.
She was simply too big a star to imagine that she
could enjoy a private holiday. The international
press followed her everywhere. At one point, Diana

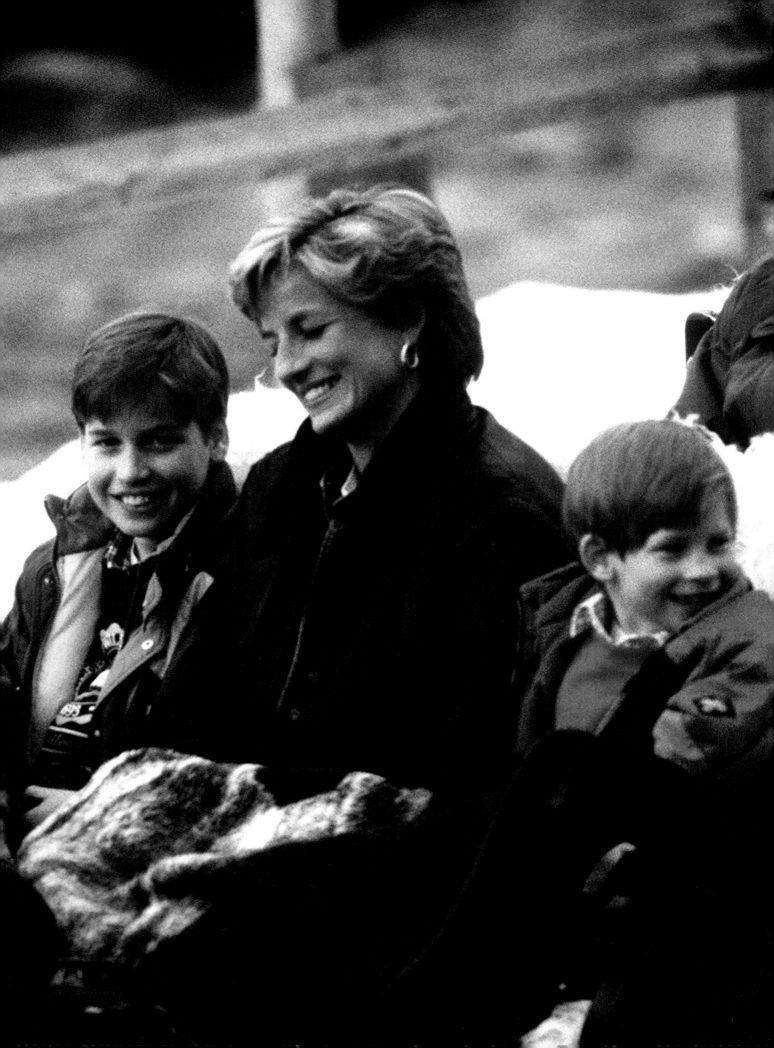

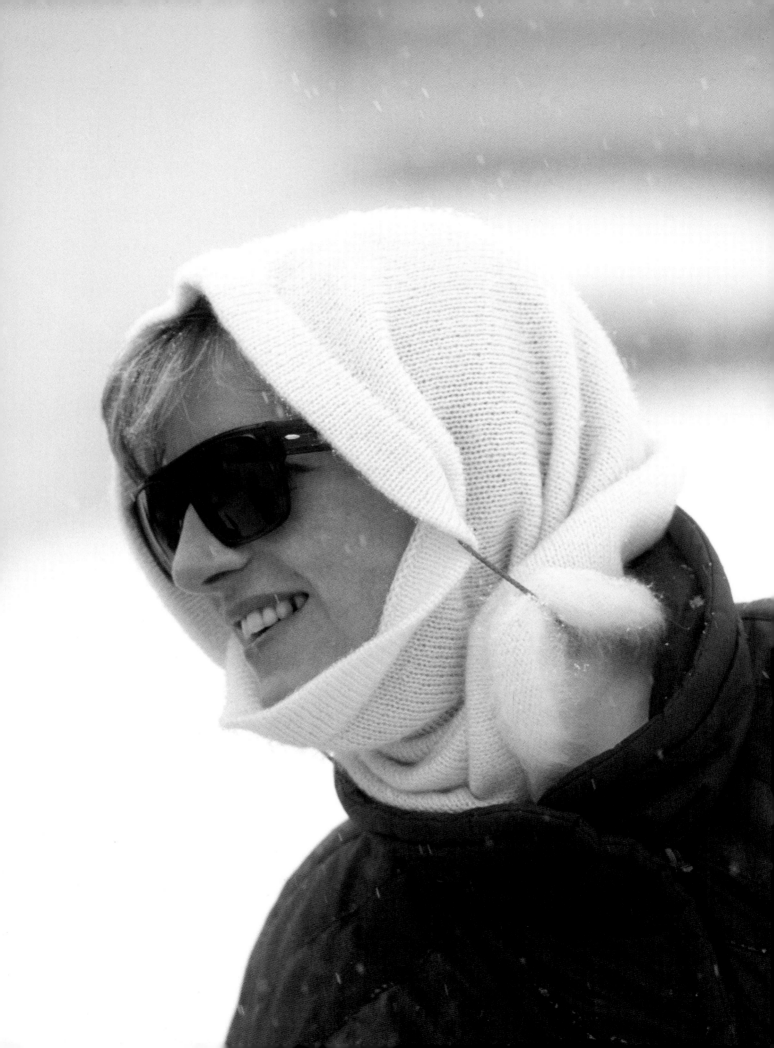

stormed up to *Daily Mirror* reporter James Whitaker and ordered him to tell the photographers to leave her alone. It was a bit like asking the fox to tell the chickens to keep it down a bit.

I had never seen Diana like this before. She was determined to confront the photographers but nobody was giving her the opportunity. Every time she approached a pap, they would run away, leaving her more and more angry and frustrated. One lunchtime, Mike Lloyd and I came across Diana, Wills and Harry sitting in a large open-air restaurant in the small town of Oberlech. We were on a sloping hill about 100m away. From that distance we figured we were quite safe. Even if Diana saw us, we would have plenty of time to disappear before she could get anywhere near our position. Mike put his video camera on to a tripod and began to film. I stood next to him, snapping away.

Diana's uncanny ability to smell the press did not let her down. She was at a table towards the rear of the restaurant with her back to us. Suddenly she lifted her head and turned around sharply. Shielding her eyes from the sun with her hand, she scoured the slopes and spotted Mike and me almost immediately.

'She's seen us,' I said. 'Let's go.'

Mike was peering through his view-finder. 'Not yet,' he said.

I watched with mounting panic as Diana got up from the table and started across the restaurant. Other diners were forced to get out of their chairs to let her pass.

'Mike, c'mon,' I pleaded, just as Diana began wading forcefully across the snow towards us. But Mike continued to film. By now, Diana was about 50m away. I threw my cameras over my shoulder.

'Mike... let's get out of here,' I said. Mike didn't reply. I had a final look at Diana striding up the hill. By now I could clearly see her angry face. She was staring straight at me.

I looked at Mike, saw he wasn't moving, then turned and ran up the slope just seconds before Diana reached us. As Diana approached Mike, she covered his camera lens with her hands. Slightly out of breath from the long clamber up the hill, she leant against his cameras as she protested at his presence on the slope. Diana knew Mike well. She knew it was pointless rowing, so she tried a different tack. 'As a parent, could I ask you to respect my children's space?' she appealed.

'Yes, certainly,' said Mike, as the camera continued to roll.

Diana continued: 'Because I've brought the children out here for a holiday and we would really appreciate the space.'

'I understand that,' said Mike, adding cheekily: 'Would it be possible to have a picture of you this afternoon. Then we'll go.'

'No,' she replied firmly, 'we've had 15 cameras following us all day.'

Rather pointlessly Mike said: 'I haven't been one of them.'

'Sure,' said Diana as she turned and strode off.

Every part of the conversation between Mike and Diana was picked up by the microphone on his camera and the whole lot was broadcast on *News At Ten* that night. The following day it was picked up by TV stations all over the world. The incident was a prime example of the hypocrisy we faced on a daily basis from the TV news. They would condemn us for pursuing Diana, yet still demand the footage when there was something to titillate their viewers.

Strawberry Fields Forever!

Mark, May 1995

As the summer sun blazed down on Hyde Park, the reason 'Great' was put in front of 'Britain' was apparent for the world to see. The celebrations to commemorate the 50th anniversary of VE Day were in full swing. Veterans of the war held grandchildren on their knees as Vera Lynn broke their hearts all over again. The massed bands of the Guards paraded along the mall, the RAF flew past Buckingham Palace, and the Queen Mother further endeared herself to an adoring public with a speech that was as compassionate as it was genuine.

For all the talk of peace, however, there was one battle that was nowhere near its armistice. For Charles and Diana, the 'phoney' war was over. Both had been on TV and admitted adultery, they were officially separated and behind the scenes the big guns in the shape of London's most powerful lawyers were beginning divorce negotiations.

But, despite their marital problems, Charles and Diana were ordered by the queen to put on a public display of unity. An event to celebrate the end of the most brutal war in history was a chance for Great Britain to flex its muscles and remind everyone that it had once commanded the greatest empire the world has ever seen. For the sake of their country, Charles and Diana shared a platform with the rest of the royal family at Hyde Park. Their appearance did not mar the event, but it didn't exactly enhance it either. Throughout the show they refused to talk or even look at each other. At one point, as the RAF flew over, Prince William tried to mediate. Turning to his father, he could clearly be heard saying: 'Mum thought that was really neat, Dad.'

It was a long journey Charles and Diana were embarking on, a journey familiar to anyone who has suffered the heartbreak of divorce. By the end of it, they were two different people. They were both hurt but, remarkably, the children never suffered.

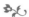

Some 450km west of Hyde Park is the tiny hamlet of Bratton Clovelly, a picturesque village standing on the border between Devon and Cornwall among some of England's most beautiful and spectacular scenery. Using his cut from *Princess in Love*, the book he claimed he had nothing to do with, James Hewitt had recently bought a £1 million mansion on the edge of the village.

Following the VE Day celebrations in London, I went down to Bratton Clovelly to see if I could persuade Hewitt to do a photoshoot in his new home. Despite his obvious betrayal of Diana, Hewitt was still in demand by publications like *Hello!*. When I arrived, Hewitt was the star attraction at the village's VE Day service, held in the small church. He strutted around like the celebrity he has since become, his solitary medal pinned to his chest. After the service ended, Hewitt made his way down the small country road that led to his house. As he rounded a sharp bend in the tree-lined lane, I was waiting for him. 'Afternoon, Mr Hewitt,' I said as I began to take pictures.

He stopped walking. 'What do you want?'

'Just a few shots,' I said, continuing to snap away.

'Why don't you people leave me alone,' he said as he carried on walking.

'Well, it's probably got something to do with the fact you shagged Diana and then sold the story, James,' I replied.

'Do you have to be so crude?' He stopped walking. It still makes me laugh when I think of that

Below: James Hewitt rides from his country manor in Bratton Clovelly.

conversation. Years later, Hewitt did a TV show where he stood in a London street and a friend of his asked members of the public: 'Do you know who this is? This is the man who shagged Princess Diana.'

Glenn, July 1995

On 16 July 1995, London played host to a royal wedding. Prince Paulos, the playboy son of ex-King Constantine of Greece, was to marry his heiress fiancée. The British royal family was represented by Prince Charles. From 6:00 a.m., the international press corps had been placing ladders in preparation for the guests' arrival. As the sun shone in the London sky, everything was geared up for a rich pageant of colour and joy as one of the world's oldest monarchies flexed its exiled muscles in another country's capital.

The wedding was due to finish at around 4:00 p.m., plenty of time for the pictures of Prince Charles and various European crowned heads to be transmitted to the Sunday newspapers in preparation for a good show the following day.

Although she had been invited, Princess Diana decided not to attend. It was her birthday and she chose instead to spend the day with her sons at Ludgrove School. Despite the worldwide interest in the wedding, both Mark and I knew Diana photographs were still more important. She was the only person in the world who could keep an event like the wedding off the front pages.

As Crown Prince Paulos and his bride, Marie-Chantal Miller, walked down the aisle, Mark and I were sitting in my car outside Ludgrove School, some 80km away. We had seen Diana go up the long driveway, as hoped, about an hour before but, because of the intense security around the school,

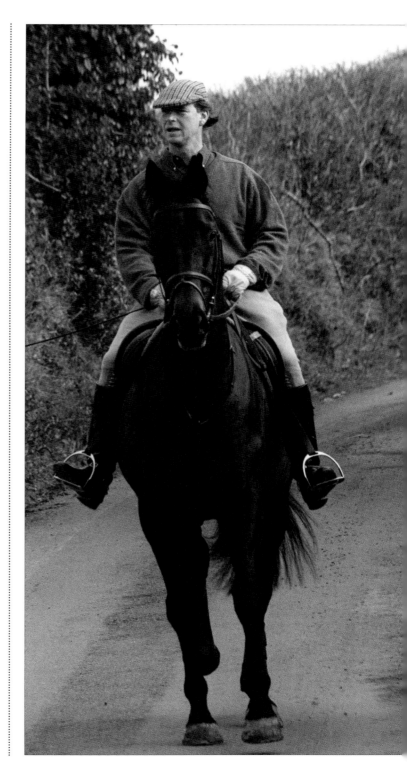

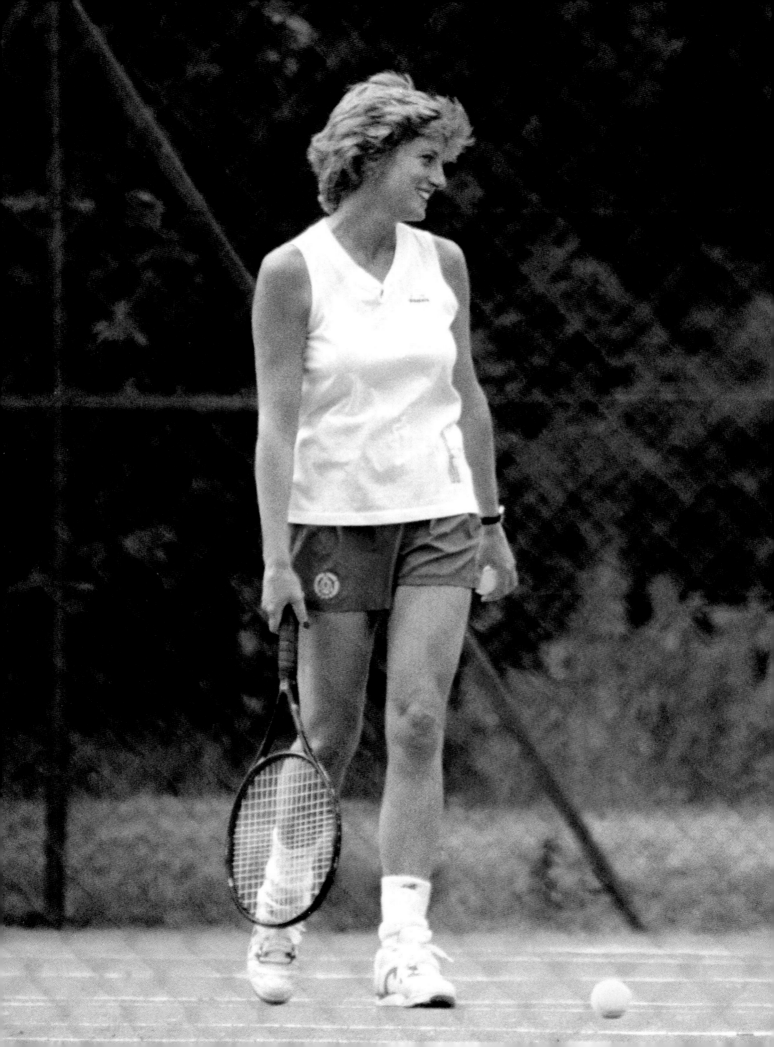

we had not been able to get a picture. Mark and I sat in the car, the time ticking on. I put the radio on as we tried to figure out what Diana could be doing with the children. On a bright summer's day like that, surely it was too hot to be sitting inside? Diana was a sun lover, and it was her birthday. She must have been out somewhere.

There was always the chance she might have collected the kids and taken them elsewhere, going out through the back entrance to the school – in which case, we were wasting our time. Mark had acquired a map that showed the school and surrounding area. Both of us were poring over it, searching for inspiration, looking for anything that would guide us to a point where Diana might feasibly be.

The radio presenter was reading the sports news, talking about cricket. Then we heard: '…and of course Princess Diana is a great tennis fan so I'm sure we can expect to see her at Wimbledon again next year.'

The instant we heard this we both looked at each other. Tennis! Of course! Ludgrove had its own courts. Looking at the map, we saw it was the only area we had not yet checked out. The problem was how to get anywhere near them. The tennis courts were at the rear of the school, at the far side of a huge expanse of strawberry fields that offered little or no cover. If we attempted to cross the fields we would have been easy pickings!

The pick-your-own fruit farm entrance was made up of two large wooden kiosks that acted as sales centres. You picked up a pallet, filled it with fruit then brought it back to be weighed and paid for. Mark and I grabbed a couple of pallets each. The salesgirl was looking at us suspiciously. We were two overweight men going fruit picking, seemingly for pleasure, dressed in black (in the middle of summer) with two huge, heavy rucksacks (stuffed with cameras and long lenses) on our backs. We didn't look like your average fruit botherers.

The field was about a kilometre wide, crossed by thousands of strawberry plants lined up in rows. We eased our way down one of the rows, heading straight towards the school. Periodically, we would pick some strawberries and, like everybody else, eat them before moving off. About halfway down, we could see the tennis courts, partially hidden behind a small clump of trees.

There was a lone policeman standing at the very edge of the field looking with binoculars towards our general direction. 'Get some more strawberries,' I shouted to Mark as I filled my pallet. 'He's watching!'

We stayed where we were picking. Every time the copper looked away, we shuffled further forwards in his direction, collecting the fruit, all the time keeping a close eye on him and the courts. When we reached the end of the row, we were still about 100m from the tennis courts. The area between us and the trees that obscured our goal was a small dirt field. There was no cover whatsoever and no more strawberry bushes. If caught, we couldn't claim to be picking strawberries in a dusty field.

Mark and I got down on the ground, desperately trying to work out how on earth we could traverse the last 100m without the cop spotting us. I was lying on my back, feeding myself the luscious fruit. Mark was lying down in the dirt trench between the rows of plants, his cheeks covered in red stains. A couple of women walked past us, one of them greeting us with a polite 'Hello'. We must have looked like a right pair of pluckers!

Below: Diana the proud mum watches as William smacks one over the net for an ace.

Right: The annual parent/student tennis competition went well for the Waleses... for a while.

The police sentry walked from left to right, raising the binoculars each time he stopped. The scene resembled one of those World War II prison-camp movies where the desperate escapees wait anxiously for the guard to disappear before crossing the mined outer perimeter. The policeman was reaching the furthest point of his beat on our right. A moment later and he would be returning again across our path. With a whack on my head to get my attention, Mark whispered: 'Let's go, we're only going to get one chance!'

The punnets dropped to the floor as we started the sprint across the no-man's-land, watched by the now bemused lady pickers.

The noise of our rucksacks jiggling up and down and our wild, desperate running caught the attention of a few more people in the field. We had interrupted what for them was a peaceful day in the country. The dust flew up behind us and hung motionless in the still air. The police sentry had completed his beat to our right and was about to turn. Mark and I, with no regard for our own safety,

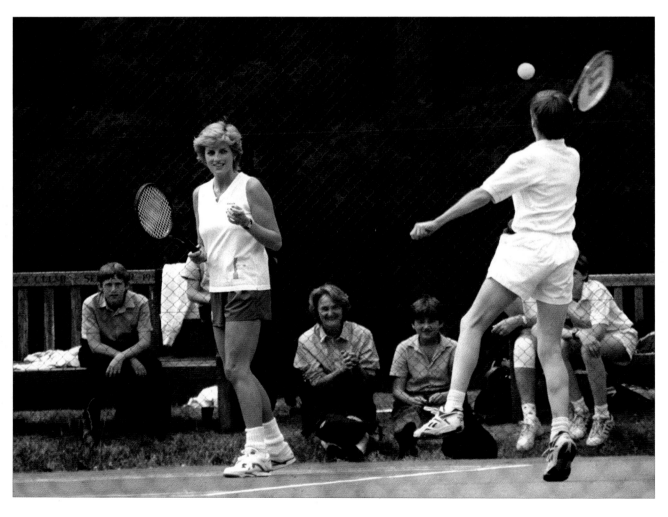

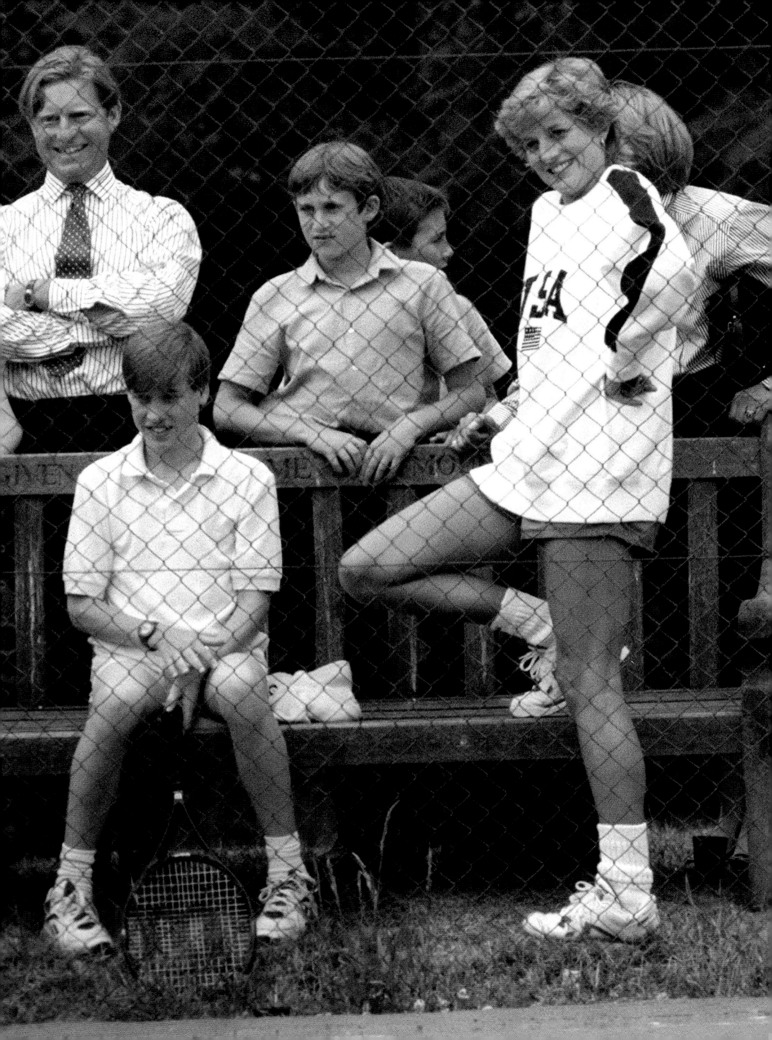

crashed into the bushes head-first. We had made the tree line. I peeped back through the hedge that we had just landed in and saw groups of stunned fruit-pickers looking over in our direction.

Crawling through the undergrowth, I could hear the distinct noise of tennis balls being whacked. The tennis courts were about 10m in front of us, surrounded by a tall wire fence. We were soon able to see Diana sitting on a bench with William next to her, both dressed in their tennis outfits. There were also many other parents and pupils, most holding tennis rackets. We later learnt that what we had found was the school's annual parent and child tennis tournament. With complete disregard for the patrolling cops, we started firing away with our cameras. Diana looked happier than usual, the air constantly filled with her familiar laugh.

When it came to Diana and William's turn in the grand tournament, she stood up and slipped off her sweatshirt. She looked quite sexy in her white sleeveless top and blue shorts. I glanced at Mark and we grinned at each other. This was getting better by the minute. Who needs royal weddings when you've got Diana in front of you looking amazing? The newspapers and magazines were going to go crazy for this set!

William led a giggling Di on to the court and began to hit some balls to another mother and son across the net. Diana couldn't stop laughing as she lunged backwards and forwards, missing the balls. It was clear where they were going to finish in this tournament. The umpire, trying to hide his own mirth, called for the players' attention and blew on his whistle to begin the competition.

I was finishing my third roll of film as the first ball was launched skywards. The contest was under way. After a few serves and rallies, it soon became clear that Diana was no expert tennis player. Was she really that bad or was she just giving the others a chance? She didn't really seem to care about the result. After all, it was her birthday and she was having fun. She looked like the Eddie the Eagle of Wimbledon! Di constantly missed even the simplest balls and tried to make up for her shortcomings by laughing with the assembled crowd. William looked away, with an embarrassed smile.

Diana's serve entailed her bouncing the ball 20 times in front of her, in true tennis-pro style, but then the wobbly princess would throw the ball about 10m into the air and literally launch herself towards it. Her right foot would tread forwards as her left flew back, creating an elaborate airborne split, whilst thrashing her racket wildly at the ball. Occasionally, she would connect with the ball, sending it rocketing in the general direction of her opponents; more usually, the ball would drop by her feet and then trickle towards the net.

The game continued but the play wasn't improving – at least, not until it was William's turn to serve. Adopting an expert stance, he lobbed the ball skywards. Whack! The ball shot down the centre of the court, over the net and passed his opponents for an ace. A huge cheer erupted from the crowd as a proud Diana ran over and hugged William. 'Mum, please calm down!' William seemed to say, embarrassed at his mother's excitement. Diana patted him on the back and retook her position. Whack! Another ace from William. Mum was now totally overwhelmed by her son's new-found skill. The high school fees had not been wasted on him. Then, following a scramble for the ball, Diana found herself twisted and tangled in the net.

Looking beyond the court for a moment, I could see the royal protection police pointing towards our position in the trees. They suddenly split up, one running left around the court and the other right.

'Scramble!' I shouted to Mark. 'We've been sussed!' I launched myself from the bush, not caring about the noise it would make. We had our pictures now and were on the run. There was no need for any stealth now. Crashing backwards through the trees we fell out on to the edge of the strawberry field and sprinted across it like two frightened hares.

'What about the strawberries?' Mark shouted, half joking from behind me.

'This is no time to think of your stomach,' I screamed as bemused fruit-pickers stepped back to let us through.

I was halfway over the field, Mark not far behind, when I first looked back. The royal protection squad had been joined by three Berkshire uniformed police, including the sentry. The cops were gaining ground, having no cameras to slow them down. We scurried the final 100m, but when we got to the car park we found that my car had been blocked in by a tractor. The strawberry farmer, suspecting we were not fruit-pickers, had penned in my car and called the police. The chase was over. We had been cornered by farmer Giles like foxes down a hole.

'How come it's always you two?' the royal protection officer who got there first asked me. 'You're supposed to be photographing that wedding in London, aren't you?'

'Not us, we're the paps!' I replied catching my breath. I could see he wasn't very impressed with my answer so I tried to move the conversation on to other things. 'Who's winning the tennis?' I asked him.

He ignored my question and radioed back to base. 'We've got the intruders. There's just the two of them. It's the normal pair, Harvey and Saunders,' he said.

I couldn't hear the reply, but with a satisfied grin he pointed towards my car and gestured for us to get in it. As with all royal protection officers, as long as they knew we were not a danger to their charges we were free to go. They were never concerned with the press as long as they knew where and who we were and that we weren't breaking any laws. They had no problems with cameras; it was guns that they were more concerned with. 'Get lost, you two, and don't come back,' he said.

We didn't need to as Mark and I had pockets stuffed full of used films ready to make us our fortune.

The grumpy farmer got into the tractor and backed off. With a nod and a sarcastic thanks to him, we pulled away slowly towards the gate.

'Ma'am's last in the tournament,' the cop shouted, laughing into my open car window.

I wasn't surprised, but I was sure she was having more fun on her birthday than at the stuffy royal wedding in London with Charles.

Glenn, July 1995

Ludgrove wasn't the only school to produce good pictures for me that year. Fergie had recently moved her children from Upton House School in Windsor to the nearby Coworth Park School near Sunningdale.

The school offered a great deal more privacy owing to the fact that it was surrounded by high fences and woodland. The main entrance was

completely out of view from any public place.
Consequently, there had been no pictures of Fergie
and Princesses Beatrice and Eugenie since they had
started schooling there. All that was to change in
dramatic fashion on the weekend of the parents
and children's family school sports day.

Previously at Upton House, I and the other
paparazzi had always photographed the sports day
by clambering up a 3m wall that stood between the
school sports field and the main road. It wasn't
unusual to see up to 50 photographers, reporters
and television crews teetering on the top, all with
the police back-up's full knowledge and
permission. The parents and children looked at us
with bemusement, watching and waiting to
see which one of us would be the first to fall off.
Prince Andrew and Fergie were always keen to
compete in the parents' race, no matter how silly
they looked and never really caring about photos
being taken.

But back at Coworth Park the police weren't so
accommodating. I had anticipated that it would be
difficult to photograph the event, so did some
homework the previous night to check for any
viable photo positions. The school outhouse I'd
picked out was packed full of hockey sticks, nets
and other sporting paraphernalia. It was the
perfect hiding place. At 6:00 a.m. the next
morning, I crept inside the shed after cleaning its
windows with a tissue I'd found in my pocket. It
was going to be a long wait until 3:00 p.m., so I
constructed a seat from some wooden boxes and
made a blanket with the goal netting, leaving an
opening just big enough to see out of the window.
It was nice and warm as I hid in my lair, thinking
about how ridiculous this job was sometimes.

Below: Touchy Fergie gets to grips with Prince Andrew at the Coworth Park School sports day, near Ascot.

It was 7:00 a.m. when the police security sweep of the area began. There would normally be a team of 10 police accompanied by dogs on a search of this scale. The first priority, of course, would be the security of the royal couple and family, so bombs, snipers and madmen were thoroughly searched for. The next priority would be to seek out the paparazzi, though I wasn't sure, sitting there at that time of the morning, that being a pap didn't exclude me from the madman category!

The dogs were on the loose and running wildly across the field in front of my hut. The handlers were having a hard time keeping pace as the hungry hounds from hell sped in my direction. Sinking lower in my hide, I feared the worst. Within a

minute of being released, a police dog was snarling at my door. I took a last look at my intact limbs then completely covered myself with the netting.

The door opened and the dog started to sniff inside. 'Bill, we've got a paparazzi here,' one policeman outside shouted to his colleague. Bill called for his dog and it bounded back out of my hut.

'OK, I'm coming out, but keep that dog away from me!' It was Mark's voice. He had been found in a bush next to the hut. 'I'm not coming out until you get that dog on a lead,' shouted Mark.

The hound was barking frantically. Dogs were not Mark's favourite animals. Mark was led from his hole in the bush. The dog was now lying down, having been ordered to do so by Bill, and the two

Below: Heading back to the house for an ice cream, Prince Andrew follows his daughter Princess Eugenie and Fergie to their car.

coppers escorted Mark from the school grounds. I could hear his worried voice getting fainter as they moved further away. 'Have they been fed this morning? I hate dogs. You sure he's been fed?'

I'd had a lucky escape thanks to Mark. I gently closed the door again and went back under my blanket. Finally, at 2:00 p.m., the parents and children began to gather on the sports field just in front of my hut. Smart but casual, Prince Andrew

led Princess Beatrice and Princess Eugenie in their school uniforms to the start of the 100m running track. They were followed behind by Fergie, dressed in thick black-and-white striped, skin-tight Lycra shorts and a dark T-shirt top (she had a flair for fashion). The school was ready, the parents were ready – and the 'paps' were ready, all set for the grand competitions to begin.

Hang on a minute: Andy and Fergie were

holding hands! The couple were standing together, watching the events and actually holding hands. The stories in the press had it that their marriage was on the rocks and that they had already separated. Rumour had it that Andrew was still in love with Fergie but that she didn't love him any more. But here they were in a moment of tenderness usually only reserved for couples. Maybe Fergie really still did love Andy after all.

I snapped one frame with my camera, but by now Fergie had disappeared. She had run off to another part of the field. Andrew, alone now, stood at the rear of the rows of parents trying to get a good view of the children's race. I watched for a while as Andrew walked around among the parents. He was standing on tiptoe, searching for Fergie. People turned and talked to him but he seemed a little muted. He obviously wanted to be with Fergie and his head moved from side to side as he spoke, searching the crowd for her. Suddenly, she was there again at his side, and Andrew's face lit up. But, as quickly as his wife had arrived, she was off again. As she turned to run away, Andrew grabbed her hand. Click... one more picture. He let go of her hand when he realised that she wasn't going to stay with him. Fergie headed off to greet the children with open arms at the finish line as they competed in their race.

The event finished with the prize givings and speeches, then Andrew carried Eugenie and led the rest of his family from the sports field to the car to return home for dinner.

I crept from my hidey-hole, feeling a bit sorry for Andrew. Having watched the couple that afternoon, it was clear to me that Andrew still loved Fergie, although I was not sure whether Fergie was still in love with Andrew.

The pictures were published, accompanied by stories that Andrew and Fergie were giving their marriage another chance. These stories were based wholly on my eyewitness account that day. The queen herself, it was said, had asked them to make another go of their marriage for the sake of Beatrice and Eugenie. The stories gathered momentum throughout the rest of the week but, with a supreme irony, I would also be responsible for proving them totally untrue the following weekend.

Glenn, July 1995

Heading for Windsor on the M25, the car phone went. The voice on the line informed me that Diana, William and Harry were on their way to Fergie's house for lunch. Quickly, I turned off the motorway and drove to Wentworth. Mark and another paparazzo, Victor Reed, were already waiting at the house for the royal arrival. The three of us discussed a plan of action in the stifling heat. One thing was absolutely certain: this was not going to be an easy photo to get.

We were desperate for pictures. At that time, it was certainly not common knowledge that Fergie and Diana's friendship had resumed after a frosty spell. In fact, most British tabloids insisted that the pair hated each other following Diana's refusal to support her sister-in-law over her marital break-up with Prince Andrew.

We had a mountain of problems facing us, although the most serious fell into three clear areas. First, Fergie's place was buried in the heart of the millionaires' row that forms the Wentworth Estate and was surrounded by state-of-the-art surveillance cameras. As well as her own security, made up of officers from Britain's élite royal

protection squad, there was the added presence of William and Harry's own detectives, who had travelled down from London with the royal party. Even if we could penetrate the ring of steel thrown around the property by the police, we still had to get into the grounds to get decent pictures.

Second, even if we got the shots, no newspaper in Britain would even consider publishing them in the wake of the PCC's new code of conduct. The new code of conduct outlawed the publication of photographs taken on private land. Also, with the government still threatening a privacy law, publishing pictures of this nature would be politically suicidal for an editor, maybe even a sacking offence. But if we sent them overseas to foreign magazines it would be altogether a different matter, with their being immune to any PCC codes. But we had to take the pictures first.

Third, I knew that Mark, along with fellow snappers Jim Bennett and Antony Jones, had tried a similar mission on Fergie's place only two weeks before and had got no further than the surrounding woods when they caught the attention of a particularly vicious police dog.

I was studying a map of the estate for the umpteenth time when the answer finally came to me. I thought I had seen something no one else had. Fergie's house was situated just off a private road in several hectares of landscaped gardens. The bulk of the security was at the north and south of the property – the front and rear – simply because the east-side fence ran parallel with the main road, where cover was extremely limited for anyone wanting to gain access. The west side was adjacent to a huge undeveloped area of marsh and overgrown trees that were seemingly impossible to

penetrate without extreme noise and jungle-fighting equipment. At least, that was what everybody thought.

'How long and deep do you think that bog is?' I asked Mark, turning the map around so he could see where I was pointing.

'About half a mile and very mucky,' came the reply. 'But it's impossible to get to without going through other people's property and they'll spot us.'

I knew he would say that, so I allowed myself a smug little reply: 'Wrong – what runs next to the road about a hundred yards in front of the entrance to the house?'

Mark and Victor knew the answer – it was something we had looked at before. 'A long ditch,' they said.

'Which is bone dry,' I answered.

Victor was not so easily convinced. 'So what? Even if you get to the swamp and then manage to smash your way through Surrey's answer to the Amazon jungle without anyone finding you, you'll only get to the west side of the house. You'll only be able to see the fence of the back garden from there.'

My thoughts exactly.

'Where do you think everybody will be on a boiling hot day like this?' I asked in triumph. 'They'll be playing around and sunbathing on those extremely expensively maintained lawns.'

Mark and Victor looked at me and we all smiled. 'Let's do it,' we said.

We managed to get to the dry stream without being spotted by security and then began the difficult journey into the swamp. Progress was slowed by the rucksacks containing our equipment and the fact that we were all wearing T-shirts and shorts – hardly appropriate attire for jungle exploring.

Below: Merry wives of Windsor. Despite press reports of their ups and downs, Diana and Fergie were great friends and much of their free time was spent together.

An army of water rats, an unforeseen enemy, further hindered us as we struggled for a kilometre over gnarled tree roots until the ground became increasingly soggy. We ended up in about a metre of filthy water, but just further ahead we could see where the stream joined the river at a sort of nautical T-junction. Beyond the river beckoned the menacing swamp with its twisted and broken trees.

We had to stop for a breather. The rucksacks, laden with 500mm lenses and film were cutting into our blistered shoulders and the sweat poured from us. The river was about 10m wide. Luckily, we had arrived at a point where it was no more than about 1.5m deep, so we were able to wade across safely, carrying our equipment above our heads. We came face-to-face with what appeared to be the

beginning of the jungle. I was already regretting embarking on what now seemed to be a suicide mission. Crawling on all fours, I was engulfed in tangled and twisted branches so thick that I couldn't see more than a metre ahead. Thousands of deadly mosquitoes had appeared almost as soon as we entered the jungle. It was as though a brisk 'Tally-ho!' had been sounded by the insect population at the sight of our exposed, sweaty and fleshy white legs and arms.

Mark and Victor were trailing behind me and I unintentionally whipped a branch back into Mark's face. 'For God's sake, Glenn, take it easy,' he said. He was crouching in the mud, his white T-shirt now a dirty brown, blood running from a gash in his cheek where the branch had struck him.

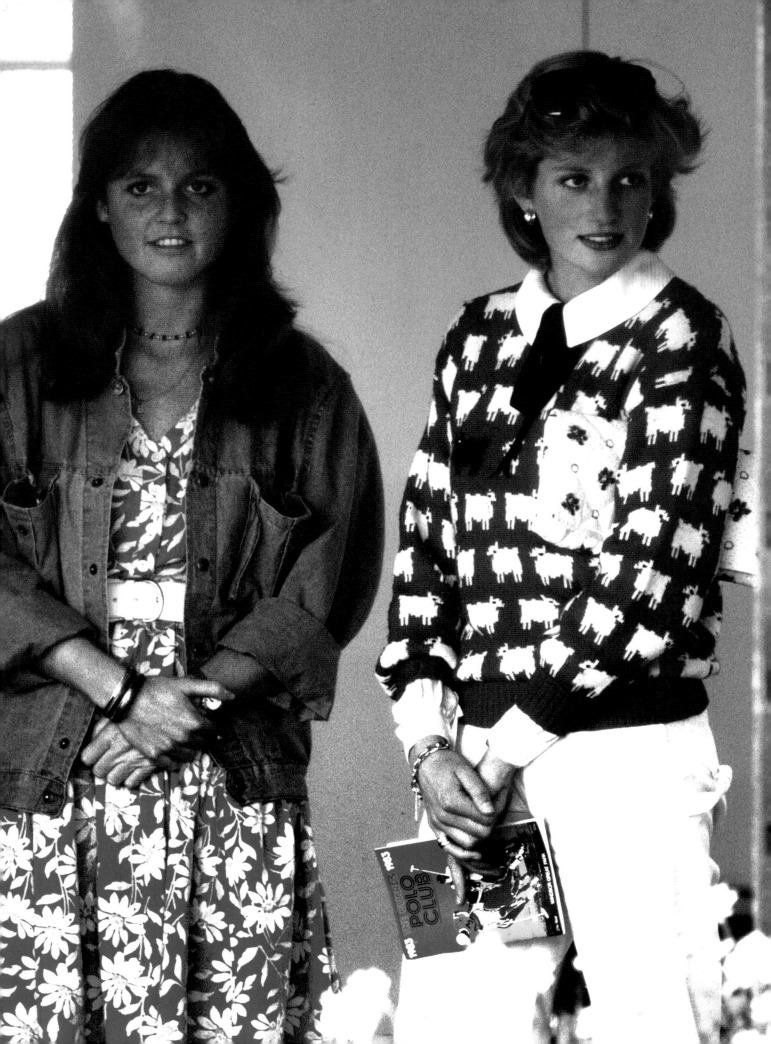

Left: Thick as thieves at a polo match.

I was beginning to regret our assault on the jungle. Only madmen would do this for a living.

We battled on for another 30 minutes and eventually the branches and bushes began to thin out so that we could see our goal. We had at last arrived at the edge of the garden. Ahead of us was a 20m green tarpaulin just inside the high fencing and it obscured any view we may have had into the grounds. Lying on my back in the mud, I heard voices. Trying to keep my breathing quiet, I strained to hear what was going on. The unmistakable sound of children playing was drifting across the otherwise silent Sunday air. 'They are in the garden!' I whispered gleefully. 'Listen.'

We could hear what sounded like a football being kicked, followed by childish laughter. Mark and Victor also lay down on their stomachs and we all crawled on our elbows the short distance to the fence. To our left was a private road patrolled by the police, but we were obscured from them by a dense row of trees. A small 2m wire fence was the only obstacle between us and the garden.

However, it was still impossible to see anything inside as the tarpaulin, which ran the length of the garden, ensured privacy as far as a large clump of bushes about 20m further along the fence. We slipped over the fence and crawled to our right towards the bushes. On the other side of the tarpaulin, we could still hear the people playing.

Then, suddenly, we all froze as we heard an extremely aristocratic female voice calling out with a laugh: 'I'm coming... I can see you... I can see you!'

For a brief moment we panicked, thinking she was referring to us. We'd hit the jackpot: Fergie, Diana and the kids playing hide-and-seek. What a nightmare it would have been if Diana had come stumbling into the bushes looking for Wills and Harry, only to find us!

Thankfully, her voice in the garden faded further away and we continued our crawl. I found a viewpoint and waited. John Bryan, Fergie's financial advisor, was jogging across the back lawn. He took us totally by surprise and all three of us missed the picture. With all the stories about a reconciliation between Andrew and Fergie that I had fed the media the previous week, what was he doing here? Fergie's PR team had been insisting that Bryan was out of her life after the couple had been photographed by paparazzi in the South of France at their villa. Bryan was seen sucking Fergie's toes by the poolside as she reclined on a sun lounger. Despite their denials, it looked as if Bryan was back in favour and maybe Andrew was out of favour again. The saga was by no means over but we still needed photographic proof.

I crawled forward and knelt next to Mark and Victor. The main French windows were opened and the patio was filled with an assortment of sun loungers. 'There's Diana,' Victor shouted and rattled off a few pictures.

She was standing on the patio, wrapped in a towel. She walked along, drying her hair with the end of the towel. Di had been swimming in Fergie's pool and was now heading back inside the house to get dressed.

'There are the boys,' Victor shouted again. They were riding quad bikes across the lawn. He rattled off more pictures.

We really needed a picture of John Bryan but he had disappeared from view. We were so close to the scoop and yet so far. It would be a tragedy to have endured all this effort and come away having missed the main picture.

I turned back to Mark and Victor. 'What about the private road that runs along the back of the house?' I asked.

'The security cameras will spot you the second you go on to it,' Victor said.

'But the response time is going to be, what, two or three minutes? By that time we could shoot a whole roll of film and get back in the swamp. They won't find us in there,' I suggested.

'But how do we get the shots?' Mark demanded. 'There's a ten-foot-high fence there and we haven't got any ladders.'

I told Victor he could climb on my shoulders then shoot as many photos as he could before we had to run for it. The idea seemed simple and yet impossible at the same time. But it was all we had at this stage. Mark reluctantly agreed.

Speed was now the key factor. The police patrols might catch us at the fence and, if they didn't, the cameras would surely spot us. I crouched down and Victor climbed up on my shoulders. With his weight pressing down hard on my body, I struggled to stand upright. Mark handed him the camera. Looking like an act from Billy Smart's circus we leant against the fence. Victor's camera fired wildly above my head.

'What is it?' I shouted up at him.

'It's Bryan! We got it!' He nearly fell off his shaky perch with excitement. I could see nothing as my face was pressed up against the wood of the fence. 'Mark, take the camera and let's get out of here!' Victor yelled down. 'Mark! Mark! Ma...'

'Can I help you, gentlemen?' a voice enquired behind us.

I spun round to see who owned the voice and in my surprise separated myself from Victor's feet.

His chin crashed into the top of the fence as he tried to walk on air. He came piling down on to my head, taking me with him to the ground.

It was the cops.

'Could you get him off me,' I replied to the policeman.

He put a hand out and tugged me up from the heap. Victor was lying in the grass, nursing his bruised chin.

It was a small world. The cops turned out to be the same ones who'd chased us through the strawberries at Ludgrove School the week before. They walked us the short distance back to their police car, where Mark was standing next to the driver's window happily chatting to the uniformed cop and the royal protection officers. The deserter had left his mates and scarpered, only to be captured further up the road.

Around the corner screeched the Wentworth private security goons, as ever too late on the scene. 'It's all right,' the uniformed officer called to them. 'They're friendly... well, sort of.'

The uniformed policeman radioed to HQ and a burst of static greeted him. He spoke quickly, informing his fellow officers to stand down as it was only the paparazzi and the situation was now under control. The royal protection squad left us. They had more important duties to attend to.

We remained in the charge of the Berkshire police. 'Do you guys ever give up?' one said with a smile.

'Not unless we're really forced to,' I replied.

At that moment there was another burst of static on his radio and a voice said: 'Main party leaving for Windsor Castle in five minutes.' The copper groaned. He knew that we had heard the message. I grinned. At least we knew where we were heading next!

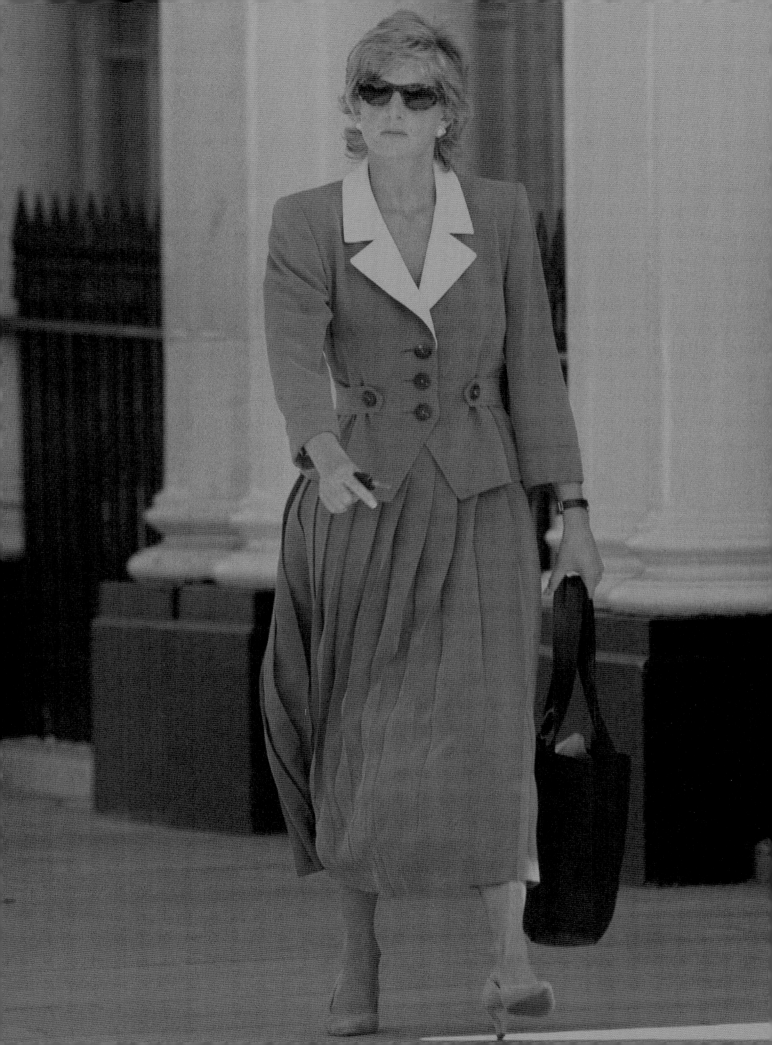

Diana in the Flesh

Right: Prince William is taken by his mother to Eton College to meet his new housemaster, Dr Andrew Gailey, July 1995.

Mark, September 1995

Eton College is Britain's most exclusive public school. Founded by Henry VI in 1440, it has remained a symbol of England's unique – and grotesque – class system ever since. For centuries, the cream of England's aristocracy has sent their sons to be educated there.

The college is named after the tiny Berkshire hamlet in which it is situated. The enormous buildings, a tribute to the magnificence of British architecture, are within sight of Windsor Castle. Steeped in academic tradition, the pupils continue to wear the old-fashioned uniform of black tails, or penguin suits, as the locals unkindly call them. Eton prides itself on providing the crown with an endless stream of advisors, servants, generals, admirals, prime ministers, archbishops – and gossip columnists for the *Daily Telegraph*.

At his mother's insistence, Prince William was due to start at Eton that September, and his brother Harry was to join him there two years later. The Spencer family had a rich tradition of attending the school. Both Diana's father and brother had boarded there.

The day after we shot William and Diana playing tennis, they went to Eton for a brief chat with the headmaster and a look around the house William would be living in for the next five years. So keen was Diana to get William into Eton, she had given little consideration to William's privacy. Eton is the most public of public schools. Tourists in their thousands gape in awe at the remarkable buildings and walk around the school grounds unattended. William would be constantly on show. Even to go to the local tuck shop, Eton boys have to walk down the High Street, and the playing fields –

surrounded by public footpaths – are at least a kilometre from the main school buildings. In a nutshell, Eton, with its glorious tradition of outdoor activities, football, rugby, rowing, cricket and army cadet training, was a paparazzi dream.

On William's first day at Eton, he was accompanied by his parents and about 300 photographers. The massed ranks of the world's press had been allocated a position opposite Manor House in preparation for the royal arrival. Charles and Di arrived at around 3:00 p.m. with a bemused William. He looked across at the cameras and TV crews and grinned, genuinely amazed by the sheer volume of press interest.

They all went inside the main building, where William signed his name in the school register, watched over by a hovering Diana. When they came outside again they posed in front of the specially erected scaffold housing the world's press. Both Charles and Di smiled, obviously proud of their eldest son's smart appearance in his new uniform. After a lengthy photocall, Charles shook William's hand and Diana kissed his cheek before they both climbed into a waiting Rover, leaving a lonely William on the pavement to wave them off.

Fleet Street packed up its cameras and left; the paparazzi stayed where they were and the first unofficial pictures of William were on the market within 24 hours.

Taking advantage of my extensive recce of the school during the summer, I was already in position when William ran out on to the rugby pitch for his first sports lesson. The photocall with his mum and dad had already flooded the market with pictures,

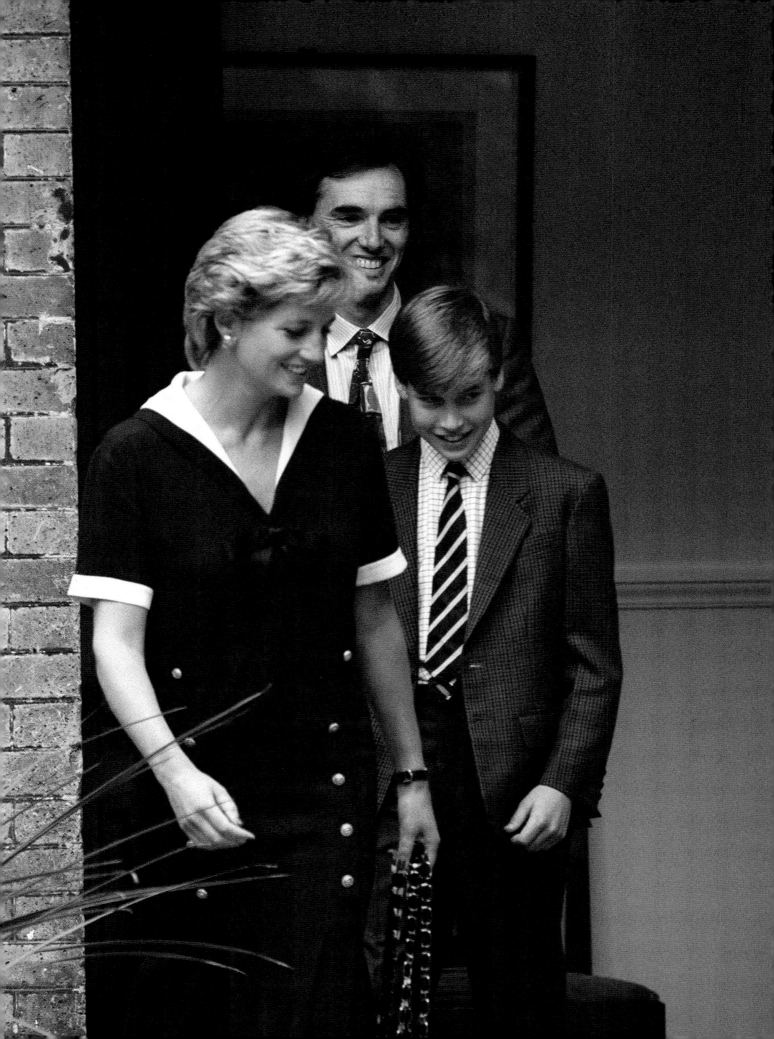

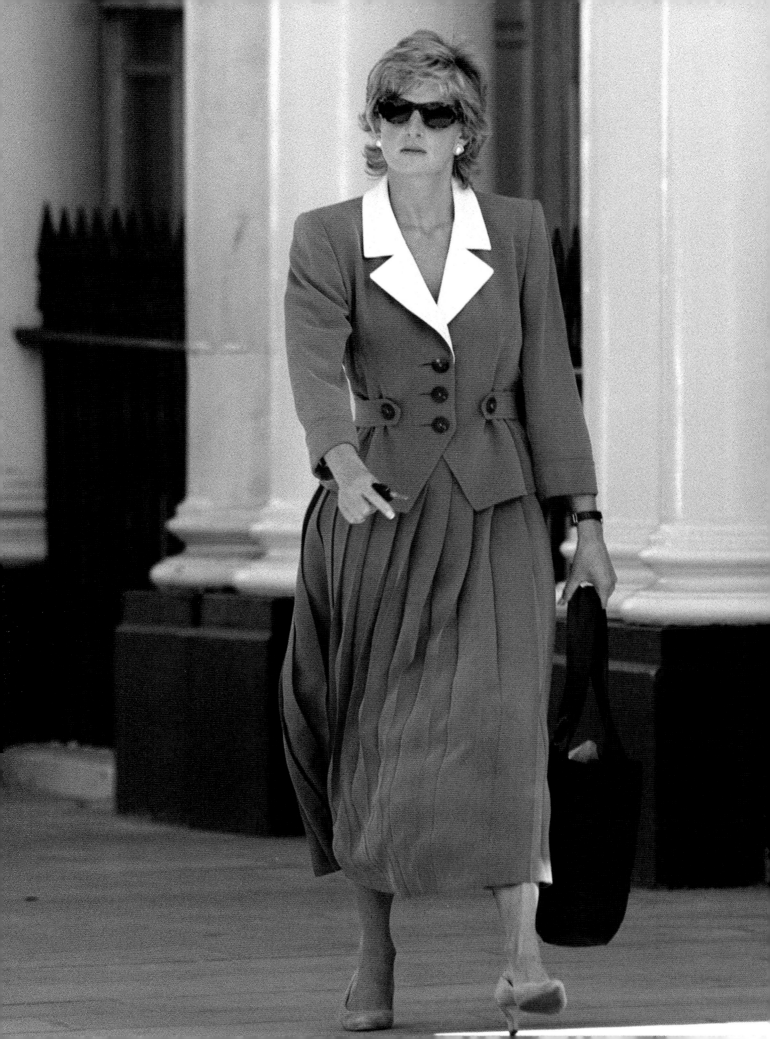

Left: The bumble-bee sunglasses got bigger …

but the more that were published, the more the public wanted. And, when an American teen magazine voted William the world's number-one pin-up, demand went through the roof.

As I watched William on the rugby pitch, I could tell any talk of him being a 'mummy's boy' was nonsense. William was in the thick of things throughout the game, diving into every scrum and tackling hard, almost as if he had something to prove.

As Buckingham Palace had hoped, the British press refused to touch any pictures, but the foreign press showed no such restraint. In William, they could see a potential superstar – a young man who one day would be as famous and glamorous as his mum. And they were right.

Glenn, October 1995

When another storm of controversy was gathering over Diana's head we always seemed to know. Maybe it was a sixth sense, or maybe we just knew the princess so well by now. Whatever it was, as October came upon us, we knew something was bubbling beneath the surface. Diana's behaviour, erratic at the best of times, seemed to be getting worse. She had taken to wearing a large pair of sunglasses throughout the day and seemed to think this would prevent us getting any sellable pictures. Diana would walk down the street, head held high, wearing bumble-bee sunglasses which, in the cold, dark London climate, would seriously hamper her vision and look out of place. But at least she was easy to spot in a crowd of winter shoppers. Often, she would walk straight past her own car if it was parked alongside several other dark ones.

At this time Diana had just taken delivery of another brand-new BMW, and like most people with a new car I knew she would lose no opportunity in taking it out for a spin. This was something that would guarantee me a good publication. Pictures of Diana in her latest sports car would walk into any of the tabloid's pages.

I knew that I had to have the first pictures and made it my mission to get them. Looking at the London *A-Z*, I searched for the most likely route she might take to the Harbour Club. There would be no possibility of taking a picture at the gates of Kensington Palace – the police at the security post would tell her that I was waiting. I took a gamble and found a hiding place half a kilometre down the road at a set of traffic lights. Hopefully, Diana would hit a red light and have to stop, giving me valuable seconds to bang away a few pictures.

I stood hiding in a telephone box for over 90 minutes before the shiny new blue sports car appeared. The BMW gleamed before me, pulling slowly up to the red light. I had guessed right, the shot was within my grasp as I bundled quickly out from my hide. Bang! One frame. As soon as she saw my flash explode, Diana looked the other way and pulled the sunblind across the window. Di had reacted too quickly for my second flash but not quickly enough for the first. I had her!

I returned to my car and was joined by a policeman on the beat. 'Do you know that lady?' he asked.

'Not personally,' I said with a grin.

He lifted his radio to report the woman in the car and her crazy driving.

'Hold on a minute,' I told him. 'I don't think you want to do that. That was Princess Diana.'

'What car? I didn't see any car. Did you?' he

Below: Hopefully, Diana would come to a red light and have to stop, giving me valuable seconds to snap a few pictures.

replied as he put his radio away. The policeman looked relieved. He wasn't going to be the one to book the Princess of Wales for bad driving. They sent people to the Tower for less.

He left me standing next to my car, but not before checking that my tax disc and tyres were in order.

Glenn, February 1996

For 20 minutes, the princess bowed her head down low. She moved only slightly as she put her hand to her face. Diana was preparing to face one of the most difficult traumas of her life. Later that day, she was to release an official statement stating that she, the Princess of Wales, would agree to a divorce from the Prince of Wales.

She was unaware of our presence as Mark and I watched her trying to compose herself while she waited in her green BMW. She had pulled over in a car park belonging to a small church just outside Eton.

This day was to mark the beginning of the end of her marriage to Prince Charles. It was the end of her dream to be queen of Great Britain and the Commonwealth. But, for now, Diana was contemplating how she would break the news to her son Prince William. William was blissfully unaware of his mother's imminent arrival. Mark and I sat and watched from my car, still ignorant of the impending headline-making news that would be spreading around the world later that day. We had been in Eton when I received a call to say that Diana was on her way down. We drove our cars out of Eton on a route that would intercept her when she came off the M4. We soon spotted Diana's BMW as it sped down the road towards us. Then, she suddenly turned right into the small car park. Diana switched the engine off and sat motionless.

To us, this just seemed to be one of her weekly visits to her son at Eton. We had no idea why she had made an impromptu stop. We waited on the

Nicht verfügbar.

road nearby and watched. 'What's going on now?' Mark whispered. He was gathering together his camera equipment and getting ready to leave the car. As he did so, Diana looked up at the sound of the car door closing. But she wasn't fully switched on and quickly returned to gazing down at the floor. We hadn't been spotted.

'Take it easy,' I said to Mark, 'I think she may have a problem.'

Mark crept off towards a nearby garden. I took a couple of pictures from my car window of Diana in her car. Maybe she had arrived early for her visit and was just killing time.

'What are you doing?' Diana shouted at a garden hedge.

A dog began barking wildly from inside the house that the garden belonged to. The rear door of the house was flung open and out came a huge skinhead with an equally large Alsatian straining on a leash. 'Go get him, boy!' the bruiser shouted, pointing towards the end of his garden.

Mark's head suddenly appeared above the garden wall. I could see his face clearly, filled with fear. Diana, in the meantime, was reversing out of the car park, and I switched on my engine and prepared to follow her. 'Help! Stop!' Mark screamed at me, but I was already driving away. He came tearing after the car, the Alsatian hot on his heels. Just as the dog was about to get him, his owner ordered him to stop, and the Alsatian came to a halt, growling in frustration at Mark.

In my rear-view mirror, I could see that Diana's BMW had pulled up next to Mark's car and she was looking inside his open window. Mark, meanwhile, was lying down on the pavement, hiding from Di. As Diana's BMW inched past his car, Mark cowered on the other side of it, shuffling around to the rear of his vehicle as Diana edged forward. When Diana reached the front bonnet, Mark was lying in the gutter by the boot of his car. All Diana must have seen was a huge dog panting and creeping forward, growling at an empty Citroën. The skinhead stopped running when he recognised Diana's face. Standing there, unshaven and in his vest and boxer shorts, he attempted a slight bow. Diana nodded with a bemused smile.

Diana was now advancing towards me. I didn't think she had seen my car but for safety's sake I drove off to the relative safety of a parade of shops, where I dumped the car and dashed into a supermarket. She sped past, heading towards Eton High Street not having noticed me.

Mark and I laughed together at the hilarious scene we had just experienced. The house owner and his dog forgave Mark for trespassing into his garden and he seemed genuinely grateful to us for

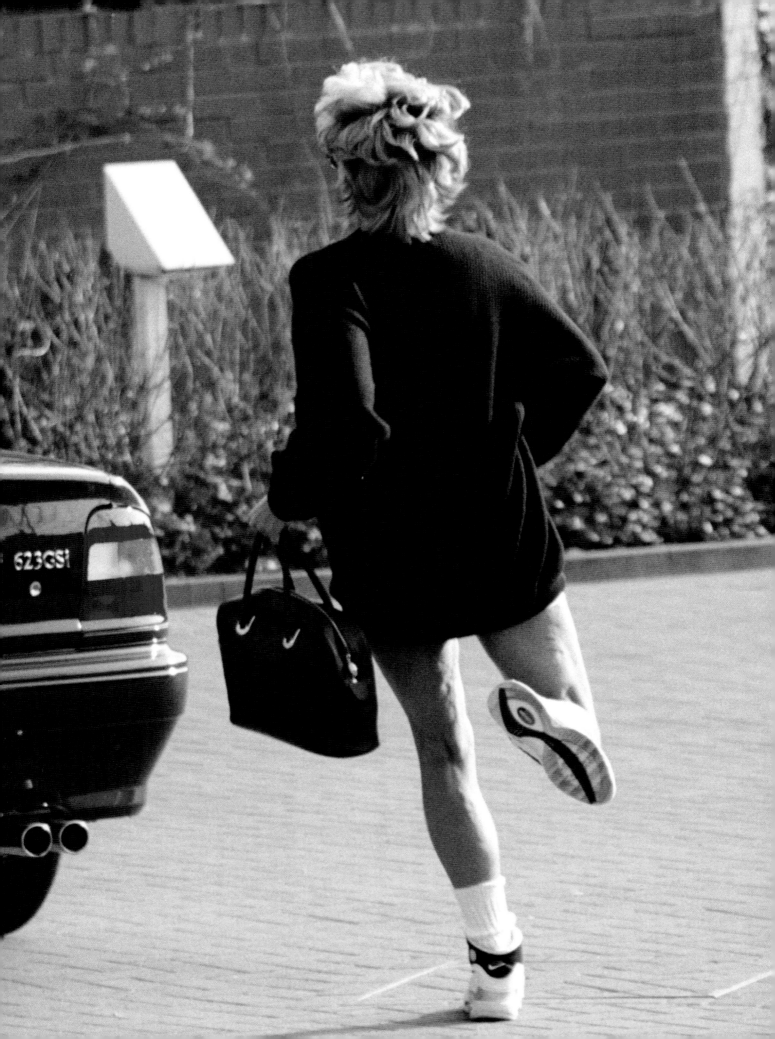

Left: Did she or didn't she have cellulite? This was the most trivial and inconsequential question of the year. But, unfortunately for Diana, it seemed that the world just had to know.

Below: Now where did I park that car? Diana sprints out from the Chelsea Harbour Club.

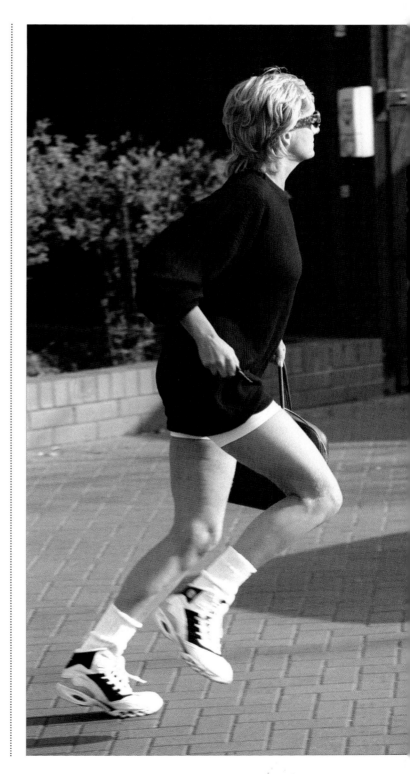

giving him the chance to see the Princess of Wales in person. He had a story to tell his mates that night in the pub. I bet he never imagined he would meet the cream of royalty in his underwear.

We left Diana to continue her visit to Eton and returned to London to develop the films. Diana's sad news had broken on the car radio during our journey back to town. The divorce of the century was finally under way.

Glenn, April 1996

Did she or didn't she have cellulite? This was the most trivial and inconsequential question of the year. But, unfortunately for Diana, it seemed that the world just had to know about her nether regions. From the remote mountains of Colombia to the paddy fields of China, people were asking the question.

'Ask as much as you like,' I thought. After all, if they really wanted to know, they would have to look at my exclusive pictures.

A routine visit by Diana to the Chelsea Harbour Club had spelt disaster for her on a grand scale late one afternoon. I had been tipped off by a member of the club, who happened to be working out on the running machine next to Diana. Dropping what I was doing, I rushed to south London and put my ladder up against the wall. Peeping over the top, I could see Diana's green Rover parked by the kitchen door at the rear. The space had been reserved for her by the club as it was the closest place to the rear door. The club had installed CCTV cameras pointing out towards the walls so that Diana could look before she left to see exactly where the paps were standing before attempting her escape.

Below: Apart from the money, exposing Diana's lower parts did not fill me with any glee. After all, what business was it of mine or anyone else's if she had cellulite or not?

Di, with her supermodel looks, was shortly to lose her catwalk status as she emerged from around the corner of the building. On reaching a point where it was possible for me to photograph her, she slipped her glasses on her face and ran at full-speed to her car. I snapped away, knowing that I was wasting my time. The pictures I had taken were fairly routine, as we had seen the princess leave the club many a time without producing a saleable snap. The shots were even less than average, I thought: profiles, back of the head shots, just the type of picture that Diana wanted you to get. This was not a set that would thrill any newspaper or magazine editor – or my bank manager.

Di had once again foiled my attempts to gain a worthwhile picture. Arriving back in my office

later, my wife, Laurie, glanced over my meagre efforts. Like most women, she couldn't look at another female form without spotting some defect in it. Of course, Diana was perfect, we all knew that. Laurie wouldn't see anything wrong with her, would she?

The beaming smile on Laurie's face was the first sign that something was up.

'Diana has cellulite,' she announced.

'What's that? I asked.

'It's what every woman dreads,' she replied.

Every. Woman. Dreads. Especially when that woman is a royal with looks that are too good to be true. Laurie had spotted something that was to change Diana's life. But I still couldn't see the significance of it. Yes, she did seem to have bumps on the rear of her upper thighs. So what? I was still feeling that Diana had foiled me.

Laurie, the salesperson in the business, kicked into action and got to work. I took a call on the mobile early the next day in the middle of yet another stress breakfast. 'Thirty thousand pounds,' was all she said and hung up. Laurie had sold my 'crappy' pictures exclusively to the *People* – a newspaper that, coincidentally, had a female editor at the time.

Diana, like many others, appeared to have fatty cellulite. I made it my duty that day to find out more about the condition that had made me so rich: persistent, subcutaneous fat causing dimpling of the skin, especially on women's hips and thighs. Diana had to face the fact that, despite her daily workouts and healthy lifestyle, she was beginning to show the signs of age. The 'perfect' princess was no more. Along with actresses Demi Moore and Sharon Stone, as well as top models Elle

Overleaf: Diana takes a dip in the private pool at the home of the British ambassador in Cairo. We were soon spotted on the rooftop by Ken Wharfe, at which point the party was over. Little did I know the trouble that was to come as a result of taking these shots …

Macpherson and Jerry Hall, Diana was also fighting the flab. After all, Diana was only human. Why shouldn't she?

The *People* splashed on the front page and inside. 'PRINCESS LUMPY LEGS' was the embarrassing headline. It was another sensational royal scoop.

'I don't have cellulite... it's bar-stool marks,' she protested in a statement released by her PR spokesperson, Jane Atkinson. 'The marks were caused by her leather car seat.' On reading the statement, I received a number of calls from reporters that specialised in royal stories for a comment on Diana's statement. I told them that Di had not been in the car for over an hour. The pictures were taken as Diana had departed the club. This information was then relayed back to the Diana camp by the reporters who were subsequently told that it wasn't the car seat, it must have been the bar stool inside the club. The saga continued for weeks, and each time the story appeared it was accompanied by the picture.

'WAS IT LARD OR BAR STOOL MARKS?' the *Daily Mirror* questioned the following day. It was a story that refused to go away quickly, unfortunately for the princess.

Diana returned to the Harbour Club at later dates wearing a long coat which completely covered her legs to her ankles. As the world watched and argued, the princess stood by her story. The tabloids came to their own conclusions, according to how friendly they were with Diana's camp. The *Daily Mail* predictably went with a 'no fat on Diana' story.

Apart from the money, exposing Diana's lower parts did not fill me with any glee. After all, what business was it of mine or anyone else's if she had cellulite or not?

Glenn, May 1992

The Egyptian security guard looked very pleased with himself as he hurriedly stuffed the filthy brown notes into his pockets. There was no fixed fee, you just offered him a roll of cash and if he thought it looked enough he would let you through. He was armed with a large rifle and a holstered pistol, so he was always going to have the last word on the matter. His gold-toothed smile became broader as he saw another three paparazzi appear in the doorway. In the hushed silence, he collected their bundles and let them pass into the building as if collecting tickets for a peep show – and what a show this was going to turn out to be.

The guard was one of a 30-strong force that surrounded the British ambassador's residence, where Diana was staying during her official five-day visit to Egypt. His job was to protect the residence and its occupants. But early that morning, on seeing the groups of paparazzi arriving near the British fortress, he had an enterprising idea that would benefit all those present – all those present *outside* the residence anyway.

'Excuse me, please, no photo.' The excited patrol officer had seen our cameras as we five paps arrived by taxi at the ambassador's house surrounded by 4m-high walls. He quickly calmed down once he realised he could make a few bob out of us and guided us to the rear door of an apartment block. The building was a 14-storey derelict shell with no windows and – on the top floors – hardly any walls where the place was beginning to collapse. Seeing his gun swinging ominously by his side, I thought

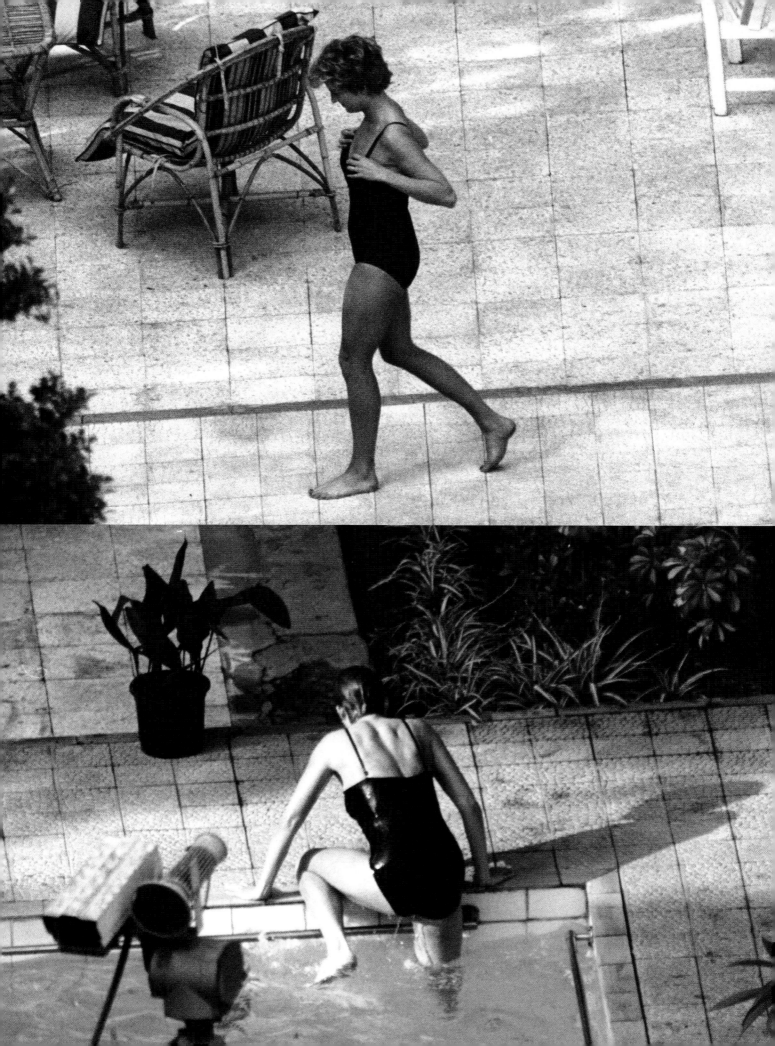

Below: ITN cameraman Mike
Lloyd: 'I have it on good authority
that the Princess doesn't mind
having her picture taken while
swimming,' Mike announced.

the guard was taking us off to be executed. We were ushered into the dark entrance hall, where the door slammed shut behind us.

His face softened as he gestured upwards and said quietly: 'I show you princess.' He was pointing towards a staircase covered with large chunks of concrete and metal wire that had just recently fallen from the ceiling. Relieved that he wasn't going to bump us off, we bartered a deal that allowed us all to go on up.

Mike Lloyd was a freelance TV cameraman on assignment for ITN. Myself and Lionel Cherruault, a fellow photographer for Sipa Press in Paris, had

convinced Mike the night before in the hotel bar that Diana didn't mind being photographed in a swimming pool. This information had been delivered to us by Diana's Buckingham Palace spokesperson, Dickie Arbiter, after Diana had been snapped swimming abroad a few weeks beforehand. Mike then phoned ITN to relay this remarkable news to the editors

Lionel took to the stairs first, followed by the others: Robin Nunn, Ken Goff, Nils Jorgenson, Dave Chancellor, Francis Dias, Mike Lloyd and myself. We were all Buckingham Palace-accredited photographers to the tour that was to start later that same day. In return for accreditation, we were expected to toe the palace line as regards our behaviour. No paparazzi were ever accredited to join the royal tours. But this was different: Diana 'didn't mind at all being photographed whilst swimming', so here we all were.

In some parts, we had to climb over boulders on all fours. The apartments had been empty for some years and there were gaping holes in the concrete at our feet.

We reached what we thought was the top of the building only to discover that there were – or had been – two floors above it, which had since collapsed to leave the building open to the elements. The remains of what had been a kitchen stood in one corner, the cooker still upright. Because of the large holes in the floor we couldn't reach the window to peer out. Two floors higher, at the far end of the corridor with no ceiling, was a piece of ceiling no bigger than the area of a car. It was the only remaining part of the roof that hadn't yet collapsed. It was 10m above us, but the stairs ended where we stood.

'Grab this!' Dias shouted. He was lifting a long, narrow plank from the rubble.

'You have got to be joking!' said Lionel, lighting a cigarette.

Dias, with the help of Nunn and Goff, lifted one end up on to the roof ledge at a 45-degree angle. 'That's it, who's first? he enquired.

There weren't many takers, so I volunteered to go first. I stepped on to the lower end and slowly edged forwards and upwards. At halfway, I lost courage and got down on my knees to crawl the rest of the way. One slip and I would have crashed through the floor below me, continuing down through to the bottom of the building.

Things weren't helped by my 500mm lens as it swung around my neck, pulling me towards the ground. 'What am I doing?' I thought to myself. 'This is ridiculous.' It was still only 5:00 a.m. I'd had no breakfast, I was in a foreign country, and I was balancing precariously on a tiny plank of wood with £20,000-worth of soon-to-be-worthless camera equipment about to send me plummeting into the abyss. To add to that, I had probably been fleeced by the security guard, who would have already told his boss what was going on, meaning that Diana was sure to cancel her swim.

I clung to the cement as I finally reached the small plateau and pulled myself up. Keeping low, I edged forwards across what was left of the roof. The sun was rising on my left and in the far corner stood an old washing line with what looked like one item of underwear still attached to it and blowing in the slight breeze. 'It's the paparazzi flag,' I shouted to the others, pointing at it.

There, far below me in the morning mist, like a tiny blue oasis in the surrounding jungle of Cairo's dusty buildings, was the swimming pool that was to make our fortunes. And in it was… nothing. Certainly no princess.

I helped the others up on to the ledge, where we all squatted down for safety – there was no fence or railing to stop us falling over the edge. In this circumstance, no one wanted to stand up. No one except Mike.

Up he got, casually brushing the dust from his trousers as if he'd just arrived to film a wedding. 'Where are we looking then?' he asked as he set up his huge 2m tripod, screwing a £50,000 TV camera to the top of it.

'Mike get down!' Goff yelled. 'You'll get us all shot!'

'I have it on good authority that the princess doesn't mind her picture taken while swimming,' Mike announced with authority.

'Yeah, but has anyone told the guards?' Nunn said.

Mike stood his ground. Nothing was going to deter ITN from capturing the world news. Like a beacon, he maintained his position. Perched like sitting ducks on a cliff edge we sat and waited for our reward: either we'd get a shot of Di or the guards would get a shot of us.

Over an hour had passed when the still-quiet air was broken with a quiet plop. Diana had slipped off her light-blue baggy trousers to reveal a black one-piece swimsuit. She broke the surface of the water to an accompanying chorus of motor-drives and uncontrolled yelps from us. Despite being the mother of two kids, it was easy to see, even at this distance, why the 30-year-old Diana had been recently voted Britain's most beautiful woman. The London paparazzi were buzzing and so was Di. The princess glided through the water with ease. After about 30 lengths she pulled herself out of the pool

Below: What a way to shift the blame. Superb! This story gave newspapers a great reason for using the snaps themselves.

and was handed a towel by Ken Wharfe, her close personal protection officer. The pair stood and chatted, unaware they were being snapped until...

In my rapid attempts to change a film, a lens dropped off my camera and rolled forward. 'Get that!' I quickly shouted as it passed Lionel's feet. He lunged forward but was too late to stop it disappearing over the edge. We all stood frozen in silence as we waited for the inevitable to happen. Seconds later there was a deafening crash as my lens smashed into a thousand tiny pieces on the street below.

Startled, Diana looked towards where the noise had come from. Wharfe, meanwhile, was already shouting orders into his radio and sheltering Di behind him. Slowly, their eyes crept skywards

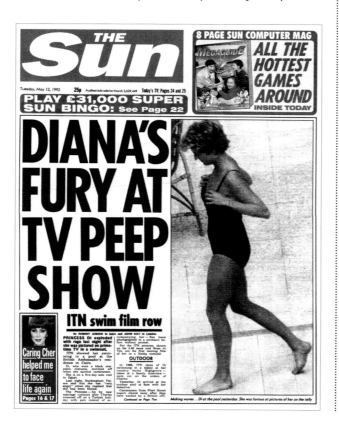

towards our position. Seven of us ducked down out of view, leaving the solitary figure of Mike standing proud and filming every moment. Ever the gent, Mike tipped his cap in a greeting gesture and mouthed the words 'Morning, ma'am' to the dumbfounded princess. Our photo session was over. Diana, with her trusty policeman, had returned inside the building.

Knowing that the Egyptian police were on their way, we scarpered like paps down a drainpipe – again, all except Mike, who knew that his heavy and cumbersome equipment would never let him get away in time. Resigned to his fate, he calmly packed his gear away while the rest of us recklessly leapt down flights of stairs in our attempts to get away. When we reached the bottom we were met by two columns of armed security soldiers. Fortunately, Ken Wharfe was also there.

'Morning, lads!' he smiled. 'If you could just let me have your names.' He was very polite and very formal, especially as he already knew who we were. Ken was a jovial royal protection officer and always had a knowing glint in his eye. He knew that his job was to catch the nutters and that this was really just a bit of sport for him, a practice run for a real-life incident.

There was a small gathering of locals at the corner of the tower block. They had surrounded a car which had no windscreen. Shattered glass covered the road and pavement. 'Your lens!' Nils said, nudging my arm.

'I think we'd better go,' I replied, knowing the equipment would be broken. The people were becoming more animated. One of them, probably the owner of the car, was gesturing upwards with his arms.

Disappointingly for the trigger-happy guards, we were let go by Ken. I'm sure his counterparts would have loved to have interrogated us, 'Egyptian style', for a few days down at the station. Instead, Ken waved us off. 'And don't come back!' he smiled.

'DIANA'S FURY AT TV PEEP SHOW: ITN swim film row,' screamed the headline in the *Sun*, accompanied by mine and Lionel's photos. ITN had shown Mike's 'raunchy' film on the 5:40 p.m. and *News at Ten* bulletins to the utter amazement of Buckingham Palace officials. The palace was outraged.

All that ITN could say in its defence was: 'There was a legitimate news interest.' The photos would have upset Diana's muslim hosts, as she was seen showing off her bare skin. The British tabloids had wound up the situation further by making a big deal of ITN's 'audacity' at using the images – thus giving them an excuse to use the photos without impunity themselves.

'BANNED' screamed the headline on the front of the tabloids. The 'Rooftop Boys', as we had been nicknamed by Diana, had been excluded from the next Diana tour to Korea. All pressmen travelling on overseas visits needed accreditation from the Buckingham Palace press office.

The night after the photos appeared, Diana asked me with a grin if I was one of the 'Rooftop Boys'. I said that I had been sitting on a roof recently to which she replied: 'I don't mind having my photo taken in the pool. I just make sure that I have a new swimsuit on so I look nice. I don't want to be seen in an old costume.' Diana also informed the royal reporter for the *Today* newspaper: 'No, I am not upset at all. I know that wherever I go I'm

going to be photographed and know that includes when I go swimming.'

For me, this was a turning-point. As a freelance photographer, I had been on numerous royal tours and was becoming well known as a royal specialist. But now, having been banned from the next Diana tour of Korea and with no sign of getting my accreditation back any time soon, there remained only one option: to continue snapping royalty – but as a full-time paparazzo. This wasn't a hard decision to make, especially after the vast sums of money I'd just made from the swimming pictures – far more than I'd made from the last 10 royal tours – and especially, as she'd said herself, Diana didn't seem to mind being photographed in private at all!

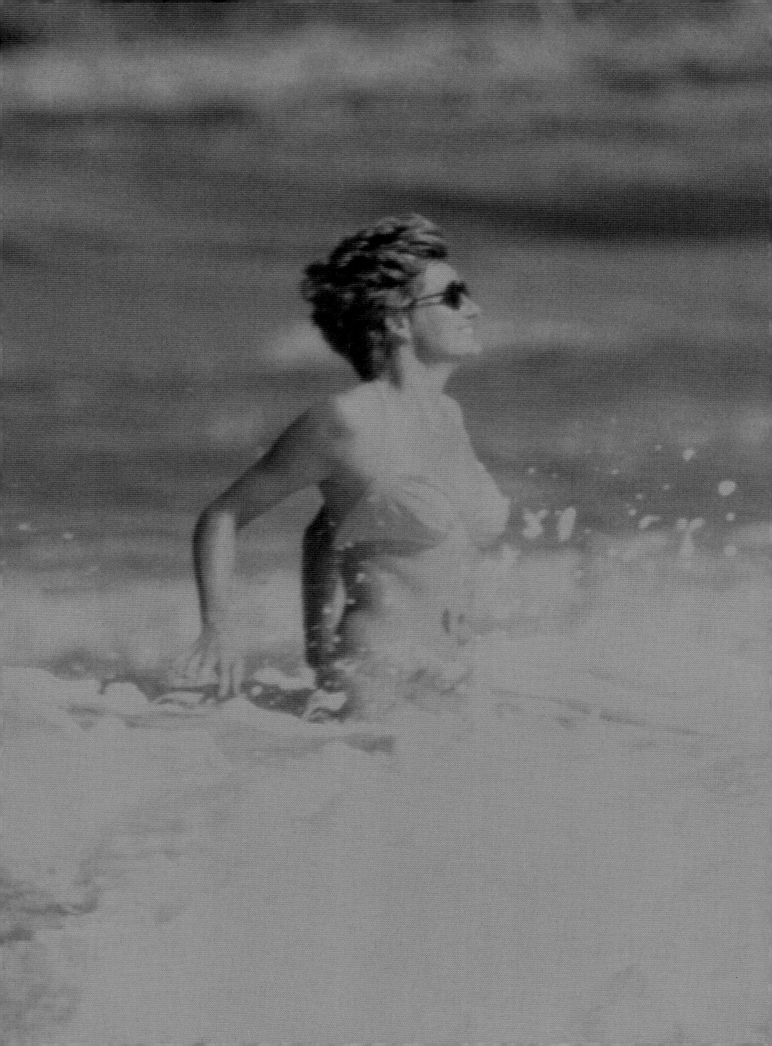

Epilogue

'If you're not there, you don't get.' These were the smug words from a grinning Buckingham Palace press officer just after I'd missed a great set of photos of Diana swimming. I was a photographer accredited to Buckingham Palace who toed the line and specialised in the kind of photographs the Royal Family wanted you to see. It was 1985. I was in London, Diana was on a beach in the Caribbean and so, it seemed, was the rest of Fleet Street. Whilst on this holiday with William and Harry, Diana had arranged an impromptu photocall with the gathered paparazzi. The press was to get access to the family on their private holiday for five minutes.

This was to be on a remote beach where many of the paps had already tried and failed to get pictures.

'What do you mean "If you're not there, you don't get"?' I asked Dickie Arbiter, press secretary to the Prince and Princess of Wales. He said no more, realising that, as an official spokesperson, he'd said too much already.

Diana had created a monster. By inviting the paparazzi into her private holiday, she determined the way that she was to spend the rest of her life – with the paparazzi. Whenever or wherever Diana was in 'private' from now on, there would always be the possibly of an impromptu photo. The line

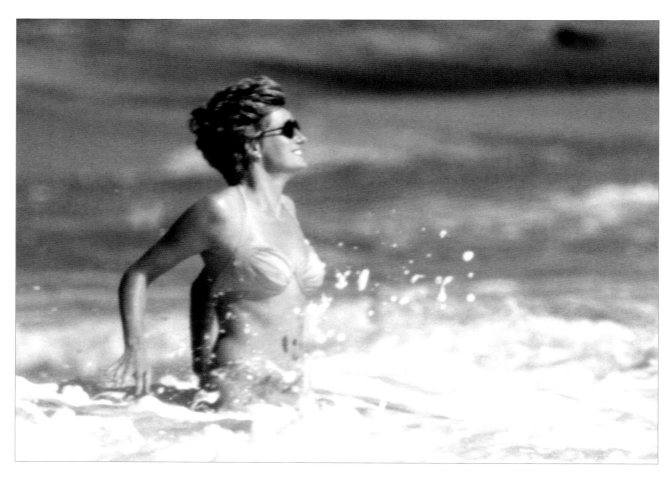

between her public and private life had disappeared. As the years progressed, and as more and more paparazzi pursued Diana, so the floodgates opened wider. When the cracks began to appear in her marriage, Diana tried to close those floodgates, but it was too late. They could never be closed.

Diana was fortunate to chance upon a fresh start away from the nightmare of her marriage with a new and true secret love, James Hewitt. She began to shut out the media she had once courted on her famous royal tours overseas. Consequently, the paparazzi pack pursuing her slowly dispersed, leaving only a few hardcore paps to take up the slack – but they didn't always portray Diana in the way that she wanted to be portrayed. And why should they? As this book reveals, Diana often tried to use the press for her own gain, which is fair enough. But it was a dangerous game to play.

It was well known in Fleet Street that many of the tip-offs that came in aimed at showing Diana in a favourable light actually came from Diana herself or her supporters. Mark and I were phoned on many occasions by Fleet Street reporters with information on where and when Diana would be that day. These would be mainly in locations and at times only she would have known about. Diana had a dream that she could continue to manipulate her high-profile image in society then turn off the celebrity tap when it suited her to do so. This dream was never going to happen. Her profile was too high and the media would never be satisfied with just the public face and they forever demanded more. After all, it was Diana that sold their newspapers

The paparazzi were sandwiched in the middle between the publications and Diana. We were the buffer zone. As long as there was a market to sell

the photos, we would deal with the papers and magazines; as long as there were droplets of cooperation from Diana, we would deal with her.

But the droplets of cooperation finally dried up – for most. Diana's final holiday in Sardinia with Dodi Al Fayed was photographed by the paparazzi with the full blessing of the princess. After all, it was Diana herself who tipped off the paparazzi which bay the luxury cruiser she was on would be anchored in so that they could obtain photographs. Diana's only complaint when the pictures were published was that they looked too grainy.

The week before Diana died, she pleaded with the British paparazzi in the south of France to give her privacy, but finished off her pleas with a bizarre invite to 'stick around to see what was going to happen next week in Paris'. Giving Diana any privacy after having this golden carrot dangled in front of them was the last thing on the paparazzi's minds after that. On the night she died, Diana phoned her confidant at the *Daily Mail*, Richard Kay, with another story. Diana was becoming even more obsessed with the tabloids and the image of her that they portrayed.

We were an integral part of Diana's life. The paparazzi and Diana were as one, both feeding off each other throughout the years of the princess's traumatic and, sadly, short life.

A year before she tragically died in Paris, Diana planted another story with us, knowing that we would sell it to the tabloids. 'I never wanted a divorce!' she told us. 'I didn't want it!' It was the last time we ever saw her.

Glenn Harvey and Mark Saunders
London, 2007